Gold in Photography

For Russ and Nick

Gold in Photography
The History and Art of Chrysotype

Mike Ware

ffotoffilm publishing

First published 2006

Cover design by Tania Fardella www.indigodesign21.com

Printed in England on acid free paper by The Cromwell Press, Ltd.
Aintree Avenue,White Horse Business Park, Trowbridge, BA14 0XB, UK www.cromwellpress.co.uk

ISBN 978-0-9551129-1-1 (10 digit ISBN 0-9551129-1-1)

ffotoffilm publishing, Brighton Media Centre, 68 Middle Street, Brighton, BN1 1AL, UK
www.ffotoffilm.co.uk

Contents

Illustrations

Figures

Tables

Plates

Preface

That if gold rust, what then will iron do?

Geoffrey Chaucer (c.1345–1400)
Prologue to the Canterbury Tales

Since prehistory, humankind has embellished many of its greatest works of art with that most alluring of metals, gold. But it was not until the 17th century that early chemistry discovered a form of this element with the power to stain glass and ceramics to a fine ruby-red. In the late 20th century this superb gold pigment was added to the select group of noble metals – silver, platinum and palladium – which lend themselves as image substances for making permanent photographic prints. Here is the history of this innovation, illustrated by examples of what the gold medium can offer to the photographic artist. Instructions for the making of gold prints are fully set out in my comprehensive workshop handbook: *The Chrysotype Manual: The Science and Practice of Photographic Printing in Gold*, which is published separately as a companion to this volume.

This is my third monograph on the historical processes of photography; the first concerned the earliest silver images made on paper by Henry Talbot, and the second explored cyanotype, the process of printing in Prussian blue invented by Sir John Herschel. Both these media are still known to us today, as conventional black and white photography and blueprinting, respectively. The present account describes a forgotten method of photographic printing invented by Herschel in 1842, but one that yields pictures in pure gold. Named "chrysotype" by its originator, this process proved to be practically non-viable at the time of its invention, due to expense and difficulty, so it lay dormant for 150 years, until recently revived and perfected by means of modern chemistry.

The literature on photographic imaging in silver is voluminous; in contrast, this is the first monograph on photography in gold. In order to set this new medium in its cultural, aesthetic, and technical contexts, these pages offer

1

an outline account of the history of gold in art. My purpose here is also to put forward a justification for this seemingly profligate use of precious metal for making photographs: chrysotype can offer advantages over every other photographic printing method, especially in the beauty and permanence of its images – advantages that in future may qualify it as a unique medium of artistic photographic practice.

Gold, as a pigment, has higher covering power than the other noble metals, a benefit which makes its use significantly less expensive than platinum or palladium. Chrysotype shares with its sister-processes, platinotype and palladiotype, the same characteristics of a totally matte print surface and a very delicate tonal gradation. It does, however, offer an important bonus: besides the usual neutral grey tones, chrysotypes can also display a wide range of subtly-muted colours, including pink, magenta, brown, purple, violet, blue or green. The creative monochrome photographer should find here an extra dimension to explore, in which the colour of an image can be matched to the expressive intent of its maker. The hue of the print is determined by the chemistry of the sensitiser and the conditions of processing, so the photographic artist has full control of this new palette of non-literal colour.

The traditional disciplines of art and science are so disparate that their respective practitioners seldom enjoy much mutual dialogue. Although direct interchanges between the artists and scientists of our divided culture seem sadly infrequent, one of the most accommodating meeting-grounds is provided by the practice of photography, where the science of photochemistry empowers the art of expressive imaging of the real world. Encounters between artists and scientists in this arena can be most fruitful. The work to be described in these pages constitutes one small example of the way that chemical science may be harnessed in the service of graphic art. Practitioners and connoisseurs of photography naturally acquire an appreciation of the cultural history of their materials; so this book is intended to present them with the

essence of the gold-printing medium, through its history and aesthetics. Details of the practice will be found in the companion workshop manual, described above.

The two elemental protagonists in our story, iron and gold, are introduced in the first chapter, which paints an impressionistic picture of their occurrence, history, and properties, including the central role that gold has played in alchemy, with particular regard to the manifestations and significances of colour within that tradition, and the extent to which alchemy can be considered a precursor to modern chemistry. The use of gold as a pigment in the graphic and decorative arts is outlined in the second chapter, which also sketches its contemporary applications in the modern world.

In 1842, one of the foremost men of science in Britain, Sir John Herschel, invented a method of photographic printing in gold, for which he coined the name 'chrysotype' from the Greek χρῡσότυπος meaning 'wrought of gold'. But by then the recently-announced process of silver photography on paper was rapidly improving at the hands of his gifted colleague, Henry Talbot, so Herschel's embryonic gold process never came to fruition, due to its high cost and very problematic chemistry. To borrow some alchemical symbolism: just as the sun is eclipsed by the moon, so gold printing was eclipsed by silver, but the eclipse was total and proved almost permanent. From the day of its invention, the elusive chrysotype process resisted the few attempts that were made to tame it. These endeavours are traced in Chapter 3, drawing on my researches into Herschel's original experimental records, which explain why gold-printing failed to be accepted into the canon of photographic practice. Over the last 160 years a number of photographic innovators besides Herschel have attempted to employ gold as an imaging substance in its own right; so a diverse cast of photo-historical personalities is introduced in Chapter 4, some of them highly idiosyncratic, but all with one characteristic in common: despite their best endeavours, they met with little real success.

In contrast to these persistent failures, gold was used with great success as a toning agent to improve the stability and appearance of silver photographs, and Chapter 5 describes their several varieties: daguerreotypes, salted paper prints, albumen and collodion prints, and gelatin printing-out papers. The high speed of modern silver halide emulsions, which we take so much for granted in our camera films today, depends critically on their sensitisation by incorporating trace amounts of gold compounds.

Chrysotype resembles closely the highly-esteemed platinotype process of William Willis, which was widely-practised and, by the end of the 19th century, had achieved great commercial success. There are, however, clear chemical reasons why it is intrinsically more difficult to use salts of gold, rather than platinum, in an iron-based photographic sensitiser. Indeed, all the leading authorities on photographic theory at that time acknowledged these difficulties, which persuaded them totally to discount the feasibility of gold printing. So, although this notion has been in the air since the dawn of photography, it has not previously been carried into successful practice. A controllable, economic chrysotype process only becomes possible with the aid of some modern chemistry, whereby the vigorously oxidising nature of the gold salts can be moderated. As the culmination of sixteen years' research, I have perfected formulae for iron-based gold-printing sensitisers. My "new chrysotype" process, retains the name to honour the original invention by Herschel, and is probably the only chemically novel method of precious metal printing to be devised in the last 100 years.

The chrysotype process finds its contemporary context among the recently-revived minority practices that have come to be called "alternative" photographic printing. The background history to this low-key, non-commercial technology is provided in Chapter 6, with a survey of the various processes and imaging substances that can be employed to make photographic prints by hand – that is, without recourse to manufactured photographic papers, which are factory-coated with silver halide emulsions.

To illustrate the results obtained from the new chrysotype process, in a variety of hands, some examples of work by contemporary artists are reproduced in Chapter 6. Although the chemical principles of new chrysotype were published in 1994, instruction in the practical techniques has been confined, so far, to one workshop in California in 2000. Practitioners of this process are consequently yet few in number – about a dozen worldwide. By showing this gallery of work, I hope to prove that there is no mystery or secret surrounding the process, and that its use is now accessible to all, with high expectations of success, for the creation of new and beautiful works.

Finally, there are the curatorial issues of the identification of the processes used for photographic images and their relative stability. The analysis and conservation of precious metal prints is considered in Chapter 7, where I suggest that chrysotypes may well prove to be the most permanent of all photographs. The gold image should enjoy great longevity: chrysotypes are extremely light-fast and resistant to chemical attack; they can claim an archival permanence excelling even that of platinotypes because, unlike platinum, gold is a relatively poor catalyst, meaning that it does not tend to promote reactions leading to the acidic destruction of the paper upon which the image is printed. For the same reason, gold is not in demand commercially as a catalyst, in contrast to platinum and palladium, so its use for image-making does not compete for a vital resource.

This time of writing is a time of revolutionary change in the prevailing technology of the lens-based media. The majority of photographers, amateur and professional alike, are presently forsaking the darkroom in favour of the desktop, enticed by the ease and convenience with which the personal computer can handle images as digital files. There can be no doubt that, during these opening years of the new millennium, the practice of electronic imaging – processed, stored, and transmitted in digital, rather than analogue forms – will exert a profound influence upon the flow of pictorial information within our societies.

As a direct consequence, the very authenticity of the photographic medium is being called into question. This transformation in the nature of the dominant technology, from chemistry to physics, brings a danger that the practices of 'analogue photography', which is already deemed obsolete from a commercial viewpoint, may be totally lost – to the detriment of the minority practice of photography as a vehicle for artistic expression. A review of the methods of hand-making photographs, which is a major theme underlying this book, would therefore seem timely.

Some echo of the personal feelings that accompanied my first success in gold printing nearly 20 years ago may be found in these words of Charles Dickens from *Great Expectations:*

> "That was a memorable day to me, for it made great changes in me. But, it is the same with any life. Imagine one selected day struck out of it, and think how different its course would have been. Pause you who read this, and think for a moment of the long chain of iron or gold, of thorns or flowers, that would never have bound you, but for the formation of the first link on one memorable day."

Acknowledgements

My investigation of the chrysotype process, which was initiated in 1983, received the support of a photographic bursary from Kodak Ltd. in 1985, which I gratefully acknowledge for "priming the pump" so many years ago. My gratitude also goes to three good friends, Jane Routh, Paul Hill, and John Benjafield, for their encouragement in those early days; without their urgings, I would not have journeyed very far down this road.

I am indebted to the custodians of the world's historic chrysotypes and manuscripts by Sir John Herschel: Tony Simcock, the Archivist of the Museum of the History of Science, Oxford; the Librarians of the Royal Society, and of the Science Museum, London; and the curatorial staff of the National Museum of Photography, Film & Television, at Bradford. I record my gratitude to the trustees of the Harry Ransom Humanities Research Center

of the University of Texas at Austin, for the award of a Mellon Research Fellowship in 1999, which enabled me to examine at first hand that most significant part of Sir John Herschel's legacy which is in their keeping. My warmest thanks go to the staff of the HRHRC, in the manuscript archive and the photography collection, especially to Barbara Brown, Linda Briscoe, David Coleman, Roy Flukinger, and Mary Alice Harper, for their assistance in making this material accessible.

Some of the leading figures in contemporary photohistorical scholarship have with kindness – and at times great patience – assisted my faltering steps down the pathways of photographic history. For this guidance I thank Michael Gray, Anne Hammond, Larry Schaaf, Sara Stevenson, Roger Taylor, and Mike Weaver; but I would add that any obvious waywardness on this journey must be ascribed solely to the vagaries of this writer, and not to his mentors.

Two distinguished professors of photographic art in the USA, Pradip Malde and Roger Vail, undertook to "prove" the new chrysotype process by using it for their own image-making. I am beholden to these two good friends for their enthusiastic and critical responses from their distant proving grounds, which have both energised and refined the research described in these pages, and I am grateful for their permission to reproduce some of their work in these pages. If I am ever called upon to justify this self-indulgent excursion into obsolete 19th century photographic process, then I shall need only to point to their work as evidence of a valued artistic outcome.

This work would not have reached print without the enthusiasm and commitment of my editor-publisher, Paul Daskarolis.

Mike Ware
Buxton, 2006

1 Iron and Gold

There was a golden age – who murdered it?
How died that age, or what became of it?
Then poets, by divinest alchemy,
Did turn their ink to gold; kings in that time
Hung jewels at the ear of every rhyme.
But Oh, those days are wasted! and behold
The golden age that was is coined to gold:
And why Time now is called an iron man,
Or this an iron-age, 'tis thus expressed, –
The golden age lies in an iron chest.

Thomas Middleton (*ca.* 1570–1627)
'The Golden Age', from *Father Hubburd's Tales*

In classical antiquity, just seven metals were known: iron, tin, lead, mercury, copper, silver, and gold. Over the span of five millennia since the beginnings of human history, these seven, together with their various alloys,[1] were all that any civilisation ever had to serve its metallic needs, whether domestic, decorative, martial, financial, or technological. Humanity has had to wait another two millennia for the foundation of chemical science, only three centuries ago,[2] before the roll-call of known metallic elements could begin rising to its present total of around eighty-eight.[3]

Of the seven ancient metals, two in particular have recurrently fired the poetic imagination, to be celebrated in an elemental antithesis: the metaphorical "battle" of iron and gold. The epigraph for this chapter, from Thomas Middleton, provides one example of this allegory, and more sources will be quoted throughout the pages that follow. The interplay of gold and iron is also the underlying theme of this book, but with this difference: the elements will not be taking on their roles in their familiar metallic forms, but rather they will make their appearances in the guise of substances which hold them in chemical combination. My purpose here is to describe how salts of gold and of iron can be wedded into a photographic printing process called chrysotype, that yields beautiful images composed of pure gold. To begin, therefore, it seems appropriate to set

1 Notably: brass (copper/zinc), bronze (copper/tin), Corinthian bronze (copper/silver/gold), pewter (tin/lead), electrum (silver/gold), speculum metal (copper/tin).

2 Zinc was added to the list in *ca.* 10 AD (Strabo), and bismuth in the 1500's. The semi-metal, antimony, was known to the alchemists. The rest of the metals were not discovered until after 1700.

3 This figure is nominal, based on the proven existence of elements as far as atomic number 110; all the most recent 'synthetic' elements are metals. The number of alloys that can be formed from 88 metals is now countless.

9

the context with a description of the cultural and scientific history of these two contrasting elements; Thomas Middleton's sentiments may have been poetic, but there is sound observation underlying his metaphors.

Iron

As a consequence of its high reactivity, iron is horribly susceptible to the all-too-familiar corruption of rust that is inevitable in the humid, oxygenated, life-giving atmosphere of our planet.[4] Iron is the second most common metal in the earth's crust,[5] of which 6.2% is iron.[6] It very rarely occurs here in its elemental metallic form, but is always chemically combined, mostly with oxygen,[7] into its various oxides, whose stable reddish-brown colours have ensured their value as pigments since pre-history.[8] From these principal terrestrial ores the metal can be freed only with some difficulty, by heating the ore with carbon (charcoal or coke) in a furnace to a temperature of about 1000 degrees Celsius.[9]

The first successful extraction of iron from its ore is shrouded in historical uncertainties. Some ancient Greek historians (Homer, Strabo, Xenophon) considered the 'inventors of iron' to be the indigenous peoples called the Chalybes and the Chaldaei, who were tribes settled on the far Eastern shores of the Black Sea, south of the Caucasus, in the ancient region of Colchis (present-day Mingrelia in Georgia). The name of the Chalybes is commemorated in the words for 'steel' both in Greek (Χάλυψ – *Khalyps*) and Latin (*Chalybs*), and it even persists in our English vocabulary today, to describe the iron-bearing waters from the chalybeate springs of our spa towns.

Colchis was the region where Greek mythology celebrated the quest of Jason and the Argonauts for the legendary Golden Fleece – said to be in the possession of King Aeëtes, son of Helios, father of Medea. From the earliest times, then, the histories of iron and gold have been mythically interwined! The discovery of iron smelting, and other metallurgical expertise, was believed to have been made during the second half of the second millennium BCE. At first the secrets were transmitted only among the castes

4 Rusting requires both air and water – and an electrolyte, commonly salt solution.

5 The most abundant metal in the crust is aluminium, which was unknown until 1827, and even then so difficult to extract that it was worth more than gold.

6 The most abundant elements are oxygen, silicon, and aluminium.

7 Also with sulphur, as the beautifully crystalline 'fools' gold': iron pyrites, $CuFeS_2$

8 The commonest ore, called haematite, is ferric oxide, Fe_2O_3; there are also: magnetite, Fe_3O_4, limonite, $2Fe_2O_3.3H_2O$, and siderite, $FeCO_3$. Ferric oxide is the principal constituent of the pigment known as Indian Red; the Ochres, Siennas and Umbers of the painter's palette consist of clay (aluminium silicate) containing various proportions of hydrated ferric oxide.

9 Limestone (calcium carbonate) is also added in some cases to remove acidic impurities.

10 I.V. Pyankov, 'The Disappeared Circumpontic Caste of Metallurgists', *International Electronic Conference 2004:* www.acnet.ge/catastrophes/III_2.htm

of metallurgists, but they eventually spread over Asia Minor, as the quality of the 'weapons-grade' metal came to be appreciated.[10] The knowledge fell into the hands of the Hittites, who soon learned to their advantage that iron was the very stuff of martial power, for this metal could boast a tensile strength exceeding any other then known. Iron was the metal that underpinned their dominance in Asia Minor for centuries. The fall of the Hittite Empire around 1200 BCE may have been due in part to rival cultures obtaining the secret of iron-smelting, whereupon the Iron Age proper could begin.

Surrounded by iron and steel artefacts in our everyday lives today, it is difficult for us to believe that there was once a time in human history when iron was scarcer and more prized than gold. Prior to the Chalybes' discovery, the only metallic iron on the surface of our planet had literally fallen from the sky, as siderites – meteorites with a high content of free iron – which had been preserved from rusting by the vacuum of space. Long before the knowledge was gained of smelting iron from its ores, ancient peoples worked with meteoritic iron, and its use persisted within those cultures which did not succeed in developing extractive metallurgy.[11] When Cortez asked the Aztec chiefs whence came their iron knives, they replied by simply pointing to the sky. It may be no etymological coincidence that the classical Greek word for iron, σίδηρος (*sideros*), so closely resembles the Latin *sidus – sideris*, the word for a star.

11 Mircea Eliade, *The Forge and the Crucible: The Origins and Structures of Alchemy*, trans. Stephen Corrin, Chicago: The University of Chicago Press, 1978.

In the 5th century, around 400–410 AD, King Chandragupta II Vikramaditya of India, had an iron column built, 7 meters high and 6 tonnes in weight, which was moved to Delhi during the 13th century, and there erected to the God Vishnu. It still stands today, showing hardly a sign of corrosion despite 1600 years exposure to the hot atmosphere and the monsoon rains. This long-standing mystery of rust-free ancient iron has only recently been solved: the surface of the pillar is thinly coated with a protective layer of an iron phosphate, arising from the presence of phosphorus in the particular ore used, and the fact that the method of extraction did not employ limestone, which would have removed it.[12]

12 by Ramamurthy Balasubramanian. See: Sanjay Kumar, 'Ancient smiths forged to last', *New Scientist*, 175:2354, 3 August 2002, 9.

Later in human history, when the extractive metallurgy of iron had been mastered in the West, the metal formed the very marrow of the Industrial Revolution, which was initiated in Britain around 1709 with the first use of coke, rather than charcoal, to smelt iron in quantity.[13] This innovation was due to Abraham Darby of Coalbrookdale, in Shropshire, where iron had been produced since the 1630's.[14] By 1773, cast-iron vessels for steam-engine boilers were being mass-produced by his grandson, the Quaker ironmaster Abraham Darby III, whose most famous achievement, at the age of 29, was to cast the components for the world's first large structure made entirely of metal – an iron bridge of 378 tons – which was erected across the Severn valley in 1779. Its hundred-foot span still arcs gracefully over the river there today, as a robust testament to his enterprise. However, this achievement did little to benefit Abraham Darby III, who died at the age of 39, deeply in debt.[15] His revolutionary use of iron had gone unrewarded in gold.

Despite its absence in elemental form on the surface of our planet, metallic iron is the chief constituent of the Earth's inaccessible core, which is thought to be a semi-molten ball of iron, at a temperature of nearly 6000 degrees Celsius, about 7000 kilometers in diameter – the same size, appropriately, as the planet Mars. Iron is also believed to be the most abundant metal in the universe as a whole; the reason for this lies in its tightly-bound atomic nucleus, which is the most stable nucleus of all the isotopes of all the chemical elements. Iron therefore tends to be the end-product of the extremely energetic nuclear reactions in exploding stars – stellar supernovae. It is a strange thought that the ultimate theoretical fate of all the matter in the universe as it reaches minimum energy is to be transmuted into iron.

Most forms of life on our planet find iron essential for providing vital biochemical functions: in a wide variety of bacteria, metallo-enzymes containing iron enable the fixation of nitrogen from the air, so nourishing the very roots of the planetary food chain, which reaches up to us.

13 It was no longer necessary to rely on the costly stripping of forests to obtain the reductant, charcoal.

14 This is now a heritage site and museum of the cradle to the Industrial revolution.

15 Owing £50,000 – the equivalent of £20 million in 2006.

In animals, an iron-containing molecule is responsible for the transport of oxygen by the blood.[16] At the heart of this process is the complex protein, haemoglobin, which is responsible for the colour of red blood cells, and contains four plate-like molecular haem groups, each with an atom of 'ferrous' iron(II) bound at its centre; these can readily accept and give up an oxygen molecule in a reversible manner. Every adult human life is sustained, with each breath, by a total of just 3 grams of iron. Other iron proteins, called cytochromes, are responsible in animals, plants, and bacteria, for an essential, energy-giving reaction: the metabolic oxidation of glucose, which involves the transfer of electrons by means of the iron(II)/iron(III) couple – a piece of chemistry which will also feature later in a photochemical context.

Gold

The least reactive chemically and most enduring of all metals, gold has always exercised an irresistible allure, and stands in gleaming contrast to iron.[17] Its scarcity is separated from the commonness of iron by a factor of about ten million: the Earth's crust contains 4 parts of gold per billion (an abundance – hardly the appropriate word – of 0.0000004%). But rarity alone is not enough to explain its charm, for there are other metals even less abundant, but largely unacknowledged. The indestructible stability, luscious colour, impressive density, and sensuous malleability of gold also contribute to the power that this metal exercises over humanity. Nowhere is this fascination better expressed than in the words of the late Professor Jacob Bronowski, from his book *The Ascent of Man*:

> "Gold is the universal prize in all countries, in all cultures, in all ages. Gold for greed; gold for splendour, gold for adornment, gold for reverence, gold for power, sacrificial gold, life-giving gold – gold for tenderness, barbaric gold, voluptuous gold..."[18]

Gold therefore occupies a special place among the elements on account of its economic and socio-political

16 There are a few creatures that have, perversely, evolved with an alternative respiratory metal complex. The sea-squirt *Ascidium* uses vanadium, and some crustaceans use copper to transport oxygen.

17 The position in the Electrochemical Series is the usual criterion invoked to calibrate the reactivity of a metal. Platinum vies with gold at the summit of stability, but this, "the eighth metal", was not introduced into Western civilisation until the 18th century.

18 J. Bronowski, *The Ascent of Man*, London: Book Club Associates, 1977, 134.

importance, but this is not the place to expand on a topic which is so well-represented in other works, to which the interested reader is referred.[19] As we read of the poetic aspects of "life-giving gold", it is salutary to keep in mind that gold has, in fact, no biochemical functions whatsoever in any known living organism, and its salts are merely toxic to animals and man; whereas without iron, we would all die. The rest of this chapter will consider mainly the physico-chemical properties and uses of gold, and the chemical manipulations to which it has been subjected over the long history of mankind's acquaintance with this wonderful element.

Gold is the earliest metal of all. It was known in prehistory simply because it could be found lying around on the surface of our planet in the elemental state, occasionally – if the finder was particularly fortunate – in large nuggets: for instance, the "Welcome Stranger" nugget found in Victoria, Australia in 1869, weighed over 71 kilograms. There are good chemical reasons why gold, although extremely scarce, should be so accessible. It is a member of that élite class of metals designated as 'noble', meaning that they do not corrode (*i.e.* oxidise) in air and water, and can be melted and re-melted without change, and are easily thrown out of chemical combination, reverting to the metallic state. Gold's inertness explains why it has persisted unaltered since the formation of our planet about ten billion years ago from the dusty, gaseous residues of a supernova explosion, in which gold and the other heavy elements were first synthesised. The concentration of gold in the earth's crust actually poses a problem for geochemistry, because it is higher than predicted by theory: most of the earth's gold, if it had been evenly distributed within our primordial planet, should have dissolved in the iron core and been lost to us. To account for this anomaly, it has been suggested that some of the precious elements in the earth's crust may have been imported later, by meteorites rich in heavy metals striking the earth's surface after its initial formation, so imparting a 'golden veneer' to our planet.[20] The classical Greek myth of Zeus manifesting himself as a shower of gold from the heavens would therefore appear to have some basis in fact.

19 C.H.V. Sutherland, *Gold: Its beauty, power and allure*, London: Thames and Hudson, 1969; Peter L. Bernstein, *The Power of Gold: the history of an obsession*, New York: John Wiley & Sons, 2000. The website of the World Gold Council carries much information: http://www.gold.org/

20 *New Scientist*, (29 July 2000) 6; *Nature*, 406 (2000) 396.

Colloidal Gold as Nanoparticles

To appreciate the chrysotype photographic process, it is essential to realise that the gold formed therein is not gold in the familiar form that we have so far been envisaging – as jewellery, coinage, or bullion. The state of gold in such bulk, and even as thin leaf, is called specular metal, from the Latin for a mirror, *speculum*. Now, a surface of purely reflective metal is incapable of rendering the subtle gradations of tone needed to faithfully represent the lights and shades of a photograph. Rather, the gold of the chrysotype image must be considered as a pigment, consisting of finely-divided gold particles of sub-microscopic size which are now called nanoparticles (the prefix derives from the Greek ναος [*nanos*], meaning dwarf). So small and highly-dispersed are they, that their properties appear quite different to those of the bulk metal. When light falls on this nanoparticulate form of gold, rather than being reflected, it tends to be both scattered in all directions and absorbed at specific wavelengths, which depend on the size of the particles. A surprising consequence of this phenomenon is that its colour can vary widely, yet the pigment giving rise to the variety of colours is nothing but pure gold. The objective of my work is to bring this superb pigment within the scope of the photographic print-maker, whose choice of metallic image substances has hitherto been restricted to the monochromatic grey or brown tones of silver, platinum and palladium.

Gold in this nanoparticulate state used to be technically described as a *colloid:* the colloidal state of matter being defined by the size of its particles, falling within a range of *ca.* 10 to 100 nanometers[21] – that is, larger than simple molecules (*ca.* 1 nm), but smaller than the wavelengths of visible light (*ca.* 400–700 nm) – but the term colloid is now not used of metals, but reserved only for gluey macromolecular organic substances, such as gelatin. Even though the term *nanoparticle gold* may be unfamiliar, the substance itself is not: we encounter it quite commonly in everyday life. It is responsible for the deep translucent reds

21 One nanometer is a billionth (US) of a meter, 1 nm = 10^{-9} m.

15

of stained-glass windows in many churches (plate 1.1); or in antique "Cranberry glass" or "Gold Ruby glass" (plate 1.2);[22] or even in the decorative Victorian glass of the author's house door (plate 1.3). Chapter 2 will have more about nanoparticle gold and its unusual properties.

Gold in Alchemy

It is inevitable that an essay touching on the cultural history of gold should strike some resonances with the traditions of alchemy. The interpretation of alchemical writings – a literature that is extensive and recondite – is not a field of scholarship that I am qualified to comment seriously upon.[23] For an introduction to the history of alchemy, readers are especially recommended to the books by John Read,[24] where they will find a fascinating account of the cultural diffusion of alchemical thinking and practise: from its conception in Asia, gestation in classical Greece, and passage through Egypt and the Arab world, to be delivered finally via Spain into Latin Europe in mediaeval times. Here, the arcane practice was seized upon, for widely varying motives, by an assortment of colourful rogues and reclusive adepts, whose lives are vividly recounted by Read. In this chapter my purpose will be more soberly confined to exploring the possible connection between the alchemists' activities and the discovery of nanoparticle gold as a pigment; but, in view of the frequency with which the word *alchemy* is invoked today by artists using alternative photographic processes, I think it will be appropriate to consider briefly the intellectual transition from alchemy to chemistry, which parallels, in some respects, the gulf between art and science which the present book is attempting to bridge.[25]

The Number Seven

Gold has always enjoyed pre-eminence in alchemy by virtue of its mystical identity with the sun. Indeed, each of the seven known metals of classical antiquity was associated with one of the conspicuous bodies of our solar

22 *The Glass Encyclopedia*: http://www.encyclopedia.netnz.com/index.html

23 There is an extensive Website devoted to alchemy: www.levity.com/alchemy/home.html The online periodical devoted to the philosophy of chemistry, *Hyle*, also carries scholarly writings on alchemy, *e.g.* Barbara Obrist, 'Visualization in Medieval Alchemy', *Hyle* 9:2 (2003) 131-170. http://www.hyle.org/journal/issues/9-2/obrist.htm

24 John Read, *Prelude to Chemistry*, London: G. Bell and Sons, 1939; idem, *Humour and Humanism in Chemistry*, London: G. Bell and Sons, 1947; idem, *Through Alchemy to Chemistry*, London: G. Bell and Sons, 1957.

25 Mike Ware, 'A Bridge for Two Cultures', in *Inscape*, Ed. William Bishop, 5 (1993) 33-35; also at: http://www.mikeware.co.uk/mikeware/Bridge_Cultures.html

26 John Beckmann, *A History of Inventions, Discoveries, and Origins*, trans.William Johnston, London: Henry G. Bohn, 1846.

system, which coincidentally also numbered just seven for much of early history, until the invention of the telescope extended human vision. Each metal had its own symbol and characteristic attributes, which are summarised in Table 1.1.[26] The celestial bodies also lend their names to the days of the week, although in Anglo-Saxon some of the gods of Nordic mythology have insinuated themselves, so this association is better seen in the French.

Table 1.1 *The seven metals linked with the bodies of the solar system and the days of the week*

Metallic element	Latin name	Alchemic/Chemical symbol		Associated celestial body	Day of the week	
Gold	Aurum	☉	Au	Sun	Sunday	Dimanche
Silver	Argentum	☽	Ag	Moon	Monday	Lundi
Iron	Ferrum	♂	Fe	Mars	Tuesday	Mardi
Mercury	Hydrargyrum	☿	Hg	Mercury	Wednesday	Mercredi
Tin	Stannum	♃	Sn	Jupiter	Thursday	Jeudi
Copper	Cuprum	♀	Cu	Venus	Friday	Vendredi
Lead	Plumbum	♄	Pb	Saturn	Saturday	Samedi

27 C.J.S. Thompson, *The Lure and Romance of Alchemy*, London: G.G. Harrap, 1932.

As C.J.S. Thompson, in *The Lure and Romance of Alchemy* observes: "From this supposed close association between the planets and the metals probably came the spiritual connexion that existed between alchemy and astrology in the early ages."[27]

The most celebrated reference to this association appears in *The Canon's Yeoman's Tale* from Chaucer's *Canterbury Tales:*

> Gold for the sun and silver for the moon,
> Iron for Mars and Quicksilver in tune
> With Mercury, lead which prefigures Saturn
> And tin for Jupiter. Copper takes the pattern
> Of Venus if you please!'[28]

28 Geoffrey Chaucer, *The Canterbury Tales*, trans. Nevill Coghill, London: Penguin Books, 1951, 475.

The alchemist Paracelsus in his *Coelum Philosophorum* sums up the nature of alchemy in the 'Seven Canons of the Metals', by prefacing with this warning: "these Seven Canons cannot be perfectly understood by every cursory reader at a first glance or a single reading. An inferior intelligence does not easily perceive occult and abstruse subjects."[29] The number seven itself had long been imbued with mystical significance; it is a tribute to human

29 See http://dbhs.wvusd.k12.ca.us/ Chem-History/Paracelsus.html

ingenuity, but not to human logic, how many diverse sets of things have been enumerated to exactly seven, by forcing them into compliance with this "holy number". For instance, we have: the colours of the Newtonian spectrum; the notes of the musical scale; the ages of man; the number of seals of the Apocrypha, and the seven pillars of wisdom, the number of herbs, seas, transformations, spirits before the throne of God, graces or virtues, cardinal sins, phases of the moon, churches of Asia, sages of Greece, joys or sorrows of the Virgin, wonders of the world, the Pleiades – the seven daughters of Atlas – and the ultimate *reductio ad absurdum* of Lewis Carroll's 'seven maids with seven mops'. The mystical significance of seven is probably even responsible for numbering the days of biblical creation and therefore the length of our arbitrary seven-day week.[30]

Chrysopoeia of the Alchemists

The literal meaning of chrysopoeia, 'gold-making', from the Greek χρῡσός (*chrysos*) and ποιέω (*poieo*), is widely believed to be the chief aim of the alchemists. Their pursuit of a recipe for synthesising this primary token of wealth found support from the sponsorship of enthusiastic patrons, who were usually driven by avarice or debt, but whose gullibility ensured that they were inevitably defrauded in the long run. The endeavours of the alchemists, however, cover a much wider spectrum of human behaviour, ranging from the one extreme of blatant fraud by the "puffers" (who were so-called because of their energetic use of the bellows to ventilate their furnaces), to the other extreme of mystical insights by the true adepts. Not every alchemical practitioner was a mountebank; there was also a spiritual dimension in the quest. The adepts saw the transformations of matter as metaphors for their own spiritual progress in the betterment of their souls.[31] The incorruptible quality of gold represented ultimate salvation because it stood at the metallic pinnacle in the ascending processes of 'perfecting' matter by chemical changes. Among the alchemists, the symbolism of birth, death, and resurrection in an

30 Dionysius Lardner, *The Museum of Science and Art*, London: Walton and Maberly, 1854, vol 5, 143; John D. Barrow, *The Artful Universe*, Oxford: Oxford University Press, 1995, 149-161.

31 C.G. Jung, *Psychology and Alchemy*, London: Routledge 1968.

hypothesised spiritual world, was given actuality by the transmutations of inanimate substances. These esoteric allegories may have risen to poetic heights, but alchemy is today remembered less for its obfuscating discourses, than for its enigmatic but fascinating iconography.

The conversion of base metals into gold was believed to be brought about by the so-called "Philosophers' Stone", a hypothetical forerunner of the modern concept of a catalyst. The preparation of this mysterious substance, also referred to as the "Powder of Projection", was the objective of the *Magnum Opus*, the "Great Work" of alchemy. The product was said by initiates to be red in colour. A number of writers seem to agree that there were four stages to the *Magnum Opus*, each characterised by a typical colour. This set of four colours was also associated by some adepts with the four elements of Empedocles, and the four humours of the body envisaged by Hippocrates (*ca.* 460–377 BCE), as set out in Table 1.2. There is even a further correlation of the elements with four of the regular polyhedra of Plato's *Timaeus*. (The fifth, the dodecahedron, is the *quinta essentia*.)

Table 1.2 *The four stages of the Magnum Opus*

Stage	Colour	Humour	Element	Platonic Solid
nigredo	black	black bile	earth	cube
albedo	white	phlegm	water	icosahedron
citrinitas	yellow	yellow bile	air	octahedron
rubedo	red	blood	fire	tetrahedron

The sequence of operations began with the "mortification of matter" by its putrefaction, followed by its rebirth and transmutation. In the process, it seems a likely conjecture that alchemists may have stumbled upon the preparation of red nanoparticle gold long before the 'official' date of its documented discovery in 1656 by Glauber, as will be described shortly. A crucial prerequisite would have been the ability to dissolve gold metal. This entailed the knowledge that a mixture of nitric acid and hydrochloric acid (respectively, *aqua fortis* or "strong water" and *spiritus salis* or "spirit of salt", as they were known to the alchemists) has the power to dissolve gold,

whereas neither acid can do so alone. This formidable acidic mixture is the only commonly-available reagent capable of dissolving gold, and for just this property earned its alchemical name of *aqua regia* or "royal water".[32] A form of *aqua regia* could also be made by mixing a strong mineral acid with appropriate salts.[33] Nitric acid itself was probably first prepared in the 8th century by the most celebrated of Arab alchemists, Jâbir-ibn-Hayyân (*ca.*702–776); it was certainly known (as *aqua dissolutiva*[34]) to the pseudonymous 13th–14th century alchemical writer, Geber,[35] who appropriated a Latinised version of the famous Arab's name to conceal his own identity and foster credibility. Geber noted that with added *sal ammoniac* (ammonium chloride), *aqua fortis* (nitric acid) had the power to dissolve gold.[36] Hydrochloric acid itself was first described in the works of the legendary Basil Valentine (*ca.* 1600).[37]

The dissolution of metallic gold in some version of *aqua regia* must therefore have been known to all alchemists succeeding Geber, and it may be significant – in view of the alchemists' stage of *citrinitas* – that the resulting solution of chloroauric acid is an intense yellow colour. To produce colloidal gold, all that is then needed is to treat this solution with a suitable reducing agent, for which many common forms of organic matter and various inorganic substances, will serve.[38] Even human skin is effective, because contact with gold salts stains it purple. The striking blood-red colour of nanoparticle gold would have commanded immediate attention because colour changes, as we have seen, lay at the heart of alchemical philosophy as manifestations of the transformations of matter in the *Magnum Opus*. It is possible that nanoparticle gold may have been responsible for the colour of the final stage – the *Rubedo*, or "work in red". There is no other obvious chemical reaction that would have given rise to this colour in solution.[39] As circumstantial evidence for this hypothesis, there are many appearances in alchemical writings of metaphors such as the "red lion", "the purple mantle of the king", "water in rubefaction", "queen of the rubedo",

32 Sometimes written *aqua regis* or "water of the king".

33 Any strong acid, such as oil of vitriol (sulphuric acid), in the presence of both chloride and nitrate will serve.

34 Obtained by distilling a mixture of saltpetre (potassium nitrate), copper vitriol (copper(II) sulphate) and alum (potassium aluminium sulphate). Geber used it to dissolve silver metal, making silver nitrate, or *lunar caustic*.

35 The name 'Geber' was assumed by an unidentified 13th/14th century Spanish alchemist, trading on the famous name of Jâbir-ibn-Hâyyan, and thereby avoiding the proscriptions of the Church, because the practice of alchemy had been prohibited in 1317 by Pope John XXII.

36 In his work *De inventione veritatis seu perfectionis metallorum.*

37 Valentine describes its preparation by heating common salt (sodium chloride) with green vitriol (iron(II) sulphate), which on heating yields oil of vitriol (sulphuric acid), and thence hydrochloric acid. The author of the writings of "Basil Valentine" is now believed to be one, Johann Thölde.

38 Reductants producing colloidal gold include: tannin, citric acid, phosphorus, and turpentine.

39 The best-known red pigment was vermilion, the naturally–occurring mineral, Cinnabar, mercuric sulphide (HgS), which is highly insoluble.

40 John Beckmann, op. cit, n. 26.

"the red tincture of multiplication", "the work of redness" etc.[40], but their meaning, like so much of hermetic literature, is now – and probably always was – wilfully obscure.

It is also significant that, in the alchemical prescriptions for preparing the Philosphers' Stone, some genuine gold was called for at the outset, in order to enter upon the operations of the *Magnum Opus*. The procedure was therefore regarded hylozoistically,[41] as one of "multiplication" in which the "seed of gold" (the *chrysosperm*) could be made to germinate and grow in a suitable environment. It was theologically unacceptable that mortals could create primary matter, but it was self-evidently God's purpose that man could legitimately foster growth from a seed. In the course of the alchemists' gold-impregnated manipulations, it would not be at all surprising chemically that the ruby-red colour of nanoparticle gold should have made an appearance.

41 Hylozoism is the doctrine that all matter contains life.

Alchemy : Precursor to Chemistry?

When one reads of their alchemical achievements, it becomes apparent that neither the fraudulent mountebanks nor the mystical adepts made many significant contributions to the foundations of chemistry. The true progenitors of this science are to be found among the humble, down-to-earth artisans and craftsmen:[42] the miners, ore-smelters, metalsmiths, jewellers, gilders, glass-makers, enamellers, ceramicists, potters, perfumers, textile dyers, and brewers, whose obligation to provide a genuine product embued them with an attitude to the physical world that was more pragmatic than the fantastic speculations of the alchemical philosophers. Although the artisans, too, enjoyed their share of myth and ritual, they were far closer to the realistic spirit of empirical science.

42 Embodied in the work *De Re Metallica* (1555) of mineralogist and metallurgist, Georgius Agricola (Georg Bauer,1494-1555). See John M. Stillman, *The Story of Early Chemistry*, New York: D. Appleton and Company, 1924.

It was little more than two centuries ago that the misbegotten pursuits of alchemy were finally re-directed into the fruitful scientific study of chemistry, largely by the vision and endeavours of the greatest French scientist, Antoine Laurent Lavoisier (1743–94). His work, supported by that of Henry Cavendish (1731–1810), and Joseph Priestley

(1733–1804) forms the basis of modern chemistry. The genius of these men has swiftly compensated us for the earlier mystical misdirections of our philosophical evolution.

Concerning the question of the composition of matter, it is sobering to contemplate today how the greatest early thinkers of human history, justly-celebrated in other regards, could have been so wrong for so long. Admittedly this judgement comes with all the easy wisdom of modern hindsight – and any scientists worth their salt should have the humility to acknowledge that they are "standing on the shoulders of giants", to use the words of Sir Isaac Newton (1642–1727);[43] himself one of the greatest of mathematical giants. Newton's devotion to alchemy, however, considerably outweighed his application to mathematical physics, and is now something of a fascinating embarrassment to historians of science. However, the plain fact is that, at the dawn of the 18th century, the truths of chemistry were just too deeply concealed for human scientific understanding – even to a genius like Newton. Professor Betty Dobbs has put Newton's concerns in perspective: "…the whole of his career after 1675 may be seen as one long attempt to integrate alchemy with the mechanical philosophy."[44] In one respect, at least, Newton's alchemical views were predictive, for they seem to anticipate the science of photochemistry: "The changing of Bodies into Light, and Light into Bodies, is very conformable to the course of Nature, which seems delighted with Transmutation".[45]

It is true that the concepts of elements and atoms arose quite early in classical thought, with the philosophical speculations of the atomists, around the 5th century BCE: Leucippus was the first to posit the existence of atoms, and his celebrated pupil Democritus (*ca.* 460–370 BCE) developed the atomistic theory to account for the properties of all matter by the different combinations of minute particles – a theory that was adopted in the philosophy of the Epicureans of the Hellenic period, and later celebrated in the great poem *De Natura Rerum* by the Roman, Titus Lucretius Carus (99–55 BCE).

43 Letter to Robert Hooke, 5 February 1676. The expresson is originally attributed to Bernard of Chartres, *ca.* 1130.

44 Betty J. Teeter Dobbs, *The Foundations of Newton's Alchemy*, Cambridge: Cambridge University Press, 1976.

45 Isaac Newton, *Optics*, London: 1704.

As for elements, the early natural philosophers had, at the outset, been presented by Dame Nature with a few genuine, accessible examples: the seven classical metals together with a couple of non-metals, carbon and sulphur,[46] but the early philosophers totally failed to recognise the elemental character of these substances. Indeed, they were not even considered at first as candidates for the role, and were ignored in favour of some of the most obviously variable or evanescent substances on this planet. Thales of Miletus (*ca.* 624–525 BCE) conjectured that water was the original substance of the universe; Anaximenes (*ca.* 560–500 BCE) believed air to be the fundamental element which could be condensed into all other matter, and Heraclitus (536–470 BCE) saw fire as the ultimate constituent of the world. These proposals were unified by Empedocles (490–430 BCE), of the School of Pythagoras, as the legendary 'four elements': earth, air, fire, and water, of which all matter was supposed to be constituted. But the conjecture was unsupported by any experimental evidence, and ideas about the nature of matter were then deflected into unprofitable modes of thought for a thousand years by the philosophical speculations of Socrates (477–399 BCE), Plato (*ca.* 428–348 BCE), and Aristotle (384–322 BCE), to be later reinforced by Christian theology, which also had scant regard for empiricism.

The 'four elements' were later augmented by the alchemists' 'three hypostatical principles' of sulphur, mercury, and common salt: the *tria prima*; so the elements then totalled to the mystical number seven. Geber is credited with the hypothesis that all metals were constituted of sulphur and mercury, but even these two perfectly genuine elements, from which much chemistry might have been learned,[47] were subjugated in alchemical thought by the nebulous and arcane concepts put forward by Paracelsus (1493–1541), referring to them as 'sophic sulphur' and 'sophic mercury', which were supposedly abstract embodiments of their qualities. These sophic substances are never explicitly defined in hermetic writings, although 'sophic sulphur' was said to be red in

46 Later to be joined by the non-metal arsenic and the semi-metal antimony.

47 The combination of these two elements under heat to synthesise mercuric sulphide, then known as the pigment cinnabar or vermilion, was reported *ca.* 900 by the Arab alchemist, Al Razi (864-923).

colour, and prepared from gold by dissolution, so – if it existed at all – it might have contained nanoparticle gold.

The thinking at this time was dominated by the vague notion of 'qualities' (hot, cold, dry, moist) rather than the genuine properties of matter (density, melting point, volatility, solubility, hardness, crystal form, colour, etc.) Cupidity too must have been a powerful motive to delude the transmutationists into thinking that it might be possible to manufacture, from common ingredients, that most obviously immutable substance of all: gold. But in spite of the evidence of their senses, they espoused the idea that gold matured in the ground from baser metals, like some garden vegetable, or a *foetus in utero*, supposedly fed by astrological emanations from the stars and planets, and especially from the sun. After all, if evidence were required that solar rays nurtured gold, one only need consider the prodigious amounts of it that had been brought back from the tropics of the Americas, where the Aztecs called gold "the sweat of the sun". It followed from this hylozoistic theory of 'obstetric metallurgy' that the growth of gold could therefore also be fostered and accelerated by man.

To view alchemy simply as the precursor to chemistry would be to misconstrue the purposes and beliefs of the alchemists. Although the pursuit gives the appearance of being empirical and laboratory-based, it was actually deeply-rooted in religious faith. The language of alchemy was a mystical rhetoric, steeped in a culture of secrecy, that served only to conceal the few chemical facts then known, which were not in themselves considered important except insofar as they facilitated the supernatural path towards the perfection of the *Magnum Opus*. There could be no hope of success without divine intervention. Whenever the pursuit of alchemy did not fulfill its promise, as must universally have been the inevitable outcome, then the failure could always be attributed to the withholding of divine grace, owing to insufficient piety on the part of the experimenter. Vladimir Karpenko has traced the historiographical evidence for the case that success in the alchemical quest was considered *donum dei* – a "gift of God"

48 Vladimír Karpenko, 'Alchemy as *donum dei*', in *Hyle – the International Journal for the Philosophy of Chemistry*, 4:1 (1998) 63-80.

– in which the adept had to be divinely appointed, rather than trained by apprenticeship, as common artisans and craftspeople were.[48] The necessary conditions for the eventual transmutation of alchemy into chemistry have been summed up by Mircea Eliade in the following succinct terms:

> "Chemistry … was born from the disintegration of the ideology of alchemy … Alchemy posed as a sacred science, whereas chemistry came into its own when substances had shed their sacred attributes."[49]

49 Mircea Eliade, op cit, n. 11, p. 9.

For its culture of obsessive secrecy, religious exclusivity, and wilful obfuscation, alchemy paid a severe penalty: its teaching stagnated for a thousand years. In retrospect, it must be conceded that, over the millenial span of their endeavours, the alchemists did indeed stumble across a number of genuine chemical discoveries, but they proved most productive when their experiments were not directed at gold-making. Histories of alchemy cite perhaps 100 identifiable chemical compounds that were made known to civilisation by the 'black art', most of them simple inorganic acids, alkalies, and salts, or naturally-occurring minerals. The development of chemical science should duly acknowledge these precursors to chemistry, and especially the invention of the apparatus and procedures used to purify them. In its most useful manifestation, alchemy was known as *Scheidekunst*: "the art of separation".

However, the underlying bases of chemistry are much less self-evident than those of many other sciences. As the early botanist Marcello Malpighi observed in his *Anatome Plantarum* of 1675: *Rerum natura tenebris obvoluta*:

50 I am indebted to Jane Routh for this quotation.

"The nature of things is cloaked in shadow".[50] The chemical combining ratios of solid or liquid substances are neither simple nor obvious. The beginnings of a correct understanding of chemical equivalence had to await the development of a technology to isolate, study, and manipulate the gaseous state of matter, for the volumes of gases could clearly be seen to combine in simple proportions. This was the "pneumatic revolution" brought about in the late 17th

century mainly by Robert Boyle (1627–91), who finally swept away the "four elements" and "three principles", in favour of a true concept of chemical elements,[51] which marked the beginnings of chemical science and the foundation of the Royal Society.

To contrast the alchemical canon of about 100 known substances with the state of chemical knowledge today, the catalogue of a typical chemical supply house will be found to carry around 20,000 entries for pure substances that can be bought off the shelf. If we enquire how many distinct substances are known to present-day chemical science *in toto*, the answer has been provided by Joachim Schummer,[52] who has shown that the growth in the estimated number of pure substances identified over the last two centuries has been approximately exponential,[53] with no sign of saturation so far:

Table 1.3 *Historical growth in the number of known substances.*

Year:	1800	1850	1900	1950	2000
Substances	400	5,000	100,000	800,000	20,000,000

While there are now in excess of twenty million characterised compounds recorded in the chemical research literature,[54] the number is potentially without obvious limit, because, given any most recent addition to the list, it is usually possible for a competent chemist to imagine and, if called upon, make yet another new derivative, by applying the theoretical principles that have been formulated in the last hundred years. Furthermore, the revolutionary perspective provided by molecular biology offers a case for arguing that the number of distinct molecules of biological origin that have existed, must greatly exceed even the number of individual organisms that have ever lived upon this planet.

Gold as Medicine: Aurum Potabile

Early in the 16th century, the focus of alchemical endeavour began to pull away from the making of gold towards a more commendable, but no less ambitious objective: to cure all

51 Nonetheless, Boyle still believed in transmutation and the Elixir – see Eliade, op. cit., n.11, p 231.

52 Joachim Schummer, 'Scientometric Studies on Chemistry I: The Exponential Growth of Chemical Substances, 1800-1995', *Scientometrics*, 39:1 (1997) 107-123.

53 Negative deviations can be attributed to the effects of widespread war in Western civilisation. The average doubling time of the growth is 12.9 years.

54 The Chemical Abstract Service (CAS) registry system has recorded all new compounds since 1965. Prior to this, a survey of historic chemical handbooks has yielded a total of 1,900,000 compounds: see Schummer op. cit., n. 52.

disease and confer perpetual youth by discovering the "Elixir of Life". This, it was privately hoped, might turn out to be the same as the Philosophers' Stone. The flamboyant figure of Paracelsus (1493–1541)[55] is regarded as the founding father of this school of "iatro-chemists" (from the Greek word for a doctor, ἴατρόσ). He believed that disease resulted from a disproportion within the body between the "three hypostatical principles" of sulphur, mercury and salt, and he was therefore largely responsible for introducing the notion that inorganic chemicals could be used for curative purposes, as alternatives to the herbal remedies of traditional folk medicine. This new practice, also called "spagyry", had some unpleasant consequences for the medical patients of the time: thanks to the administration of salts of antimony, arsenic, mercury, and copper, many of them were severely, and sometimes fatally, poisoned.

Among these apalling medicaments there was one, possibly the least harmful of them, which was particularly prized: *Aurum Potabile* or 'drinkable gold'. It was prepared by dissolving gold in *aqua regia*, neutralising with alkali, and reducing the gold solution with ethereal oils, or possibly tannins and tartrates obtained from wine. This produced a ruby-red liquor, which appears to have been a hydrosol of gold – the same as our now familiar pigment, nanoparticle gold, in aqueous suspension.[56] *Aurum Potabile* is celebrated by many alchemical commentators of the 16th and 17th century.[57] This panacea was hailed as the long sought-after Elixir of Life, and fabulous medicinal virtues were attributed to it by its proponents and retailers, such as Francis Anthony (1550–1623), who leaves a record of having been repeatedly fined and imprisoned for practising medicine without a license. Undaunted, he successfully defended his *panacea aurea* in several published pamphlets.[58]

Potable gold was not the only candidate for the 'red elixir' of alchemy, however. In 1668, Thomas Henshaw (1618–1700), one of the founding Fellows of the Royal Society, who had been collaborating for five years with another Fellow, Sir Robert Paston (1631–1683) on alchemical investigations, began their attempt to prepare the

55 He rejoiced in the full name of Philippus Theophrastus Aureolus Bombastus von Hohenheim, but modestly adopted the pseudonymn "Paracelsus" – meaning "greater than Celsus", who was one of the most revered figures in Roman medicine.

56 Colloidal hydrosols give the appearance of being true solutions: their particles do not settle out under gravity and can pass through a filter paper.

57 For instance, by Andreas Libavius (1540-1616) in his monumental work *Alchemia*, Francofurti, 1597, considered by some to be the first textbook of chemistry; by A. Neri, *L'arte vetraria*, Firenze, 1612, and later by Johann Rudolph Glauber in *De auri tinctura sive auro potabile vero* (Concerning the tincture of gold, or the true drinkable gold) Amstelodami, 1646.

58 See C.J.S. Thompson, op.cit., n. 27, p. 200: Francis Anthony, *A Receit showing the Way to make the most Excellent Medicine called Aurum Potabile*. 1683.

'red elixir' from 'sophic mercury' as described in a secret recipe obtained from Henshaw's tutor, Oughtred. The recipe, true to the alchemical tradition, is less than explicit, calling for starting materials defined only as "our Spiritt" and "our pure bodie". The unsurprising failure of their collaborative pursuit has been fully documented from the contemporary records in a scholarly paper by Donald R. Dickson, who provides a valuable insight into the transition from alchemy to chemistry.[59]

Faith in the nostrum persisted nonetheless into the 18th century. The Silesian doctor Hans Heinrich Helcher (1672–1729) promoted the elixir in a popular publication,[60] and continued to believe in the efficacy of potable gold – until he died of apoplexy. The basis for such belief was that: "Gold receives its influence from the sun, which is, as it were, the heart of the world, and by communicating those influences to the heart, it serves to fortify and cleanse it from all impurities."[61]

Geoffrey Chaucer was always a highly critical observer of the foibles of alchemists, and in the Prologue to his *Canterbury Tales* he makes a sardonic comment on the employment of the nostrum by his 'Doctor of Physik':

"Gold in Physik is a cordial
Therefore he loved gold in special"

This verse has been neatly modernised in Nevill Coghill's version:[62]

"Gold stimulates the heart, or so we're told.
He therefore had a special love of gold."

It is easy now to mock the spagyrists, iatro-chemists, and their victims, but the uncomfortable fact remains that with *aurum potabile* these quacks were unwittingly on the right track. Within the arsenal of modern pharmacology, some of the most successful (and expensive!) drugs used to treat rheumatoid arthritis are compounds of gold, with proprietary names such as Sanochrysin, Myochrysin, and Auranofin, and the treatment employing these pharmaceuticals by intramuscular injection is now referred to as Chrysotherapy. The chemistry involved in their

59 Donald R. Dickson, 'Thomas Henshaw and Sir Robert Paston's pursuit of the red elixir: an early collaboration between Fellows of the Royal Society', *Notes and Records of the Royal Society of London*, 51:1 (1997) 57-76.

60 Heinrich Helcher, *Aurum Potabile, oder Gold-Tinctur*, Leipzig, 1712.

61 Quoted by J.W. Mellor in *A Comprehensive Treatise on Inorganic and Theoretical Chemistry*, London: 1929, vol 3, 554.

62 Chaucer, op.cit., n. 28, p. 31.

preparation resembles that which will be described later, when it is applied in the new chrysotype process. There is also a long history of the use of gold in traditional Chinese medicine, which includes versions of potable gold, although it is not apparent that any of these entailed the use of the nanoparticle form.[63] As a frivolous postscript to this topic, it is curious that a form of *aurum potabile* is still available today – as *Danziger Goldwasser* – a spicy strong liqueur (38% alcohol) made in Danzig (now Gdansk in Poland) since the 16th century, which is characterised by tiny flakes of pure gold leaf floating in the clear liqueur.

63 Zhao Huaizhi and Ning Yuantao, 'China's Ancient Gold Drugs', *Gold Bulletin*, 34:1 (2001) 24-29.

2 Gold in Art and Science

Much have I travelled in the realms of gold,
And many goodly states and kingdoms seen.

John Keats (1795–1821)
On First Looking into Chapman's Homer (1817)

Gold as Pigment: Purple of Cassius

To reiterate our current theme: gold need not always be yellow. Plate 1.4 shows a fine example of Crown Derby China;[1] the decorative use of specular gold leaf on this piece is obvious, but there is another form of gold embellishing this jug: the red pigment that has been used for the painted floral decoration is also gold, in the nanoparticle form called Purple of Cassius. This gold pigment has been known for more than 300 years to the makers of coloured glass and ceramics. It is the only good red enamel colour available to ceramicists that can be fired at temperatures around 1100 degrees Celsius without deterioration (dull red pigments containing iron tend to degrade). The pigment is prepared by the addition of tin(II) chloride[2] to a solution of chloroauric acid[3] and is formed as a precipitate[4] of colour varying from red to purple.[5] The tin(II) chloride acts as a reducing agent for the gold(III) in this preparation, producing nanoparticle gold, with its characteristic colour, and the other reaction product, colloidal tin(IV) hydroxide, forms a jelly-like matrix to 'protect' the gold nanoparticles that are dispersed and adsorbed upon it. The following history of the purple of Cassius is abstracted in part from the excellent account by L.B. Hunt.[6]

There are some precursors to the discovery of purple of Cassius: red glass is mentioned by Agricola,[7] and in the writings of Paracelsus. Andreas Libavius in his *Alchymia*[8] claimed that glass was coloured red by a solution of gold, and a recipe for red glass, albeit rather defective, was given by Antonio Neri in his *L'Arte Vetraria*.[9] It has long been recognised that the name 'purple of Cassius' is a misattribution,[10] but it is the name that has stuck historically

1 Many fine specimens of this indigenous ceramic can be seen in Derby Museum and Art Gallery.

2 Tin(II) chloride or stannous chloride, $SnCl_2$.

3 The "gold chloride" obtained by dissolving gold in aqua regia.

4 It is actually a hydrogel of colloidal tin(IV) hydroxide, $Sn(OH)_4$, also called 'stannic acid'.

5 The colour depended on mixing in a proportion of tin(IV) chloride.

6 L.B. Hunt 'The True Story of Purple of Cassius', *Gold Bulletin*, 9:4 (1976) 134-139.

7 G. Agricola, *De Re Metallica*, Eds. H. C. and L. H. Hoover, London: British Museum, 1912.

8 Andreas Libavius, *Alchymia*, Francofurti, 1606.

9 Antonio Neri, *L'Arte Vetraria*, Firenze, 1612; A. Neri, *L'arte Vetraria distinta in libri sette*, Ed. Il Polifilo, Milano, 1980.

10 John Beckmann, *A History of Inventions, Discoveries, and Origins*, trans.William Johnston, London: Henry G. Bohn, 1846, 125-9.

in the literature on glass and enamel technology, most of which perpetuates the error that the substance originated with someone called Cassius. In fact, neither Andreas Cassius, father (1605–1673), nor Andreas Cassius, son (1645–1700?), was actually responsible for its discovery, although the latter did publish an account of its preparation in 1685 in his pamphlet *Concerning Gold*, but without laying any claim to be its inventor and without even mentioning his father.[11] The first preparation of the pigment should be credited to the celebrated Bavarian proto-chemist, Johann Rudolf Glauber (1604–68) who, as early as 1648 in his first publication, *New Philosophical Furnaces*[12] had described experiments with gold-purple, precipitating it with "liquor of flints"[13] and melting it into a red glass. In 1656 Glauber followed this with his major work, *Germany's Prosperity*[14] in which he clearly described the precipitation of gold-purple with metallic tin dissolved in hydrochloric acid, but he did not however, suggest it could be used for staining glass. This application was taken up in 1678 by Johann Kunckel (1630–1703) when he was given charge of a glass factory in Potsdam, but he did not disclose the details of the preparation at the time.[15] He later revealed the secret in 1716, rather transparently disguised in alchemical language as *praecipitatio Solis cum Jove*[16] which translates as "the precipitation of the sun [*i.e.* gold] by means of Jupiter [*i.e.* tin]". He further claimed that artificial rubies could be made from glass so coloured. Meanwhile in 1684 Johann Christian Orschall had published his *Sol sine Veste*: "The sun [*i.e.* gold] unclothed"[17] which also mentioned the use of purple of Cassius for coloring artificial stones and ruby glass.

By 1719 the pigment was in use for the decoration of the porcelain manufactured at the famous Meissen pottery, and by 1723 the secret of the pigment had found its way to China, where it was put to use as a pink colorant in the production of the exquisite *Famille Rose* porcelain.

The chemical nature of purple of Cassius was for long ill-understood, and two rival theories were put forward to explain its composition.[18] The first dictionary of chemistry,

11 Andreas Cassius, *De Auro*, Hamburg, 1685. The full title of this work translates from the Latin as: "Thoughts concerning that last and most perfect work of nature, and chief of metals, gold, its wonderful properties, generation, affections, effects, and fitness for the operations of art; illustrated by experiments."

12 Johann Rudolf Glauber, *Furni Novi Philosophici*, Amsterdam, 1648.

13 A strong solution of sodium or potassium silicate – now commonly known as "water-glass".

14 Johann Rudolf Glauber, *Des Teutschlandts Wohlfahrt (Prosperitatis Germaniae)*, Amsterdam: 1656-61, Part IV, 1659, 35-36.

15 Johann von Löwenstein Kunckel, *Ars Vitraria Experimentalis*, Frankfurt and Leipzig, 1679, p192. J. Kunckel, *Ars Vitraria Experimentalis, oder Vollkommene Glasmacherkunst*, Deutsches Museum Ed., Abhandlungen und Berichte, 5 Ig, Heft 2, 1933.

16 Johann von Löwenstein Kunckel, *Vollständiges Laboratorium chymicum*, Hamburg, 1716.

17 Johann Christian Orschall, *Sol sine Veste*, Augsburg, 1684. The revealing subtitle of this work, translated from the German runs: "Thirty Experiments to Extract the Purple from Gold, which in Part proposes the Destruction of Gold, with Instructions for preparing the Long Sought After Ruby Flux or red Glass at its Most Perfect; Disclosed from Personal Experience."

18 J.W. Mellor, *A Comprehensive Treatise on Inorganic and Theoretical Chemistry*, London: 1929, vol 3, 564-8.

by Pierre Joseph Macquer in 1766, correctly stated that the "colour was due to finely divided gold",[19] but the weight of subsequent chemical opinion, especially with the support of the mighty J.J. Berzelius, took the view that the colour must be due to an oxide of gold, because the substance does not have the normal properties associated with gold metal in bulk; for example, the gold is not extracted by mercury, as an amalgam. As Turner remarked in 1847: "The chemical nature of the purple of Cassius is very obscure."[20] Most texts of the 19th century preferred to specify it as "a compound of peroxide of tin and protoxide of gold." Tin hydroxide is not essential to the colour: similar products can be formed with basic hydroxides of other metals, such as magnesium, calcium, and barium. Athough Michael Faraday in 1857 recognised its true nature as metallic gold in a fine state of division,[21] we shall see below that his view was not generally accepted until nearly 50 years later, when experimental work by Schneider, Zsigmondy, and Moissan confirmed its correctness.[22] For his work on the nature of colloids, especially gold, Richard Zsigmondy (1865–1929) was awarded the Nobel Prize for chemistry in 1925.

The Craft of Gilding

A technology of extractive metallurgy is not needed to win gold from the earth; it is obtained from alluvial deposits by the simple, albeit tedious, practices either of panning the sediments of streams, or by trapping the small, dense gold particles in animal pelts, a practice which doubtless gave rise to the legend of the Golden Fleece. Throughout history, therefore, gold has always been available for decoration and for fashioning into the rarest works of art. There is evidence that Sumerian goldsmiths were at work in the Euphrates valley over 5000 years ago, and their skills were taken up by Egyptian goldsmiths, some of whose finest productions now rank among the great treasures of early civilisation.

19 M. Macquer, *Dictionnaire de Chymie*, vol 3, Paris: 1778, 269.

20 Edward Turner, *Elements of Chemistry*, 8th Edn. London: Taylor and Walton, 1847, 540; William Thomas Brande, *A Manual of Chemistry*, 5th Edn. London: John W. Parker, 1841, 975.

21 Michael Faraday, 'Experimental Relations of Gold (and other Metals) to Light', *Philosophical Transactions of the Royal Society*, 147 (1857) 145-181.

22 E.A. Schneider, *Zeitschrift für Anorganische Chemie*, 5 (1894) 80; R. Zsigmondy, *Liebig's Annalen*, 301 (1898) 29; H. Moissan, *Comptes Rendus*, 141 (1905) 977.

Gold metal is very dense, weighing 19.3 grams per cubic centimeter; it is also relatively soft, but highly cohesive. These properties result in a phenomenal malleability – that is, the capacity to be beaten into sheets. When very thin, such sheets are called 'gold leaf' having been hammered out, between sheets of vellum or goldbeaters' skin, to a thickness of less than one ten-thousandth of a millimeter (usually *ca.* 0.00009 mm), so 1.74 grams of gold – a piece the size of a tear-drop – can be beaten out into a sheet one meter square (or one ounce of gold to nearly 200 square feet). Such gold foil is only about 300 atoms thick. When it is this thin, gold becomes translucent, appearing green by transmitted light, but its yellow reflectivity is undiminished.

Needless to say, gold leaf is very delicate in its manipulation; the least breath of air can carry it off or cause it to crumple. For its decorative application, gold leaf usually requires a very flat surface, smoothed off with a filler, and to cause it to adhere a binding agent is chosen to suit the nature of the surface: whether paper, parchment, leather, canvas, wood, metal, glass, or ceramic. For canvas paintings, a ground is prepared of 'Armenian bole', which is an orange-coloured iron earth (iron(III) oxide) blended with a pure gelatin (isinglass), painted onto the surface to provide a bond for the gold leaf. This technique is called 'leaf over bole'. Once again we see here a union of iron and gold in the service of art – but of a quite different sort. Alternatively, 'mordant gilding' may be employed, in which the surface to receive the leaf is prepared with acidified egg-albumen, known as 'glaire'. To ensure adhesion, the applied leaf is burnished with a smooth tool of agate, and the excess is removed with a soft brush. In painting we find many glorious examples of this technique, for instance, in Carlo Crivelli's Altarpiece *The Anunciation with Saint Emidius*,[23] where the ray of celestial light has been applied by mordant gilding. A third method of application is as 'shell gold': a paint of powdered gold particles, obtained from broken leaf, suspended in gum.[24] The use of gold paint to illuminate the lettering in mediaeval manuscripts is known as *Chrysography*.

23 The National Gallery, London, NG 739.

24 Charles H. Savory, *The Practical Carver and Gilder's Guide*, London: Simpkin, Marshall & Co., n.d.

The Golden Calf

A particularly apposite, and self-referential employment of gold is illustrated in Nicolas Poussin's wonderful painting *Moses and the Golden Calf*. The Old Testament describes Moses' reaction to this outbreak of tribal idolatry:

> "He took the calf which they had made, and burnt it in the fire, and ground it to powder, and strewed it upon the water, and made the children of Israel to drink of it."[25]

This passage has given rise to the speculation whether Moses, besides his many other accomplishments, was also skilled in the hermetic arts! The notable German chemist, and proponent of the deeply erroneous phlogiston theory, Georg Ernst Stahl (1660-1734), published in 1697 an exegesis on sulphur,[26] in which he proposed that Moses could have made use of brimstone to solubilise the gold.[27] Some have read into this reference to drinking the metal an early preparation of the alchemists panacea, *Aurum Potabile*, described above, but more orthodox commentators discount the chemical possibility, and suggest instead a simple physical dispersal of the metal in Moses' beverage.[28] Appropriately, Poussin's pictorial composition for *Moses and the Golden Calf* also displays the proportion of classical art known as the *golden section*. This ratio of 1.618… or $(\sqrt{5}+1)/2$ cannot claim any genuine connection with gold whatsoever, but it is a fascinating study in mathematical aesthetics in its own right.[29]

Elizabeth Fulhame 'Dying' with Gold

It is both remarkable and disappointing that we should know so little about "the ingenious and lively Mrs Fulhame", as Count Rumford described her in 1798.[30] She was that rarest of 18th century creatures: a female scientist. Our knowledge of Mrs Fulhame rests solely on one publication, her book of 1794, strikingly entitled: *An Essay on Combustion with a view to a New Art of Dying* [sic] *and Painting. Wherein the Phlogistic and Antiphlogistic Hypotheses are Proved Erroneous*.[31] The experimental work

25 The Old Testament, Exodus 32:20.

26 According to Stahl, 3 parts of sulphur and 3 of caustic potash (potassium hydroxide) dissolve one part of gold when boiled with it in water.

27 The fusion of gold with sodium sulphide and sulphur yields the colourless, water-soluble substance, sodium aurosulphide, $NaAuS.4H_2O$. See J.R. Partington, *A Textbook of Inorganic Chemistry*, London: Macmillan and Co., 1931, 816.

28 John Henry Pepper, *The Boy's Book of Metals*, 8th Edn. London: George Routledge and Sons, n.d., 118, 208. H.E. Roscoe and C. Schorlemmer, *A Treatise on Chemistry*, London: Macmillan and Co., 1880, vol 2.

29 Matila Ghyka, *The Geometry of Art and Life*, New York: Dover Publications, 1977. Mario Livio, *The Golden Ratio*, London: Review, 2002.

30 Count Rumford, 'An Inquiry concerning the chemical Properties that have been attributed to Light', *Philosophical Transactions of the Royal Society*, 88 (1798) 458.

31 Mrs Fulhame, *An Essay on Combustion with a view to a New Art of Dying and Painting. Wherein the Phlogistic and Antiphlogistic Hypotheses are Proved Erroneous*, London: Printed for the Author by J. Cooper, 1794. The Preface is dated November 5th!

she describes there, and her theoretical interpretation of it, impressed the leading men of science of the day, besides Count Rumford. Her book was extensively reviewed,[32] translated into German in 1798,[33] and published in an American edition in 1810.[34] She was cited as an authority in several early textbooks of chemistry.[35] Subsequently, her name has largely disappeared from the pages of chemical history, but it is still referred to in at least one comprehensive 20th century treatise.[36] In recent years, Elizabeth Fulhame (her Christian name was re-discovered only in 1984 by Dr. Larry Schaaf[37]) has regained some of the recognition that is her due, at least among historical scholars, and on no less than three deserving counts: as a discoverer of catalysis,[38] as an inventor of photography,[39] and as an early torchbearer for feminism.[40] Schaaf has conjectured that she was the wife of a Dr. Thomas Fulhame, an Irish-born Edinburgh resident and ex-student of the distinguished Scottish chemist, Dr. Joseph Black (1728–99). Beyond this, all other scholarly attempts to uncover any biographical details of this remarkable woman have so far proved fruitless.[41]

Mrs Fulhame was, as she confesses in her Preface: "averse from indolence and having much leisure", so she set out to occupy herself by devising a method for dyeing fabrics with precious metals; but it is evident from her prefatory remarks that this research proposal was greeted with domestic disapproval, and that she only won through in the teeth of it:

> "The possibility of making cloths of gold, silver, and other metals, by chymical processes, occurred to me in the year 1780: the project being mentioned to Doctor Fulhame, and some friends, was deemed improbable. However, after some time, I had the satisfaction of realising the idea, in some degree, by experiment."[42]

Her text does indeed describe numerous experiments, some of which must have been accompanied by significant hazards and considerable discomfort – which Mrs. Fulhame seemed able to disregard. Many of the substances that she

32 J.F. Coindet, *Annales de Chimie*, 27 (1798) 58-85.

33 Mrs Fulhame, *Versuche über die Wiederherstellung der Metalle durch Wasserstoffgas, Phosphor, Schwefel, Schwefelleber, geschwefeltes Wasserstoffgas, gephosphortes Wasserstoffgas*, Göttingen: 1798, trans. A.G.W. Lenten.

34 Mrs Fulhame, *Essay on Combustion*, Philadelphia: James Humphreys, 1810.

35 Colin McKenzie, *One Thousand Experiments in Chemistry*, London: 1821, 35-37. Samuel Parkes, *The Chemical Catechism*, 6th Edn. London: Lackington, Allen & Co., 1814, 297, 367, 508. Edward Turner, *Elements of Chemistry*, 8th Edn. Eds. Baron Liebig and William Gregory, London: Taylor and Walton, 1848, 539.

36 J.W. Mellor, *A Comprehensive Treatise on Inorganic and Theoretical Chemistry*, London: 1929, Vol 3, 554.

37 Larry J. Schaaf, *Sun Gardens: Victorian Photograms by Anna Atkins*, New York: Aperture, 1985, 100, note 8.

38 Keith J. Laidler and Athel Cornish-Bowden, 'Elizabeth Fulhame and the Discovery of Catalysis: 100 Years before Buchner', in *New Beer in an Old Bottle: Edward Buchner and the Growth of Biochemical Knowledge*, Valencia, Spain: Universitad de Valencia, 1997, Ed. A. Cornish-Bowden, 123-6. See also *Journal of Bioscience*, 23 (1998) 87-92.

39 Larry J. Schaaf, *Out of the Shadows: Herschel, Talbot, & the Invention of Photography*, New Haven & London: Yale University Press, 1992.

40 Derek A. Davenport and Kathleen M. Ireland, 'The Ingenious, Lively and Celebrated Mrs. Fulhame and the Dyer's Hand', *Bulletin for the History of Chemistry*, 5 (Winter1989) pp37-42.

41 Larry J. Schaaf, 'The first fifty years of British photography: 1794-1844', in *Technology and Art: the birth and early years of photography*, Ed. Michael Pritchard, Bath: Royal Photographic Society Historical Group, 1990.

42 Mrs Fulhame, op. cit., n. 34, Preface.

handled with such insouciance in a domestic environment, e.g. phosphine, would today be severely confined to a chemical research laboratory, and only there with full protective measures!

She employed a variety of chemically energetic inorganic reducing agents,[43] both gaseous and liquid, to reduce gold and silver salts[44] soaked into silks and cloths, so producing on them deposits of the precious metals in both colloidal and specular forms. Of particular relevance to our present concern is her use of sunlight to form coatings of gold:

> "Chapter VIII. Reduction of Metals by Light.
> Exp.3. Gold.
> On the 24th of July a piece of silk was immersed in a solution of nitro-muriate of gold in water, and dried by a gentle heat; it was then suspended in a window, exposed to the sunbeams, as much as possible: no change was perceived on it until the 26th, when the margin of the silk began to assume a purple tinge, which increased gradually, and on the 29th exhibited a few obscure specks of reduced gold on the side of the silk opposed to the light. The purple tinge continued to increase…"[45]

Apart from the observation by Robert Boyle in 1663 that gold chloride in contact with the skin also produced a purple colour in the light, this is the first recorded observation of colloidal gold being generated photochemically, so earns Elizabeth Fulhame an accolade as the 'mother of chrysotype'. But she went on to perform a crucial control experiment, as scientists would now call it: she repeated the test on an identical piece of silk, but contained in a desiccated atmosphere,[46] protected from the intrusion of external humidity. No purple colour or gold developed, even in three months exposure. By many such experiments, she established that the **presence of water** is essential to many of these reactions.[47] This conclusion by Elizabeth Fulhame marks one of the origins of what we now call wet chemistry: an approach to carrying out chemical reactions wholly different from the dry conditions at high temperature in the furnaces of the alchemical tradition.

43 Namely, hydrogen, phosphorus, sulphur, hydrogen sulphide, and phosphine.

44 Gold chloride, from the solution of gold in aqua regia, and silver nitrate.

45 Mrs Fulhame, op. cit., n. 31, Chapter 8, 143-4.

46 By placing it in a sealed crystal phial containing potassium carbonate to absorb all moisture.

47 J.W. Mellor, 'History of the water problem (Mrs Fulhame's theory of catalysis)' *Journal of Physical Chemistry*, 7 (1903) 557-567.

Mrs Fulhame's observation of the light-induced deposition of gold and silver also constitutes one of the earliest examples of photochemical imaging, because she describes one of her applications thus:

> "Some time after this period, I found the invention was applicable to painting, and would also contribute to facilitate the study of geography: for I have applied it to some maps, the rivers of which I represented in silver, and the cities in gold."[48]

48 Mrs Fulhame, op. cit., n.31.

In recognition of her photochemical discoveries, Schaaf has for over two decades championed the right of Elizabeth Fulhame to be included among the fore-runners of the invention of photography,[49] as she was also clearly recognised to be by the authors of early American photography texts, Snelling and Humphrey,[50] and by Sir John Herschel, in his first written account of the subject in 1839:

49 Larry J. Schaaf, op. cit., n. 41.

50 H.H. Snelling, *The History and Practice of the Art of Photography*, New York: Putnam, 1849; S.D. Humphrey, *American Handbook of the Daguerreotype*, New York: Humphrey, 1858.

> "As an enigma to be resolved, a variety of processes at once presented themselves of which, as the most promising, it is only worth while to mention three … and 3ly the reduction of Gold in contact with deoxidising agents by light as described by Count Rumford and Mrs Fulhame".[51]

To conclude this short resumé of Elizabeth Fulhame's achievement, and to justify her distinction as a feminist pioneer mentioned earlier, I cannot resist offering the reader two brief samples of her polemical style, which reflects a justifiable cynicism towards both the plagiarism and the anti-feminism prevalent in her day. Following an observation in her Preface that, even if she could afford the means to take out a patent on her discovery, it would avail her little, she writes:

51 Sir J.F.W. Herschel, 'Note on the Art of Photography or the Application of the Chemical Rays of Light to the purposes of Pictorial Representation', read before the Royal Society, London, 14 March 1839. A summary was published in *Proceedings of the Royal Society*, 4:37 (1839) 131-3, but Herschel voluntarily withdrew the full paper from publication in the *Transactions*. The unpublished MS is transcribed by Dr. Larry Schaaf, 'Sir John Herschel's 1839 Royal Society Paper on Photography', *History of Photography*, 3:1 (Jan. 1979) 47-60.

> "Thus circumstanced, I publish this Essay in its present imperfect state, in order to prevent the furacious attempts of the prowling plagiary and the insidious pretender to chymistry, from arrogating to themselves, and assuming my invention, in plundering silence: for there are those , who, if they can not by chymical, never fail by stratagem, and mechanical means, to deprive industry of the fruits, and fame, of her labours."

The history of photography was destined to see more of the "prowling plagiary", who remain forever with us, even to this day, as many an inventor knows to their cost. But Elizabeth Fulhame's battle for the recognition of the role of women in scholarly pursuits is now substantially won. She goes on to declare:

> "It may appear presuming to some, that I should engage in pursuits of this nature, but averse from indolence, and having much leisure, my mind led me to this mode of amusement, which I found entertaining, and will, I hope, be thought inoffensive by the liberal, and the learned. But censure is perhaps inevitable; for some are so ignorant, that they grow sullen and silent, and are chilled with horror at the sight of any thing, that bears the semblance of learning, in whatever shape it may appear; and should the spectre appear in the shape of woman, the pangs, which they suffer, are truly dismal."

Photogenic Dyeing Re-invented

Elizabeth Fulhame's premonitions of plagiarism were prophetic: nearly half a century after the publication of her discoveries, which had been largely forgotten by 1841, there appeared an article entitled "Photogenic Dyeing", by a M. Lapouraille,[52] a dyer in Lyons, France, who claimed to have developed a means of dyeing silks and cottons by a solution of gold, producing beautiful lilac and violet tints. The gold solution he described was the usual one, as prepared previously from aqua regia by Mrs Fulhame, and the colours were generated by exposure to light, hence Lapouraille's appropriation of the adjective "photogenic", which had been introduced by Henry Talbot just two years previously in his first published method of photography on paper. Of course, Lapouraille's 'invention' may have been an innocent coincidence, based on an idea that was by then obvious and well-circulated; certainly, he makes no acknowledgement to Mrs Fulhame. But this was not to be the last outbreak of re-invention: nearly a century after Elizabeth Fulhame's publication, her method of dying silks with gold was actually patented by Odernheimer in Germany in 1890,[53]

52 M. Lapouraille, 'Photogenic Dyeing', *Magazine of Science*, 92 (2 January 1841) 324. See also *The Chemist*, 2:13 (January 1841) 17-18.

53 E. Odernheimer, *German Patent* D.R.P. 63842, 1890.

and, a further century after that, in 1988, two Japanese researchers, evidently innocently unaware of all that had gone before, announced in the scientific literature a similar method for the "dyeing of silk cloth with colloidal gold", including a quantitative study of the rate of uptake.[54] The shade of Elizabeth Fulhame should be gratified to witness how her forgotten discovery has reached down over two centuries to haunt textile technologists! It seems probable that her use of gold as a pigment for dyeing fabrics was rather eclipsed in 1856 by William Perkin's accidental discovery of the organic dye, mauveine; the consequent foundation of the huge dyestuffs industry based on coal-tar derivatives provided colours similar to those of nanoparticle gold, but at a fraction of the cost.[55]

54 Y. Nakao and K. Kaeriyama, 'Dyeing of silk cloth with colloidal gold', *Journal of Applied Polymer Science*, 36:2 (1988) 269-277.

55 Simon Garfield, *Mauve*, London: Faber and Faber, 2000.

Count Rumford's Experiments

Sir Benjamin Thompson FRS, Count Rumford (1753–1814), was an Anglo-American scientist and administrator, noted for his foundation of the Royal Institution. As has been earlier remarked, he was fulsome in his appreciation of Elizabeth Fulhame's work. In a footnote to his 1798 paper in the *Philosophical Transactions of the Royal Society*, reporting the action of light and heat on salts of gold, he states:

> "This agrees perfectly with the results of similar experiments made by the ingenious and lively Mrs. Fulhame. (See her Essay on Combustion, page 124.) It was on reading her book, that I was induced to engage in these investigations; and it was by her experiments, that most of the foregoing experiments were suggested."[56]

56 Rumford, op.cit., n. 30.

The experiments Rumford describes do indeed parallel and repeat some of those of Elizabeth Fulhame: he soaked silk and cotton fabrics in solutions of chloroauric acid, and exposed them to the actions of heat and light, comparing with control specimens, to test his hypothesis that it was not light, but the heat resulting from its absorption, that caused the chemical changes. However, from both agencies of heat and light, Rumford obtained purple stains – which

we now know to be nanoparticle gold – but whose nature, as elemental gold, he did not then appreciate; believing it to be a modification of gold oxide, he noted that it had the same colour (Purple of Cassius) as that produced in the furnaces of the enamellers.

> "I searched, but in vain, for traces of revived gold, in its reguline form and colour…"

These results contrasted with the action of chemical reducing agents, such as charcoal or turpentine, which yielded gold in its yellow, obviously metallic, bulk form that Rumford referred to as "reguline". Rumford therefore remained somewhat puzzled, and his paper is ultimately inconclusive:

> "I own fairly, that the results of these experiments were quite contrary to my expectations, and I am not able to reconcile them with my hypothesis, respecting the causes of the reduction of the oxide, in the foregoing experiments…"

He did however demonstrate conclusively that an extract of chloroauric acid in diethyl ether was entirely reduced to metallic gold under the action of sunlight – a reduction reminiscent of Count Bestucheff's 'tincture'.

Gold Plating

Polished steel may be heat-gilded with gold leaf, which is so employed for the decoration of ceremonial swords, but metallic objects generally can be plated with thin layers of gold by a number of chemical means which are less labour-intensive than applying beaten gold leaf. So-called 'gold dipping baths' were widely used for the decoration of the metal surfaces of cutlery or the protection of surgical instruments against corrosion; they relied on a straightforward chemical displacement of the one metal by another, analogous to the toning of silver prints (see chapter five). A simple bath could be obtained by dissolving 'gold chloride' (chloroauric acid) in diethyl ether; on evaporation of the solvent a layer of gold was left, which could be burnished. Alternatively, in 'water-gilding' the well-cleaned object

could be immersed in a boiling aqueous solution of neutral potassium or sodium chloroaurate.

The mis-named process of 'wash-gilding' involved no water at all, but made use of an application of gold amalgam (gold dissolved in mercury), rubbed onto the metallic surface, followed by strong heating to about 370 degrees Celsius to drive off the mercury and leave a film of gold behind. This was "a most pernicious process to those engaged in it" owing to the dangerously toxic nature of the mercury vapour evolved.[57] It was, happily, almost entirely superseded by electro-gilding.

The coherence and strength of gold coatings deposited by these dipping baths was not good. After 1839 these older methods were supplanted by the development of the new sub-science of electro-metallurgy, which stemmed from Faraday's fundamental researches in electrochemistry and the development of powerful galvanic batteries by Daniell, Wollaston, Grove, and Smee. The method for laying down a layer of gold on the surface of an object by electrodeposition from a solution of a gold salt was known as 'electro-gilding', and the invention is attributed to Wright of Birmingham in 1840, but it was patented by Messrs Elkington in 1836.[58] The electrolyte generally used is a solution of gold(I) in potassium cyanide – the complex salt, gold potassium cyanide[59] – which produces a smooth, coherent film of metal; if plain gold chloride is used, the deposit formed is too crystalline. The highly-cleaned object to be gold-plated is made the cathode of the electrochemical bath (*i.e.* it is connected to the negative pole of the battery) so gold metal is deposited upon it; the anode (connected to the positive pole of the battery) is a piece of pure gold that slowly passes into solution during the passage of the current. Thus the net outcome is effectively to transport gold from anode to cathode.

Electrochemical cells for gold-plating can also be set up without any external power supply: a sacrificial anode of zinc dipping into dilute sulphuric acid is connected electrically by a wire to the object as cathode, immersed in a solution of gold chloride which is depleted in gold as the

57 John Henry Pepper, *The Boy's Book of Metals*, London: George Routledge and Sons, 8th Edn., n.d., 202-7.

58 Sheridan Muspratt, *Chemistry, Theoretical, Practical and Analytical, as applied and relating to the Arts and Manufactures*, Glasgow: William Mackenzie, 1860.

59 More accurately, potassium dicyanoaurate(I): $K[Au(CN)_2]$.

plating proceeds; the two regions of electrolyte are separated by a porous pot or a permeable membrane of animal gut, which allows the passage of electric current while inhibiting extensive mixing and dilution of the gold solution.

Metallic replicas of surfaces could also be prepared by electro-deposition onto electrically-conducting moulds, usually made of 'fusible alloy'.[60] Non-metallic moulds could be rendered electrically conducting by coating the surface with graphite ('plumbago'). This copying process was called 'electrotyping', and it became a Victorian craft industry for the duplication of coins, medals, curios, and art works in relief. By its description as "the sister art of heliography" it was likened to the contemporaneous invention of photographic negative-positive printing. When the metallic layer was thick, (usually of copper, rather than gold, for economic reasons) the technique of making such facsimiles was accorded the delightful Victorian name of 'glavanoplasm'.

60 An alloy composed of 8 parts bismuth, 5 parts lead and 3 parts tin, which melts below the temperature of boiling water, 100 Celsius.

Faraday's Researches on Gold and Light

The first comprehensive study of elemental gold was carried out by the great experimental scientist, Michael Faraday (1791–1867), during most of the year 1856; in a letter to Christian Friedrich Schönbein, he confesses:

> "I have been occupying myself with gold this summer; I did not feel head-strong enough for stronger things. This work has been of the mountain and mouse fashion; and if I ever publish it and it comes to your sight I dare say you will think so."

But Faraday did indeed publish his work on gold – it was first delivered as the Bakerian lecture to the Royal Society of 1857: *Experimental relations of gold (and other metals) to light*, which then appeared in print in the *Philosophical Transactions of the Royal Society*. This proved to be his last published work.[61]

61 Michael Faraday, The Bakerian lecture: 'Experimental Relations of Gold (and other Metals) to Light', *The Philosophical Transactions of the Royal Society*, 147 (1857) 145-181.

Faraday was 65 at the time, and conscious that his intellectual powers were beginning to wane. His original intention had been to test the theory that light was propagated by "undulations" through an exceedingly tenuous medium then referred to as the "luminiferous ether"; and he proposed to do so by observing its effect on the very small metallic particles of gold because, as Faraday very perceptively put it

> "…known phenomena appeared to indicate that a mere variation in the size of its particles gave rise to a variety of resultant colours."[62]

62 Ibid, 146.

Faraday's published account is minutely descriptive, in the extent of its 36 pages, and readers will not find the benefit of an abstract, so an attempt now follows to summarise its most salient features relating to gold, which also draws on the review by Mogerman.[63]

63 W. D. Mogerman, 'Faraday's Lecture on Gold: the Optical Effects of Fine Particles', *The Gold Bulletin*, 7:1 (1974) 22-24.

After a preamble on the nature of light, Faraday begins by describing the properties of beaten gold leaf, emphasising correctly the fact that its thickness is between $\frac{1}{5}$th and $\frac{1}{8}$th of the wavelength of light, and he reports the effects of heat, pressure and various chemical reagents upon it, and especially upon the colour of light transmitted through it. Next he describes the dispersion of gold metal by "deflagrations" – vapourising it with powerful electric discharges, and depositing it as thin films of metal onto various surfaces, which were studied likewise. A different method of preparing thin films of gold follows this, in which aqueous solutions of gold chloride are reduced to the metal, but only at the liquid surface, by particles of floating elemental phosphorus. A fourth form of dispersed gold is obtained by treating gold chloride solution with a variety of chemical reducing agents, also in solution. Faraday demonstrates the scattering of light in these "fluid preparations" which we would now call hydrosols of gold – including the purple of Cassius – the pigment which is the central theme of this book.

In his comparison of the properties of these various forms of "divided gold", obtained by beating, chemical dissolution or etching, evaporation, surface reduction, and

precipitation, Faraday demonstrates their essential unity. Despite the variety of their colours, they are all composed of gold metal in differing states of dispersion, and it is possible to infer a correlation of colour with fineness of particle size: passing from the smallest particles to the larger, the colours change from ruby, amethystine, green, and violet, to blue. From these observations, Faraday concludes, in contradiction of the popular gold oxide theory:

> "I believe the purple of Cassius to be essentially finely-divided gold, associated with more or less of oxide of tin."

Some of Faraday's original preparations of colloidal gold are preserved to this day at the Royal Institution. Faraday admitted that he did not achieve his original objective with this programme of research, and in retrospect the reason is not surprising. It turned out that an adequate theory of the propagation of light had to await the mathematical treatment of electromagnetism by James Clerk Maxwell (1831–79) in 1873. Mathematics was not Faraday's strong suit, however, he did make several pioneering observations in the field of nanoparticle metals, including the phenomenon of Tyndall scattering[64] and the effect of electrolytes in flocculating colloids.[65] It was not until half a century later that Faraday's "variety of resultant colours" finally received an adequate explanation, in 1908, when Gustav Mie first successfully applied Maxwell's electromagnetic theory to the problem of the scattering of light by very small metal particles.[66]

Colours of Gold Nanoparticles

In everyday experience, we are accustomed to different substances displaying different characteristic colours – artists' pigments, for instance; this commonsense idea may tempt us into the false conclusion that a difference of colour always implies substances of different composition. It may therefore seem incomprehensible that a single, pure substance – gold, in a finely divided state – can appear with so many different colours, as was discovered by Faraday and is illustrated by the chrysotypes reproduced in

64 Tyndall scattering is the scattering of light by colloidal particles, such that a beam of light passing through the sol, which would be invisible in a pure liquid, becomes visible as a bright cone of light.

65 Flocculation occurs when nanoparticles clump together to form much larger particles, that are consequently precipitated.

66 Gustav Mie, *Annalen der Physik*, 25 (1908) 377.

this book. The gold precipitated by these photochemical means has a particle size in the nanometer region,[67] in contrast to the micron-sized bundles of filamentary metallic silver in most developed silver-gelatin photographs.[68]

The scientific answer to this puzzle, first worked out by Gustav Mie, lies wrapped up in a rather heavy piece of mathematical physics, but it is possible to gain a qualitative understanding of the underlying cause without the technical background. The key to the phenomenon lies in the size of the microscopic particles of the metal that form the image, because their ability to absorb different wavelengths of light depends on their dimensions.

In any particle of a metal, some of the electrons are not bound to their parent atoms, but are liberated to roam throughout the whole particle – this is why metals are good conductors of electricity – and these are known reasonably enough as 'conduction electrons'. Just like water in a container, which will naturally adopt a wave-like motion to and fro when agitated, this 'sea' of electrons in a metal particle has certain natural wavelengths;[69] and it should be intuitively apparent that the natural wavelength of this motion will be smaller in a little basin than in a large bath. Now the electrons contained in any substance are negatively charged, and will absorb light, or more generally, electromagnetic radiation, when their natural motion is excited by, or comes into resonance with, the fluctuating electric field that accompanies the light wave. So for small metal particles, light can excite collective oscillations in their conduction electrons, or 'electron waves' which are known in quantum-mechanical language as 'plasmons'.

For most metals, such 'surface plasma resonance' generally gives rise to absorption in the ultra-violet region of the spectrum, so they do not appear highly coloured. But in a few cases – notably the coinage metals, copper, silver, and gold – the natural wavelengths of the conduction electrons cause absorption of light in the visible region of the spectrum, giving rise to the striking colours that first attracted Faraday's attention. Thus, the smallest gold

67 1 nanometer is one billionth of a meter 10^{-9} m.

68 The micrometer or micron is one millionth of a meter 10^{-6} m.

69 Wavelength is the distance between one crest and the next.

46

particles absorb short wavelength light (blue), so when illuminated by white light they take on the complementary colour – pink or red. The larger particles absorb long wavelength light (red), so appear blue. Particles of mixed sizes can produce purple or violet colours. If the shape of the particles departs from spheres to ellipsoids, then each ellipsoidal particle can absorb light at two wavelengths, in the red and the blue regions of the spectrum,[70] giving rise effectively to green colours. The differing shapes and sizes of the gold nanoparticles are the result of the chemistry and conditions of the process of their formation, and so a control of the resulting colour can be established.

The chemistry and physics of metallic nanoparticles is attracting great interest at the present time. This topic has been taken up again and greatly extended by Milton Kerker, whose publications should be consulted for a more rigorous technical account.[71] It is relevant to ask if metals other than gold are capable of displaying such colours, and this question has been answered recently by Creighton and Eadon,[72] who have calculated absorption spectra for small particles of most of the metallic elements.[73] Their work shows that distinctive colour is a relatively uncommon property among nanoparticle metals: the surface plasmon absorption band only peaks in the visible region for: the alkali metals,[74] alkaline earths,[75] coinage metals, and four scarce "rare earth" elements.[76] In view of the requirement for a useful pigment to be chemically inert, it follows that only copper, silver and gold are the metals to provide distinctive colours for decorative or image-making purposes, other inert metals being grey or brown in the nanoparticulate state.[77]

The colours of metal nanoparticles may be modified by several factors: besides the particle size and departure from sphericity mentioned above, the linear aggregation of spherical particles causes the appearance of a long wavelength absorption band.[78] The plasmon absorption band is also shifted by the presence of molecules or ions adsorbed onto the surface of the particle, where the metal atoms are freely exposed to bind them.[79] These factors are

70 An ellipsoid has two or three characteristic dimensions, or axes, unlike a sphere which has only one – its radius.

71 Milton Kerker, *The Scattering of Light and Other Electromagnetic Radiation*, Academic Press (1969).

72 J.A. Creighton and D.G. Eadon, *Journal of the Chemical Society, Faraday Transactions*, 87 (1991) 3881.

73 Spheres of diameter 10 nanometers (one millionth of a centimeter)

74 Lithium, sodium, potassium, rubidium, and caesium (and francium) – which are all highly reactive with air and water.

75 Beryllium, magnesium, calcium, strontium, barium, and radium, which are also highly reactive.

76 These scarce "rare earth" elements are scandium, yttrium, europium and ytterbium; they are also highly reactive in the metallic state.

77 Nanoparticle silver in various colours can be formed on silver-gelatin photographic papers by chemical treatments; this has been dubbed "Chromoskedasic Painting" by its inventor, Dominic Man Kit Lam. See *Scientific American* (November 1991) 48.

78 Due to the splitting of the degenerate surface dipolar plasma mode into lateral and longitudinal components, similar to a prolate ellipsoid.

79 Henglein has shown that silver nanoparticles can act as an electron pool towards redox active species, and that the stored charge influences the plasma resonance absorption. See A. Henglein, 'Reactions of Organic Free Radicals at Colloidal Silver in Aqueous Solution. Electron Pool Effect and Water Decomposition', *Journal of Physical Chemistry*, 83:17 (1979) 2209-2216.

responsible for some of the striking changes in the colours of metal photographic images during their wet-processing procedures. Gold nanoparticles so formed[80] may be "protected" against aggregation by the surface adsorption of macromolecules, typically hydrophilic colloids such as gelatin, which inhibit coagulation of the particles. The influence of particle size on colour is indicated in Table 2.1, which is condensed from the observations of Frens, and Turkevich *et al.*[81]

80 It is technically described as "a negatively charged hydrophobic sol."

81 G. Frens, *Nature, Physical Sciences*, 241 (1973) 20; J. Turkevich, P.C. Stevenson, and J. Hillier, *Discussions of the Faraday Society*, 11 (1951) 55.

Table 2.1 *Colour and particle size of gold nanoparticles*

Shape	Size/nm	Colour
Spherical	<3	Pale blue
	12	Pink
	16	Orange
	20–40	Red
	70	Dark magenta
	100–150	Violet
Irregular	200	Light Blue
Ellipsoids	60x90	Purple
Aggregated		Blue

In a chrysotype, the size and state of aggregation of the gold nanoparticles is governed by the pH, humidity, and sizing agent in the sensitised paper, and the wet-processing chemistry. The colour of the image may thus be controlled over a considerable range, including a good magenta and a passable cyan; ironically, yellow gold nanoparticles are not readily obtainable, so full three-colour printing in pure gold does not yet seem achievable.

Contemporary Significance

From the scientific employment of gold to probe the subtle nature of light itself, and the use of gold to embellish the sublimities of Renaissance art, we must now descend briefly to the ridiculous. In our commercially-dominated times, the advertising copywriters have seized upon the universal virtues that "gold" connotes, and their impoverished imaginations have thoroughly debased the

Figures 2.1–2.3 *Scanning electron micrographs (ca. 100,000 x magnification) showing nanoparticles of gold bonded to the fibrils of cellulose paper. Courtesy of Dr. Sharali Malik, Institut für Nanotechnologie, Karlsruhe, Germany.*

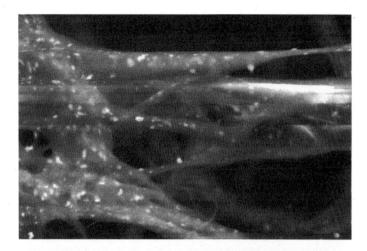

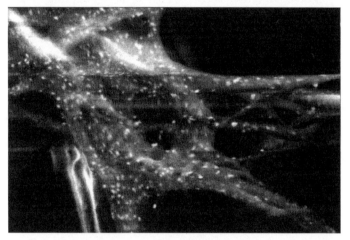

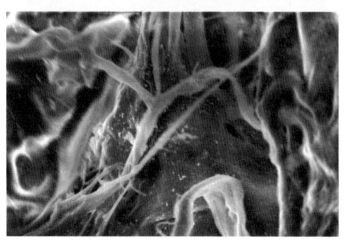

coinage, in contemporary language. The word "gold" is now applied indiscriminately to consumer goods such as aftershave lotion, margarine, tea, tobacco, biscuits, yoghurt, paint brushes, and of course credit cards. The list could be endless. It is not surprising, therefore, that the label "gold" today is automatically dismissed as meaningless, or viewed with total scepticism. Only jewellers can guarantee the genuineness of the description "gold" by the legally binding assurance of hallmarking their pieces.[82] One of the difficulties I have experienced as a printer in chrysotype is persuading the viewers and potential purchasers of my work, that gold is exactly and solely what composes it.

82 The purity of gold is defined in carats: 24 carats = 100% pure.

Gold continues to serve, of course, as an enduring token of the wealth of nations, and for the settlement of international debts. The greatest hoard of gold in the world is *ca.* 30,000 tonnes[83] residing in the vaults of the US Federal Reserve Bank in New York, the property of more than 80 nations. Lesser amounts are held in depositories such as Fort Knox, Kentucky, and the Bank of England, London. The irony does not go unnoticed that the principal fate of this beautiful metal, having been laboriously excavated from the earth, is simply to be returned underground again.

83 The metric tonne is 1000 kilograms.

For much of recorded history the production of "new" gold was small; most was recycled from the store looted by Western Europeans from the ancient South American civilisations. At the beginning of the 19th century the annual production of gold was *ca.* 12 tonnes. Following the "gold rushes" in California (1849), New South Wales (1851), Transvaal (1884), and Klondike (1896), the world production rose to 150 tonnes per annum by 1899. Gold became a potent incentive that propelled the imperial growth of the colonising nations. The world production is now *ca.* 1200 tonnes per annum: 56% comes from South Africa, 25% from Russia, 3.8% from Canada, and 2.5% from the USA. If all the extracted gold in the world could be fused together, it would occupy a cube about 60 feet on edge, the volume of a modest house.

Beside the decorative, genuine uses of gold have been few: in dentistry; and in the wiring of electronic microchips, for gold has high electrical conductivity and is of course corrosion-free. The heat-reflecting property of gold foil is used to wrap space vehicles and protect them from sunlight. A thin (20 picometer) gold film coated on the windows of office buildings, blocks the entry of both ultraviolet and infrared radiation. Colloidal gold is employed in cell microscopy as a marker for proteins, because it is an electron-dense pigment, opaque to X-rays and electrons, and so creates intense shadows in an electron microscope. The control of the formation and growth of colloidal gold is now a vital part of research in the burgeoning new sub-science of nanoparticle technology, which may in the future find much greater employment for the metal.

To conclude this chapter, here is an observation that should please any reader who appreciates the history of scientific ideas. For over five thousand years, the lustrous colour, massive density, and outstanding inertness of gold have impressed themselves on human sensibility. These most striking characteristics of our oldest metal can now be completely explained by the sophisticated ideas of modern theoretical chemistry: the quantum-mechanical description of atomic structure – but the calculations only fully succeed in predicting a yellow colour for gold if we also take account of another, equally important part of modern physics: the Special Theory of Relativity.[84] Those who truly wish to understand why gold appears golden, must acknowledge the work of Albert Einstein.[85]

84 A simple "planetary model" of the atom offers a crude explanation: the orbiting electrons in the gold atom close to the nucleus experience a very strong attraction because of its high positive charge; some of them must therefore orbit at velocities which are a substantial fraction of the speed of light, thereby, according to Einstein's theory, increasing their effective mass and contracting the radii of their orbits. The gold atom has nearly twice the mass, and twice the number of fundamental particles, as the silver atom, but the two are about the same size.

85 See Neil Bartlett, 'Relativistic Effects and the Chemistry of Gold', *Gold Bulletin*, 31:1 1998, 22-25, and references cited therein.

3 Herschel's Chrysotype

Gold is for the Mistress,
Silver for the maid,
Copper for the craftsman
Cunning at his trade.
"Good," said the Baron, sitting in his hall,
"But Iron, cold Iron, is master of them all."

Rudyard Kipling (1865–1936)

Figure 3.1 *Sir John Herschel, as photographed in 1869 by Julia Margaret Cameron, courtesy of The JMCT Collection.*

1 Sir John F.W. Herschel, 'On the Action of the Rays of the Solar Spectrum on Vegetable Colours, and on some new Photographic Processes', *Philosophical Transactions of the Royal Society*, (1842) 181-21.

2 William Henry Fox Talbot, 'Some account of the art of photogenic drawing', *Proceedings of the Royal Society*, 4:36 (1839) 120-1; idem,
'An account of the processes employed in photogenic drawing', 4:37 (1839) 209-11.

The alchemists saw gold as the mineral embodiment of the sun's light – the source of all life. There is no scientific rationale for making this connection, but we can accept it as a prophetic metaphor, at least in a poetic sense. Until the 20th century, sunlight had always been the most powerful illumination known to humanity, and the sun was *faute de mieux* the primary source of light essential to the invention of photography in the 19th century. During the brilliant English summers of 1840 and 1842, the consistent sunshine enabled one of the leading men of science, Sir John Herschel (figure 3.1), to progress his photochemical researches as far as inventing a novel method for making photographic images in gold by means of sunlight.[1] Herschel, well-versed in classical languages, named his new process *chrysotype*, from the Greek word for gold, χρυσός (*chrysos*), which has also given us words such as chrysalis and chrysanthemum, and the suffix τύπος (*typos),* meaning strike or print. This invention followed just three years after the first public disclosures in 1839 of the independent inventions of silver photography, on metal and on paper, by Louis Daguerre and Henry Talbot, respectively.[2]

There is no evidence that Rudyard Kipling had Sir John Herschel in mind when he composed the verse chosen for this chapter's epigraph; notwithstanding Herschel's baronetcy! On the contrary, we may be fairly sure that Kipling's jingoistic views on the proper employments for iron, which probably echoed those of the Hittites, diverged considerably from Herschel's. Yet the metallic allusions in this verse, so reminiscent of Chaucer's that were quoted

earlier (p. 1), offer an uncannily apt metaphor to Herschel's early experiments in photography. The essential content of this chapter has been previously published in the periodical *History of Photography*.[3] My first purpose is to describe how Herschel discovered that certain light-sensitive salts of iron provide the key to printing in gold and other precious metals, so that – in a photochemical sense, at least – iron may indeed be dubbed "master of them all".

3 Mike Ware, 'Herschel's Chrysotype: a Golden Legend Retold', *History of Photography*, 30:1 (Spring 2006), 1-24.

Iron Tonics and Sunlight

The chrysotype process is just one member of a whole class of photographic printing processes which all share a common type of light-sensitive component: namely, a ferric salt – or in modern chemical language, an iron(III) salt[4] – of certain organic acids, such as citric, tartaric, and oxalic acids. In Herschel's time, these were appropriately referred to as "vegetable acids", which reflected their widespread natural occurrence within the plant kingdom: citric acid occurs, of course, in all citrus fruits; tartaric acid is found in grapes; and oxalic acid is present in rhubarb, spinach, and sorrel. The discovery that many such organic salts of iron(III) were sensitive to light pre-dates the invention of photography itself, and the history of this finding is curious enough to deserve relating here.

4 The parenthetical Roman numeral (III) denotes the oxidation state of the iron; it is read as "iron three".

The first observation is attributed to Count Bestuscheff (1693–1766), the Lord High Chancellor of Russia. In 1725 this worthy is reputed to have devised a nostrum for most ills, which rejoiced in the name of *Tinctura tonico-nervina*. The formula was kept secret, but the medicine was reputed to contain gold – presumably in order to justify an exorbitant price. Bestuscheff intimated that the agency of sunlight was employed in its production. In France, a similar secret preparation, known picturesquely as the *Golden Drops of General De La Motte*, also became extremely popular for its supposedly marvellous restorative properties. It was likewise reputed to contain gold; a bottle of about half a fluid ounce (14 cm^3) cost one *livre* (about equal to the late French franc). Louis XV was moved to

send 200 bottles to the Pope as a gift, presumably because he was impressed by its efficacy, and he granted De La Motte an annual pension of 4000 *livres*, to manufacture the preparation for the Hôtel des Invalides.[5] It is possible that these distinguished mountebanks, Bestuscheff and De La Motte, were trading on the public's distant recollection of *aurum potabile*, whose iatro-chemical virtues as a panacea had been much to the fore in the previous century, as described in Chapter 1.

The secret of the tincture's composition was finally revealed by the Empress Catherine the Great, who purchased the formula from Bestuscheff's heirs. It turned out to be no more precious than a solution of ferric chloride in alcohol, which had been decolourised by exposure to sunlight, thereby reducing the yellow iron(III) to colourless iron(II).[6] Gold was conspicuously absent from the formulation. Despite the unmasking of its commonplace nature, the tonic continued to enjoy a long-lived commercial success as *Bestuscheff's Nervine Tincture*, although we cannot be sure whether it was the iron, or perhaps the alcohol, that contributed most to the patient's sense of well-being. As late as 1853, the tincture can still be found listed in the pharmacopoeias as *Spiritus Sulphurico Etherus Martiatus*, or as *Ferruginated Sulphuric Ether*,[7] having undergone in 1782 a modification due to Martin Klaproth, who replaced the ethyl alcohol with diethyl ether – making an altogether headier elixir – but the tincture was still said to be "blended in light". In 1813, a scientific investigation of the light-induced bleaching of ferric chloride in ether solution by Henri August Vogel, found it to be very sensitive.[8]

Döbereiner's Photochemistry

Those early preparations of sun-struck organic iron tinctures had only an indirect bearing on the historical invention of iron-based printing, but they were the forerunners of an important observation published in 1831 by the distinguished German chemist, Johann Wolfgang Döbereiner (1780–1849). The following translation from

5 C.J.S. Thompson, *The Lure and Romance of Alchemy*, London: G.G. Harrap, 1932; republished, New York: Bell Publishing Company, 1990, 23; Josef Maria Eder, *History of Photography*, Trans. Edward Epstean, New York: Columbia University Press, 1945, 56.

6 The yellow solution of ferric chloride is decolourised by sunlight, corresponding to the reduction of iron(III) to iron(II); some of the organic component is correspondingly oxidised.

7 G.C. Wittstein, *An Explanation of Chemical and Pharmaceutical Processes*, Trans. Stephen Darby, London: John Churchill, 1853, 132.

8 Josef Maria Eder, *History of Photography*, Trans. Edward Epstean, New York: Dover Publications, 1978, 159.

the German of his original paper, describes in quite picturesque terms the discovery of light-sensitivity in iron salts, as published in *Schweigger's Journal für Chemie und Physik*.[9]

9 Wolfgang Baier, *Quellendarstellungen zur Geschichte der Fotografie*, Fotokinoverlag Halle, 1964, 40.

"On the chemical knowledge of imponderables and of organic nature. New observations and emended communications from J. W. Döbereiner.

As is well-known, oxalic acid, especially in slight excess, forms with iron oxide a compound which is very easily soluble and of a yellow colour. I have recently prepared this compound in order to ascertain experimentally if it is light-sensitive in its dissolved state, or if it is decomposed by heat and light in the same way as the purple manganese oxalate. The investigations instituted to this end have yielded the following interesting results:

If the solution of ferric oxalate is kept in a dark place, or maintained for many hours at a temperature of 100 °C, then the substance undergoes no change perceptible to the senses...but if one exposes the concentrated or dilute solution of ferric oxalate to the action of sunlight (preferably in a glass bulb furnished with a long delivery tube), then very soon one observes a most interesting phenomenon. This is, that after a short time, there are evolved within the irradiated liquid innumerable little bubbles of gas, which ascend the column of liquid with increasing speed and thus give rise to the appearance of sugar juice undergoing brisk fermentation. The evolution of gas becomes gradually more lively, and even vigorous, if one dips into the liquid a glass rod roughened on the surface, or a thin splint of wood. The liquid itself is thence brought into a state of motion, swirling to and fro, becoming gradually greenish-yellow and turbid, and under the continuing gas evolution it yields a precipitate of ferrous oxalate in small, lustrous crystals of a beautiful lemon-yellow colour. These contrary phenomena, the gas evolution and the crystal precipitation, last until all the ferric oxalate has been changed into the ferrous salt, whereupon the liquid becomes completely colourless, and all its internal motion ceases."

The photosensitivity of ferric oxalate was later to provide the basis for several important photographic printing processes of the 19th century, including platinotype and kallitype. It was soon discovered that the sensitivity was confined to the blue end of the spectrum:

> "Suckow, in 1832, found that the action of light on ferric oxalate, after passing through a violet glass, was the same as that of white light; that the action was retarded by a blue glass, and still more by a green. In yellow or red light he remarked no change. Applied to paper, ferric oxalate is sensitive to the green to a notable degree beyond the visible violet of the spectrum".[10]

10 J.M. Eder, *The Chemical Effect of the Spectrum*, Trans. Captain W. de W. Abney, London: Harrison & Sons, 1883, 35.

However, the observation by Döbereiner did not lead directly to the invention of iron-based photography, although all the chemical knowledge needed for this was now in place. The final step in its application was only achieved later, by roundabout means, which had to await a concatenation of events involving Sir John Herschel, who is the main proponent in our story, and therefore deserves first an outline biographical sketch. The following details are condensed from the account by J.J. O'Connor and E.F. Robertson.[11] Readers are also referred to the biography by Gunther Buttman.[12]

11 http://www-history.mcs.st-andrews.ac.uk/history/Mathematicians/Herschel.html

12 Gunther Buttman, *The Shadow of the Telescope: A Biography of John Herschel*, (German edition 1965), Trans. B.E.J. Pagel, Ed. D.S. Evans, New York: Charles Scribner's Sons, 1970.

Sir John Herschel – a biographical sketch

John Frederick William Herschel was born on 7 March 1792 in Slough, Buckinghamshire, the son of Sir William Herschel, the noted astronomer of Hanoverian extraction, famous for his discoveries of the planet Uranus, and double stars. John Herschel was brought up in Observatory House, under the shadow of his father's 40 foot telescope. He went up to St John's College Cambridge in 1809, and graduated in 1813, taking the first place (as Senior Wrangler) in the final examination of the Mathematical Tripos. He was immediately elected to a fellowship of St John's, and in the same year he was also elected Fellow of the Royal Society,

having published a mathematics paper in its *Transactions*.
His mathematical work continued up to 1820, but from
1816 he also began to undertake work in astronomy and
chemistry. In 1819, Herschel published details of some
chemical experiments with "hyposulphites" (now known as
thiosulphates) which, 20 years later, would prove of
fundamental importance to the development of
photography. Following the founding of the Astronomical
Society in 1820, he was elected its vice-president.
Herschel's polymathic versatility is evident from the award
of the Copley Medal of the Royal Society of London in
1821, for his work on mathematical analysis (he was
awarded it a second time in 1847).

1822 was the year in which John Herschel published his
first paper on astronomy, to be followed by an important
catalogue of double stars in 1824. On a trip to the Continent
in that year, Herschel visited Josef von Fraunhofer, one of
the founding fathers of the sub-science of spectroscopy,
and there had his first meeting with Henry Talbot who was
also visiting Fraunhofer at the time.

The Paris Academy awarded Herschel its Lalande Prize
in 1825, and the Astronomical Society awarded him its Gold
Medal the following year, electing him President in 1827.
In 1829, John Herschel married Margaret Brodie Stewart.

Herschel's involvement with the Royal Society was at
the heart of his career. He had been elected Secretary in
1824 (although he resigned the post in 1827) and in 1831 he
was proposed for President by Charles Babbage. However,
as a "reformer" he failed narrowly to be elected, the
traditionalists winning the day. Despite this disappointment,
he was to receive the Society's Royal Medal on no less than
three occasions – in 1833, 1836 and 1840 – and he was
knighted in 1831, so did not lack for honours.

The episode of the failed bid for the Presidency may
have provided Herschel with a motive for making his
lengthy visit to the Cape of Good Hope. The Royal
Observatory at the Cape had been completed in 1828 with
the scientific aim of cataloguing astronomical objects
which could not be observed from the Northern

hemisphere. Herschel sailed for South Africa with his family in 1833, taking with him his own 20 foot refractor telescope. Their ship reached the Cape in January 1834. His objective was to fulfill a major astronomical project which was also a personal obligation: to complete the unfinished work of his deceased father, Sir William, to study and draw up star maps of the Southern sky. He also made observations of Halley's comet on its 1835 appearance. In May 1838 Herschel returned to England, soon to be enmeshed in the development of photography, as will be described below. In the midst of these discoveries, in March of 1840, he moved his family home from Slough to 'Collingwood' at Hawkhurst, in Kent.

In 1850 he accepted the appointment as Master of the Mint. This was not a post which suited Herschel's talents: there were many difficulties in dealing with staff and the Treasury; but above all, Herschel was obliged to sacrifice his scientific interests to commercial issues. He resigned after five taxing years, his health having suffered through the stresses of the post. He retired to Collingwood in 1855, to resume his chemical and photographic studies, at the age of 63.

Sir John Herschel died at Collingwood on 11 May 1871, and was buried in Westminster Abbey. Although his name is not attached to any one major innovation in science, he was esteemed by many of his peers as the leading scientist of his day. In his obituary it was remarked:

> "In John Frederick William Herschel British science has sustained a loss greater than any which it has suffered since the death of Newton, and one not likely to be replaced."

Entry into Photographic Research

13 'On the Action of Light in determining the Precipitation of Muriate of Platinum by Lime-water; being an Extract from a Letter of Sir John F.W. Herschel to Dr. Daubeny', *The London, Edinburgh and Dublin Philosophical Magazine*, 1:1 (July 1832) 58-60.

Like Döbereiner, Herschel too had been pursuing photochemical investigations as early as 1831. In that year he discovered that certain calcium salts of platinic chloride in aqueous solution were sensitive to light, and upon exposure threw down a white precipitate which he designated as "platinate of lime".[13] He was later to suggest

this as a potential method of positive-working photography, but there is no evidence that it was ever tested for image-making in practice.[14] Herschel's photochemical research was interrupted by his sojourn at the Cape of Good Hope from January 1834 until May 1838 as described above. His absence from the mainstream of European science for four years left the field clear for Döbereiner to publish his own analytical investigations of "platinate of lime". It is significant that Herschel, normally an assiduous international correspondent, never made any reference to Döbereiner or his work. There are therefore grounds for thinking that the converging photochemical interests of Herschel and Döbereiner may have been the source of some degree of scientific competition between them: a rivalry that would account for this uncharacteristic omission of any acknowledgement or citation by Herschel of Döbereiner's work. I have examined this possibility elsewhere, in my book on cyanotype.[15]

Soon after Herschel's return from the Cape, the news broke of the independent invention of photography, by Daguerre in France, and by Talbot in England. The entire history of the British side of photographic discovery is related in illustrated detail by Larry Schaaf in his book *Out of the Shadows*, to which the reader is recommended for an insightful and scholarly view of this historic invention.[16]

Owing to the natural secretiveness of the inventors, neither man realised for some months that the other's rival method of photography differed very substantially. Herschel heard of them both in mid-January, 1839. Dominique Arago had announced the photographic invention by Louis Jacques Mandé Daguerre (1789–1851) to a meeting of the French Académie des Sciences, held in Paris on 7 January.[17] The news was reported in English in the Literary Gazette on 12 January, but Herschel was also alerted to this discovery by a note from Sir Francis (then Captain) Beaufort, dated 22 January. Shortly thereafter, Herschel must have been further surprised to learn directly in a letter of 25 January from his friend and colleague, William Henry Fox Talbot, that he had been experimenting

14 The present writer doubts that the reaction could be made to proceed effectively within a layer upon paper, because it requires a considerable excess of water to bring about the photo-hydrolysis.

15 Mike Ware, *Cyanotype: the history, science and art of photographic printing in Prussian blue*, London: Science Museum and National Museum of Photography, Film & Television, 1999.

16 Larry J Schaaf, *Out of the Shadows: Herschel, Talbot & the Invention of Photography*, New Haven & London: Yale University Press, 1992.

17 Dominique François Jean Arago, 'Fixation des images qui se forment au foyer d'une chambre obscure', *Comptes Rendus hebdomédales des Séances de l'Académie des Sciences, Paris*, 8 (1839).

successfully with photography for fully five years previously, but had never made his discoveries known beyond his immediate family circle. As a British response to Daguerre's startling claim, Talbot's invention of silver photography on paper was publicly announced by Michael Faraday on 25 January 1839 at the Royal Institution, accompanied by an exhibition of Talbot's photographic specimens. In a letter to Herschel of the same date, Talbot suggested a meeting. Herschel replied on 27 January, explaining his absence – he was in bed with sciatica – and informing Talbot of his discovery of thiosulphate fixation. Despite his indisposition, Herschel immediately took up the experimental study of the phenomena. Without knowing any details of Talbot's process, it took Herschel only a few days to invent silver photography for himself, and on 30 January he made a camera negative of his father's telescope on a glass plate (the first negative on glass), and made a silver print from it, by methods recorded in his *Notebook of Chemical Experiments*. Although Herschel did use a camera obscura to make negative images as Talbot had done, these were very few, and his preference in photographic experimentation was simply to contact print from published engravings using sunlight, as an easier way of investigating the processes. Within a week he had found a solution to the problem of 'fixing' silver images far superior to Talbot's, drawing upon his early chemical observation of 1819 that sodium thiosulphate solution can dissolve silver chloride. Herschel also recorded his first diary entry on photography:

> "Wed Jan 30 1839 … Experiments on the fixation of a Camera obscura picture…"

On 31 January, Talbot read his first paper on photography to a meeting of the Royal Society in London. Herschel was again absent owing to continuing ill-health. On the following day, Talbot visited Herschel at Slough to discuss their respective experiments in photography, and Herschel demonstrated his method of thiosulphate fixation.

This event of 1 February was described in a letter by Herschel's wife, Margaret:

> "I happen to remember well the visit to Slough of Mr Fox Talbot, who came to show Herschel his beautiful little pictures of Ferns and Laces taken by his new process. – when something was said about the difficulty of fixing the pictures, Herschel said "Let me have this one for a few minutes" and after a short time he returned and gave the picture to Mr Fox Talbot saying 'I think you'll find that fixed' – this was the beginning of the hyposulphite plan of fixing."

Herschel subsequently gave accounts of his photographic researches in four papers published in the Philosophical Transactions of the Royal Society: in 1839, 1840, 1842, and 1843.[18] Much more may be learned, however, from his original experimental notes. I have already recorded in an earlier book those aspects relating to his invention of cyanotype, so my concern here will be to tease out the single golden thread woven into this rich tapestry of photographic experimentation.

18 The first paper, in 1839, was withdrawn by Herschel before publication in the *Transactions*, and it was only published as an abstract.

Early Experiments with Gold

Sir John Herschel recorded the results of some photographic tests on gold salts as early as 1839,[19] nearly three years before his discovery of the chrysotype process. His words: "I was on the point of abandoning the use of silver in the enquiry altogether and having recourse to Gold or Platina" come from his unpublished Royal Society paper of 1839, intimating that he had nearly forsaken silver as an imaging substance, in favour of gold. As we have seen, the phenomenon of the precipitation of gold from its salts, by the action of light in the presence of organic matter, was quite well-known by this time.[20] To quote further from his paper, where Herschel reviews possible chemical systems for photography: "...and thirdly the reduction of gold in contact with deoxidising[21] agents by light as described by Count Rumford and Mrs. Fulhame."

19 Sir John F.W. Herschel, 'Note on the Art of Photography, or the Application of the Chemical Rays of Light to the Purposes of Pictorial Representation', [Abstract] *Proceedings of the Royal Society*, 4:37 (1839) 131-133. For the complete text of the full paper, see Larry Schaaf, *History of Photography*, 3:1 (1979) 47-60.

20 J.F. Daniell, *An Introduction to the Study of Chemical Philosophy*, 1839, 399.

21 In modern chemical language, "reducing".

22 Sir John F.W. Herschel, *Diary* entry for 29 January 1840, HRHRC.

His diary entry for 29 January, 1840 records: "Many Photographic Expts with Chlor Gold &c."[22] His experimental notebook, at the Science Museum, records "strong black impressions" obtained by exposing gold chloride and treating it with Rochelle salt and ammonium

23 Science Museum Library, London, Archive Collection, MS 478.

oxalate.[23] The stimulus for Herschel's entry into non-silver photography may therefore be attributed ultimately to the discoveries of Elizabeth Fulhame fifty years earlier. In his paper published in 1840, Herschel records explicit details of some of these experiments with gold:

> "Papers were washed with the chlorides of gold and of platina, freed from excess of acid. In the case of platina, they proved insensible; in that of gold, a slow but regular increasing darkening takes place, and the paper at length,

24 Sir John F.W. Herschel, 'On the Chemical Action of the Rays of the Solar Spectrum on Preparations of Silver and other Substances, both metallic and non-metallic, and on some Photographic Processes', *Philosophical Transactions of the Royal Society*, 1840, 1-59.

> under the influence of light, becomes purple." [24]

In contrast to silver chloride, gold chloride is not intrinsically sensitive to light, which is demonstrated by the lack of change on exposing it in a sealed glass container. As pointed out above, it is only the oxidisable nature of the paper, or other organic component of the substrate, that enables the light-induced reaction in which the gold(III) is reduced to gold metal, and part of the cellulose is oxidised to oxycellulose. However, if a readily oxidisable anion such as oxalate is also present, the light-induced reaction becomes much more facile, as Herschel went on to discover by performing, in fact, the precise experiment proposed earlier in Talbot's Notebook:

> "If paper impregnated with oxalate of ammonia be washed with chloride of gold it becomes, if certain proportions be hit, pretty sensitive to light; passing rather rapidly to a violet purple in the sun. It is next to impossible to dry paper so prepared, however, as a very gentle heat blackens it. It passes also to the same purple hue in the dark, though much more

25 Sir John F.W. Herschel, ibid.

> slowly; so that, as a photographic combination, it is useless".[25]

This observation highlights the inherent problem of using gold salts such as the oxalate as photographic sensitisers: their decomposition is brought about, not only

by light, but also by ambient heat. In chemical language, the reaction is promoted thermally as well as photochemically. To avoid the problem of a competing "dark reaction" promoted by heat, the most successful gold printing process would prove to be an indirect one, in which the light-sensitive component is an iron salt.

Experimental Archives

For many years Herschel recorded his chemical experiments in a disciplined, linear chronology, in bound notebooks; four of these cover the years 1815–1870,[26] but there is a lacuna in Volume III: between two successive experiment numbers, recorded on the same page, there is an interval of four years, from August 1841 to January 1845! During this period his method of record-keeping apparently underwent a profound change. It became multistranded after August 1841, taking a new format, of unbound loose leaves which he kept in separate envelopes titled by topic, reflecting a convenient way of coping with the diversity of different parallel lines of photochemical research that he was following concurrently. These records were sold at auction by Sotheby's on 4 March 1958, and were little thought of at the time, but the collector and photohistorian, Helmut Gernsheim, was shrewd enough to acquire them for his collection, which was subsequently donated to the Harry Ransom Humanities Research Center of the University of Texas, which also has Gernsheim's copy of the original Sotheby's auction catalogue, with his autograph annotation against the Herschel lot:

26 Science Museum Library, London, Archive Collection, MS 478.

> "This comprises a lot of scraps which other people would consign to the waste paper basket. The laboratory notebook contains no interesting data, thoughts or descriptions merely dry factual one line statements of the obscure substances tried; only the prints prepared with ferroprussiate of potash still show their image, those prepared with others are a blank."

Among these ill-considered "scraps" is Herschel's "List of Prepared Papers", a sequentially-numbered list of abbreviated chemical descriptions of his sensitive coatings

applied to paper, which proves to be an invaluable key to his photographic experiments, enabling cross-references to be made between his specimen prints and his loose leaf memoranda. One difficulty in making the correlation with extant specimens is that we have no record of the size of Herschel's prepared sheets of paper, which were cut into an unknown number of smaller pieces for the individual tests. A second problem is that Herschel did not record after-treatments in his list, so that a paper sheet coated for photographic testing could be cut into 12 or 16 pieces, each exposed and then treated variously to make a cyanotype, a chrysotype, or an argentotype. Herschel's symbolism and abbreviations are sometimes cryptic, for instance he habitually used the alchemical symbols for mercury and the sun. (see Table 1.1)

The statistics of Herschel's investigations are significant: out of 771 experimental coatings made over the period of his greatest activity, 1839–1843, the number of silver imaging experiments was 314, a further 225 were devoted to plant dyes; 132 tests were performed on mercury sensitisers, and approximately 25 were cyanotype experiments, but Herschel only devoted a total of 12 tests to preparations of gold, and then quite sporadically.[27]

27 The remainder of tests (63, in all) were upon a variety of inorganic salts of the metals, chromium, uranium, iron, lead, copper, platinum, nickel, and iridium.

Table 3.1 *Numbers of Herschel's photographic experiments, 1839–43.*

Silver prints	314
Anthotypes (plant dyes)	225
Kelaenotypes (mercury)	132
Cyanotypes	25
Chrysotypes	12
Other metals	63
Total number of prepared papers	771

In view of the strong images that Herschel obtained with gold, we might wonder why he did not make more use of his chrysotype process, that had fallen so readily into his hands. A possible answer is that he did not see it as serving his wider purpose, and thought that there was no scope for

improving this particular invention in the direction he desired. It was very expensive, because the gold had to be contained in the development bath, and it was ineluctably negative-working, which we know was not to his taste because at the time he was particularly interested in seeking direct positive-working processes.

Quest for Colour Photography

Although the majority of Herschel's experiments were with silver salts, firmly in the mainstream of monochrome photographic investigation, we see from the statistics an almost comparable number of anthotype (phytotype) experiments; between August 1840 and July 1842 he coated 225 sheets with plant dyes, which took considerable effort in preparation and exposure. In view of their very low sensitivity to light, compared to silver salts, and the fact that their images could not be fixed, Herschel's persistence with these unpromising plant extracts requires some explanation. The 1842 paper is devoted mostly to an account of these experiments. Substances of such low sensitivity had one important characteristic, which silver lacked, and which fulfilled Herschel's purpose – namely, colour. From an early stage, his underlying objective had been a direct positive process of colour photography by bleaching intense dyes by means of light. It is also significant that he devoted much effort to a positive-working cyanotype process, which is far harder to achieve than the normal negative-working process, but would also have provided him with a good blue primary colour.

Although Herschel declared in 1839 that he believed colour photography was possible, in the end his search for a direct positive-working process in natural colours was to prove a fruitless quest, as he admitted retrospectively in 1866.[28]

28 Sir John Herschel, 'Photography in Natural Colours, &c', *American Journal of Photography and the Allied Arts & Sciences*, n.s. 8:15 (1 February 1866) 342-5. See also *Photographic News* no. 382

Herschel's Diary

Herschel's personal diary is also in the HRHRC collection, and while it does not go into much technical detail, its brief entries are useful for confirming the dates of his key discoveries. The 'List of Prepared Papers' reveals that in late April of 1842 he was again trying papers simply coated with 'gold chloride' (tetrachloroauric acid) neutralised by sodium carbonate (to give sodium tetrachloroaurate) just as he had three years previously, and brief diary entries confirm this:

"25 April 1842 Mur Gold Satd with Carb Soda"

[Mur is short for 'muriate' which is the old-fashioned word for chloride, so this entry translates as: 'gold chloride saturated with sodium carbonate']. A week later, the diary simply records:

"3 May 1842 Photography of Gold"

These papers must have given a measure of success that encouraged him, bringing out a comparison with Talbot's recently announced calotype process, because the diary goes on with an excited-sounding entry for the next day:

"4 May 1842 Redding up of Photography. The Calotype in Gold."

However, around 10 June, on the recommendation of Dr. Alfred Smee, Herschel obtained a sample of a substance, at the time called "Ammonio Citrate of Iron", and soon discovered that this iron salt was very sensitive to light and provided a much better means of making images in gold. We can witness the days of discovery from Herschel's diary entries for 1842:

"11 June Properties of Ammoniocitrate of Iron

12 June Discovered my Chrysotype Process

13 June Photography in perfection. Worked at the Chrysotype process and prepared specimens for R.S. Method of fixing by Bromuret of Pot.

14 June Dispatched per Coach my paper on Photography to RS."

('RS' here refers to the Royal Society of London. "Bromuret of pot." is potassium bromide.) One is struck by Herschel's eagerness to publish this finding – within two days of the initial discovery, his account of it was complete and on its way to the editor. But the key to this new success lies in the first mention of the "Ammonio-Citrate of Iron".

Ammonio-Citrate of Iron

From an early stage in his photochemical investigations, Herschel had been in consultation with Dr. Alfred Smee (1818–1877), a promising young man of science, and newly-elected Fellow of the Royal Society, who had already published a paper on the use of electrochemistry for synthesising certain inorganic compounds. Smee was also no stranger to the newly-invented technology of photography; as early as May 1839, only a few months after Talbot's first disclosure of his achievement, Smee published an account of "Photogenic Drawing" in the Literary Gazette, in which his observations on the best proportions for the sensitising chemicals and the choice of the paper were both perceptive and useful.[29] We are indebted to Dr. Larry Schaaf for researches that have brought to light the important role played by this talented young surgeon and chemist in enabling the discoveries by Herschel that were to follow.[30] In furtherance of his quest for colour photography, Herschel originally enquired of Smee for "deeply-coloured salts" which he evidently hoped could be bleached by light. Smee supplied him with a sample of the bright red substance, potassium ferricyanide, which would prove to be the essential component in Herschel's invention of the cyanotype process, a narrative that I have published elsewhere, but which is closely intertwined with the present one.[31] Smee's letter to Herschel of 10 May 1842 also suggested the key substance that was to unlock an entire photochemical treasure-trove for Herschel:

> "There are two salts which of late have been used in Medicine having been vamped up by the Chemists and Druggists. The Ammonio Citrate and Ammonio Tartrate of Iron which are

29 Alfred Smee, 'Photogenic Drawing', *Literary Gazette* (18 May 1839) 314-16.

30 Larry J. Schaaf, *Out of the Shadows: Herschel, Talbot, & the Invention of Photography*, New Haven & London: Yale University Press, 1992.

31 Mike Ware, *Cyanotype: the History, Science, and Art of Photographic Printing in Prussian Blue*, London: Science Museum and National Museum of Photography, Film & Television, 1999.

perfectly soluble and give very dark solutions. I mention them thinking it just barely possible that they may not have found their way into your laboratory and should my anticipation be correct it will afford me much pleasure to send some of each."[32]

32 Letter, Smee to Herschel, Library of the Royal Society, London.

This deferential tone is what we might expect from the 23-year-old Smee, a newly-elected Fellow of the Royal Society, addressing the 50-year-old Herschel, already one of the most distinguished elder statesmen of British science. Smee could hardly have realised that he was placing in Herschel's hands a substance that would soon enable a whole gamut of iron-based photographic processes: not only the chrysotype, but also the argentotype, kelaenotype, and cyanotype. Smee appears to have simply thought, as did Herschel, that the "dark solutions" might lend themselves to bleaching by light, and thereby provide direct positive photographic processes. The reality turned out to be both more complex and more rewarding.

Although they were not difficult to prepare, the 'Ammonio Citrate and Ammonio Tartrate of Iron' were quite new substances on the chemical scene in 1842. Interest in them had been stimulated by the well-appreciated pharmaceutical benefits of iron tonics, dating back to Bestuscheff's "tincture" and De la Motte's "golden drops", mentioned earlier. It is evident from his reply to Smee, that Herschel had not been previously aware of the existence of these salts. That they were new is apparent by their absence from the chemistry textbooks and pharmacopoeias before 1842,[33] at which time they began to be promoted by druggists as "chalybeate remedies",[34] but another year or two elapsed before they became common items on the pharmacy shelves. Indeed, they are still valued as iron tonics today.[35] Four years later, Herschel would find himself consulting a Dr. Watson in London for his stomach complaint of "mucuous irritation", and being prescribed 'ferrocitrate of ammon.' which he noted in his diary for Saturday 17 January 1846 as "a persalt of my own ...". Having to take his own medicine might be termed the "ultimate irony"! Among the Herschel papers at the HRHRC there is also a doctor's prescription dated 29 Sept. 1851 for "Ferric Ammonio Citratis".[36]

33 Christison, R, *A Dispensatory, or Commentary on the Pharmacopoeias of Great Britain*, Edinburgh: Adam and Charles Black, 1848, 975.

34 "Chalybeate" was the term used to describe natural mineral waters that contained iron salts.

35 M. Taniguchi, H. Imamura, T. Shirota, H. Okamatsu, Y. Fujii, M. Toba, and F. Hashimoto, 'Improvement in Iron-Deficiency Anemia through Therapy with Ferric Ammonium Citrate and Vitamin-C and the Effects of Aerobic Exercise', *Journal of Nutritional Science and Vitaminology*, 37:2 (1991) 161-171.

36 HRHRC MS archive WO177.

To return to the summer of 1842: within a month, as indicated by his diary entry for 11 June quoted above, Herschel followed Smee's recommendation to try "Ammonio Citrate of Iron" photographically (rather than medicinally) and immediately discovered that it was highly sensitive to light. A copy of his reply to Smee on 15 June 1842,[37] clearly expresses his excitement and pleasure at the quality and variety of processes that this discovery had made possible, especially one employing gold:

> "I cannot help thanking you for your mention in one of your late notes to me of the Ammonio citrate and Ammonio tartrate of Iron as highly coloured salts. The former of these salts I have procured and examined, and it has furnished me with an infinity of beautiful photographic processes, both in conjunction with your Ferrosesquicyanate and with other ingredients. I take the liberty to enclose you a specimen or two, to appreciate which they should be wetted, laid on white paper and examined with a pretty strong magnifier. This process if you should happen to attend next Thursday's meeting of the R.S. you will hear described under a name I have invented to give it in imitation of Mr. Talbot's Calotype – viz. – Chrysotype – from the use of Gold as a stimulant to bring about the dormant picture which the action of light produces on paper prepared with this salt. It is one of the most striking and magical effects which has yet turned up in photography, the Calotype and Argyrotype (Daguerreotype) themselves not excepted."[38]

Herschel's early tests of the substances that he abbreviated as "ACI" and "ATI" in his notes are not recorded chronologically, however, because his Memoranda relating to these experiments appear to have been written-up retrospectively. This was an uncharacteristic lapse for a keeper of such impeccable scientific records. It is possible that the excitement of discovery was so great as to distract him from a lifetime's discipline of systematic note-taking.

15 June 1842 was also the day on which Herschel's long and significant paper entitled "On the Action of the Rays of the Solar Spectrum on Vegetable Colours, and on some new

37 Herschel's letters to Smee are lost, and Smee's biography by his daughter, which is otherwise fulsome in cataloguing his achievements, (which were indeed considerable) makes no mention of this correspondence and collaboration with Sir John Herschel. See: Elizabeth Mary Smee Odling, *Memoir of the Late Alfred Smee*, FRS, London: George Bell and Sons, 1878.

38 Draft of a letter, 'Substance of letter to Smee', Herschel to Smee, 15 June 1842. Royal Society Library.

Photographic Processes" was accepted for publication by the Royal Society. Part of this paper was read before the Society on 16 June, but it did not appear in print until September; this seminal work will be referred to as 'the 1842 Paper'.[39] The first published account of Herschel's discovery of chrysotype, however, appeared in an August issue of *The Athenæum*, within a report of the June meeting of the Royal Society.[40] Unfortunately the part of that account relating to chrysotype was seriously misreported, confusing the chrysotype process with the one that Herschel was later to call cyanotype, and consequently stating, erroneously, that potassium ferricyanide was involved in the chrysotype process. Two weeks later, a letter from Herschel was published in *The Athenæum* setting the record straight; nonetheless, this error was perpetuated in more than one treatise and periodical of the time.[41] The error was a happy accident for posterity, however, because it called forth from Herschel the following account of the chrysotype process, which is actually more detailed and informative than his terse description in the Transactions:

"The preparation of the chrysotype paper is as follows: dissolve 100 grains of crystallised ammonio-citrate of iron in 900 grains of water, and wash over with a soft brush, with this solution, any thin, smooth, even-textured paper. Dry it, and it is ready for use. On this paper a photographic image is very readily impressed: but it is extremely faint, and in many cases quite invisible. To bring out the dormant picture, it must be washed over with a solution of gold in nitro-muriatic acid,[42] exactly neutralised with soda, and so dilute as to be not darker in colour than sherry wine. Immediately the picture appears, but not at first of its full intensity, which requires about a minute or a minute and a half to attain (though, indeed, it continues slowly to darken for a much longer time, but with a loss of distinctness). When satisfied with the effect, it must be rinsed well two or three times in water (renewing the water), and dried. In this state it is half fixed. To fix it completely, pass over it a weak solution of hydriodate of potash,[43] let it rest a

39 Herschel wrote four papers on photographic processes, of which three were published in the *Philosophical Transactions of the Royal Society*, in 1840, 1842 and 1843. The first paper, written in 1839, was withdrawn before publication, and was long thought lost until the MS copy was discovered by Dr. Larry Schaaf, 'Sir John Herschel's 1839 Royal Society paper on photography', *History of Photography*, 3:1 (1979), 47-60.
For ease of future reference, Herschel numbered his 'articles' throughout these three published papers: the 1840 paper comprises §1 to §148; the 1842 paper comprises §149 to §216, and its postscript §217 to §230; the 1843 paper comprises §231 to §241.

40 *The Athenæum*, 771 (6 August 1842) 714.

41 Robert J. Bingham, *Photogenic Manipulation*, London: George Knight and Sons, 1850, p59: Henry H. Snelling, *History and Practice of the Art of Photography*, New York: Morgan & Morgan 1849. *The Photographic News*, 2:37 (20 May 1859) 126.

42 "Nitro-muriatic acid" is another name for *aqua regia*.

43 "Hydriodate of potash" is the rather misleading 19th century name for potassium iodide.

minute or two (especially if the lights are much discoloured by this wash), then throw it into pure water until all such discolouration is removed. Dry it, and it is thenceforward unchangeable in the strongest lights, and (apparently) by all other agents which do not destroy the paper."[44]

44 *The Athenæum*, 773 (20 August 1842) 748.

["Nitro-muriatic acid" is aqua regia, and "hydriodate of potash" is potassium iodide.]

The 1842 Royal Society Paper

Herschel's passing mention of his chrysotype process is buried in the academic literature within his long paper in the Philosophical Transactions of the Royal Society of 1842, in which he deals mostly with the light-induced fading of plant colourings, a direct positive printing process which he dubbed anthotype or phytotype. As described above, he saw these experiments as a means to a direct dye-bleach method of colour photography. The relatively short section within this paper describing the discovery of iron-based photographic printing has a seminal importance that merits its quotation in full. [It will assist the reader to be aware that the "double ammoniacal salt" initially referred to here by Herschel is 'ammonio citrate of iron' or ammonium ferric citrate.]

"212. In order to ascertain whether any portion of the iron in the double ammoniacal salt employed had really undergone deoxidation,[45] and become reduced to the state of protoxide as supposed, I had recourse to a solution of gold, exactly neutralised by carbonate of soda. The proto-salts of iron,[46] as is well known to chemists, precipitate gold in the metallic state. The effect proved exceedingly striking, issuing in a process no wise inferior in the almost magical beauty of its effect to the calotype process of Mr. TALBOT, which in some respects it nearly resembles, with this advantage, as a matter of experimental exhibition, that the disclosure of the dormant image does not require to be performed in the dark, being not interfered with by moderate daylight. As the experiment will probably be repeated by others, I shall here describe it *ab initio*. Paper is to be washed with a moderately concentrated

45 "deoxidation" would be called "reduction" in modern chemical language.

46 The "proto-salts" are those of iron(II); "per-salts" are of iron(III).

solution of ammonio-citrate of iron, and dried. The strength of the solution should be such as to dry into a good yellow colour, not at all brown. In this state it is ready to receive a photographic image, which may be impressed on it either from nature in the camera obscura, or from an engraving on a frame in sunshine. The image so impressed, however, is very faint, and sometimes hardly perceptible. The moment it is removed from the frame or camera, it must be washed over with a neutral solution of gold of such strength as to have about the colour of sherry wine. Instantly the picture appears, not indeed at once of its full intensity, but darkening with great rapidity up to a certain point, depending on the strength of the solutions used, &c. At this point nothing can surpass the sharpness and perfection of detail of the resulting photograph. To arrest this process and to fix the picture (so far at least as the further agency of light is concerned), it is to be thrown into water very slightly acidulated with sulphuric acid and well soaked, dried, washed with hydrobromate of potash,[47] rinsed, and dried again.

213. Such is the outline of a process to which I propose applying the name of Chrysotype, in order to recall by similarity of structure and termination the Calotype process of Mr. TALBOT, to which in its general effect it affords so close a parallel. Being very recent, I have not yet (June 10, 1842) obtained a complete command over all its details, but the termination of the Session of the Society being close at hand, I have not thought it advisable to suppress its mention."[48]

In a later Postscript to this paper, Herschel was able to add:

"217. I gladly avail myself of the permission accorded by the President and Council to append to this communication, in the form of a Postscript, some additional facts illustrative of the singular properties of iron as a photographic ingredient, which have been partially developed in the latter articles of it, as well as an account of some highly interesting photographic processes dependent on those properties, which the superb weather we have lately enjoyed has enabled me to discover, as also to describe a better method of fixing the picture, in the

47 "Hydobromate of potash" is potassium bromide.

48 Sir John F.W. Herschel, op.cit., n. 1.

process to which I have given the name of Chrysotype; that described in Art. 212. proving insufficient. The new method (in which the hydriodate is substituted for the hydrobromate of potash) proves perfectly effectual; pictures fixed by it not having suffered in the smallest degree, either from long exposure to sunshine, or from keeping; alone, or in contact with other papers. It is as follows –As soon as the picture is satisfactorily brought out by the auriferous liquid (Art. 212.) it is to be rinsed in spring water, which must be three times renewed, letting it remain in the third water five or ten minutes. It is then to be blotted off and dried, after which it is to be washed on both sides with a somewhat weak solution of hydriodate of potash. If there be any free chloride of gold present in the pores of the paper, it will be discoloured, the lights passing to a ruddy brown ; but they speedily whiten again spontaneously, or at all events, on throwing it (after lying a minute or two) into fresh water, in which, being again rinsed and dried, it is now perfectly fixed."[49]

49 Sir John F.W. Herschel, ibid.

[The "hydrobromate of potash" is potassium bromide, and the similar "hydriodate" is potassium iodide.] Herschel makes much here of the similarity between his chrysotype and Talbot's calotype, presumably because of the apparent ongoing development of his gold images after exposure. The analogy does not hold up to scrutiny, however: Herschel did not at the time recognise that chrysotype has very little potential as a development process of sufficient sensitivity to be useful for securing images in the camera, because it does not depend on a latent image in the way that the calotype does. Rather, the ongoing process that he witnessed with gold was an intensification of the printed-out image by what is now called electroless plating, or 'physical development'.[50] Chrysotype remained a slow process suited only for printing, whereas calotype, as a true development process, had the potential to offer camera speed, and to be useful for negative-making.

50 W.S. Rapson and T. Groenewald, 'The Use of Gold in Autocatalytic Plating Processes', *Gold Bulletin*, 8:4 (1975) 119-126.

The 1843 Royal Society Paper

In 1843, Herschel published a number of emendations and additions to his ferric processes. These were mainly concerned with printing in metallic mercury, a process by that time known as "amphitype", but the following short section relates to chrysotype. It is significant in revealing Herschel's recognition that the presence of water was vitally import to the chemistry, so echoing the conclusions reached by Elizabeth Fulhame fifty years earlier (see Chapter 2):

"237. This singular power of water to excite the dormant impression, strongly recalls the analogous power of moisture to deepen the tints photographically impressed on auriferous papers, of which an instance is given in Art. 45, and of which a still more striking example is shown as follows. Let a paper be washed first with ammonio-citrate of iron, and when dry with neutralised chloride of gold, and thoroughly dried in the dark. It is then, apparently, almost insensible to light; a slip of it half exposed to sun being hardly impressed in any perceptible degree in many minutes; yet if breathed on, the impression comes out very strong and full, deepening by degrees to an extraordinary strength. Treated in the same manner, silver also exhibits a similar property. Nor, indeed is there any feature in photography more general or more remarkable than the influence exercised by the presence of a certain degree of moisture in favouring the action of light, whether direct or indirect."[51]

"Breath Printing"

As is evident in the final sentences of the quotation above, Herschel recognised the paramount importance of moisture in facilitating the image-making reaction after exposure of iron-sensitised papers. In the course of his experiments with these sensitisers, Herschel stumbled upon an extreme example of this moisture-dependent behaviour, using a derivative of iron(III) tartrate and silver nitrate. He described this process to the 13th meeting of the British Association for the Advancement of Science, held in Cork in 1843, under the title "Notice of a remarkable Photographic

51 Sir John F.W. Herschel, 'On Certain Improvements on Photographic Processes Described in a Former Communication, and on the Parathermic Rays of the Solar Spectrum', *Philosophical Transactions of the Royal Society* (1843).

Process by which dormant Pictures are produced capable of development by the Breath or by keeping in a Moist Atmosphere." The same details were duly reported in *The Athenæum*, and included in Hunt's *Manual*.[52]

This rather spectacular process occasionally captures the imagination of alternative process experimentalists, who wish to try it out, but find that the original sources are rather difficult to access; for their benefit a full transcript of Herschel's (admittedly rather sketchy) account now follows:

"Section IV.–Ferro-tartrate of silver.

Extending his inquiries still further into these very remarkable changes, the following process presented itself to Sir J. Herschel, which is in many respects remarkable.

If nitrate of silver, specific gravity 1.200,[53] be added to ferro-tartaric acid, specific gravity 1.023, a precipitate falls, which is in great measure redissolved by a gentle heat, leaving a black sediment, which, being cleared by subsidence, a liquid of a pale yellow colour is obtained, in which a further addition of the nitrate causes no turbidness. When the total quantity of the nitrated solution amounts to about half the bulk of the ferro-tartaric acid, it is enough. The liquid so prepared does not alter by keeping in the dark.

Spread on paper, and exposed wet to the sunshine (partly shaded) for a few seconds, no impression seems to have been made; but by degrees (although withdrawn from the action of the light) it develops itself spontaneously, and at length becomes very intense. But if the paper be thoroughly dried in the dark (in which state it is of a very pale greenish-yellow colour), it possesses the singular property of receiving a dormant or invisible picture; to produce which (if it be, for instance, an engraving that is to be copied), from thirty seconds' to a minute's exposure in the sunshine is requisite. It should not be continued too long, as not only is the ultimate effect less striking, but a picture begins to be visibly produced, which darkens spontaneously after it is withdrawn. But if the exposure be discontinued before this effect comes on, an invisible impression is the result, to develope which all that is necessary is to breathe upon it, when it immediately

52 Report of the British Association for the Advancement of Science, *Transactions of the Sections*, 8. The same details were duly reported in the *The Athenaeum*, (16 September 1843) 847, and included in: Robert Hunt, *A Manual of Photography*, 4th Edn., London: Richard Griffin and Company 1854, 58-9.

53 A silver nitrate solution of S.G. = 1.200 corresponds to a concentration of 24.3%w/v.

appears, and very speedily acquires an extraordinary intensity and sharpness, as if by magic. Instead of the breath, it may be subjected to the regulated action of aqueous vapour by laying it in a blotting-paper book, of which some of the outer leaves on both sides have been damp, or by holding it over warm water. Many preparations, both of silver and gold, possess a similar property, in an inferior degree; but none that I have yet met with, to anything like the extent of that above described. These pictures do not admit of being permanently fixed; they are so against the action of light, but not against the operations of time. They slowly fade out even in the dark; and in some examples which I have prepared, the remarkable phenomenon of a restoration after fading, but with reversed lights and shades, has taken place."

"Ferrotartaric acid", which was evidently quite a commonplace chemical to Herschel, is now little-known, and its preparation is buried rather deeply in the older chemical literature.[54]

As he states above, the phenomenon was not confined to silver. In his list of prepared papers, Herschel notes that a preparation of neutralised gold chloride and "peracetate of iron" behaved thus: "Dry. Sunned – gave no impression till breathed on." We shall find that humidity is a key factor in controlling the colour and contrast in the modernised form of the chrysotype process, and that it can also be induced to provide a "gold breath print".

A Mysterious Absence

Although Herschel worked extensively with the 'ammonio citrate' and 'ammonio tartrate of iron', there is an organic salt of iron – the oxalate – which is even more light-sensitive, but which is conspicuously absent from his records, despite its photosensitive properties being well-known since Döbereiner's experiment of 1831. It is possible that the substance was not so readily available to Herschel, but it is nevertheless very surprising that such an avid experimentalist should not have tested the properties of ferric oxalate, or ammonium ferric oxalate, of which he

54 The preparation of "Ferrotartaric acid" was described by Herschel in a letter to Talbot of 13 September 1844 (Database Document 05065. FTM Lacock 44-61): "P.S. To prepare Ferrotartaric acid precipitate Tartrate of Ammonia & Iron by lead and decompose the lead salt by weak sulphuric acid." Talbot's correspondence is online at: http://www.foxtalbot.arts.gla.ac.uk/letters/letters.html

must have been aware at the time. The author of the first manual on photographic processes, Robert Hunt (1807–1887), was well-acquainted with this photochemistry and was moved to comment tactfully in his 1844 edition on Herschel's omission:

"So extensive have been the researches of the distinguished philosopher, whose labours I have so frequently quoted, particularly into the action of the sun's rays on the salts of iron, that little can be added to his published information. It may not, however, be uninteresting to add a few brief remarks on some of the salts of iron, to which Sir John Herschel has not extended his observations, or at least which have not been recommended by him as photographic agents."[55]

Hunt offers no explanation for the lacuna in Herschel's research, but goes on to describe his own experiments with ferric oxalate, which was to prove a very popular photosensitive salt, destined to be used successfully by several photographic innovators in the years to come:[56]

"OXALATE OF IRON in solution, to which an excess of oxalic acid has been added, affords, after a few minutes' exposure, when washed with nitrate of silver, a very intense black picture, which slowly fades into a dingy grey. If the oxalate of iron and silver be combined in the paper, and exposed, so powerful a picture results, that it is difficult to tell the right from the wrong side, the impression penetrating quite through the paper."

Thus, in 1844, Hunt essentially invented the process that in 1889 was announced as Kallitype, and is generally attributed to Dr. W.W.J. Nicol.[57] In spite of Hunt's precedence, William Abney[58] credits John Draper as the first to make a print by means of ferric oxalate, in 1857,[59] although Thomas L. Phipson later claimed to be the first to use it for making photographs in 1860;[60] followed by Reynolds as mentioned below.[61] But Hermann Halleur describes the use of ammonium ferric oxalate as early as 1853,[62] and Charles Burnett and John Mercer were separately using it by 1858. The fact that photosensitivity in

55 Robert Hunt, *Researches on Light*, London: Longman, Brown, Green and Longmans 1844, 147.

56 Most importantly, it formed the basis for Willis's Platinotype (1873) and Nicol's Kallitype (1889) processes.

57 W.W.J. Nicol, British Patents nos. 5374, 7312 (1892). Dick Stevens, *Making Kallitypes: a definitive Guide*, Boston: Focal Press 1993.

58 J.M. Eder, *The Chemical Effect of the Spectrum*, Trans. Capt. W. de W. Abney, London: Harrison & Sons 1883, 35.

59 J.W. Draper is cited by Abney in ref 58, but no reference is given.

60 T.L. Phipson, *Photographic News*, 1862.

61 Reynolds, *British Journal of Photography*, 1861, 9.

62 G.C. Hermann Halleur, *The Art of Photography*, trans. G.L. Strauss, London: John Weale 1854, 56-7.

ferric oxalate was originally associated with the name of Döbereiner, however, may offer an explanation for Herschel's wilful omission of this salt from his investigations, for the reason I have described earlier in this chapter. Comparison with silver chloride revealed that the iron salt was more sensitive:

> "Reynolds compares the relative action of the solar spectrum on paper impregnated with ferric oxalate with that of silver chloride. He found that the action of light was nearly the same as that on silver chloride. According to my researches, ferric oxalate is relatively more sensitive to the green than silver chloride. A mixture of ferric chloride and oxalic acid, or of oxalates, behaves in the same way. It is also the same when double oxalates of iron (ferricum) and ammonium, sodium, or potassium are used. The presence of free hydrochloric acid does not hinder the reduction by light. According to my researches, such mixtures can scarcely be surpassed by any other in their sensibility to direct light. Reynolds and Phipson published, independently of each other, printing processes with oxalates of iron."[63]

63 J.M. Eder, op. cit., n. 58.

Herschel's Chrysotypes

The experimental prints in gold made by Herschel himself are almost the only historical specimens of Chrysotype to come down to us, and they are now distributed between the collections of the Museum of the History of Science, Oxford, England,[64] where there are a probable 13 specimens;[65] the Library of the Royal Society, London, which has four fine chrysotypes (plate 2),[66] and the Harry Ransom Humanities Research Center, University of Texas at Austin, where there are also four chrysotypes among the 43 mounted specimens that Herschel prepared for showing at the Royal Society in November of 1842 (plates 3–6).[67]

All the images that Herschel made in chrysotype were obtained by contact printing from published prints of fine steel engravings, which were supplied by Peter Stewart, a printer's compositor who worked for the publisher, Smith, Elder & Co., of London. Many of these engravings were

64 A.V. Simcock, Archivist, Museum of the History of Science, Oxford, private communication. Bruce Jenkyn-Jones, *Some Chemical Aspects of the Colours and Tones of Nineteenth Century Photographs*, Part II Thesis, Honour School of Natural Science in Chemistry, Oxford University, 1988.

65 R.S. Schultze, 'Rediscovery and Description of Original Material on the Photographic Researches of Sir John F.W. Herschel, 1839-1844', *Journal of Photographic Science*, 13 (1965) 57-68.

66 Herschel MS PT 26.11, Library of the Royal Society, London.

67 Photography Collection, Harry Ransom Humanities Research Center, University of Texas at Austin, Texas.

published in an annual Victorian gift book called *Friendship's Offering*.[68] The identification and sourcing of these pictures is described in detail in my monograph *Cyanotype*.[69] Most of the chrysotypes are negative images, made directly from the engravings,[70] and their subject matter, typically, includes portraiture of 'ladies of quality', romantic vignettes, tableaux vivants, or outdoor scenes of countryside, classical landscape, or ships at sea. Most of the original engravings actually used by Herschel as diaphanes are still in the collection of the Museum of the History of Science at Oxford, (one is in the NMPFT) some of them showing clear evidence of having been waxed, or otherwise rendered more translucent.

The total number of known chrysotypes by Herschel therefore appears to be 21. To this number should be added those specimens that he recorded as having been sent to other interested parties, 9 in all; the whereabouts of these remain presently unknown, if they have survived at all, but they are included in the list. There are also one or two experimental chrysotypes known to have been made by Hippolyte Bayard [71] and by Robert Hunt.[72]

Herschel's chrysotype process, although startlingly strong and beautiful, never took its promised place in the photographic repertoire. Far from rivalling the calotype in general practice, as Herschel had hoped, it was destined to be dismissed as impractical, unsatisfactory, and obsolete by all the major photographic authorities of the nineteenth century, as will be related in the next chapter.[73] Chrysotype was never carried into successful widespread practice, because it was eclipsed at an early stage by Talbot's less costly, and more tractable procedure based on silver, which proved to be the forerunner of all modern negative-positive photography. The consequences for photohistorians have been profound, owing to the deterioration of many silver images; as Schaaf has remarked:

68 *Friendship's Offering A Literary Album and Annual Remembrancer*, London: Smith, Elder and Co.

69 M. Ware, *Cyanotype*, op. cit., n. 31, p.74-81.

70 There is one positive chrysotype in the HRHRC collection, taken from a silver internegative, which is in the Oxford collection.

71 At the J. Paul Getty Museum, Los Angeles.

72 At the HRHRC and at the NMPFT.

73 See, for example: J.M. Eder, *Ausführliches Handbuch der Photographie*, Part 13, 'Die Lichtpausverfahren, die Platinotypie und verschiedene Copirverfahren ohne Silbersalze', Halle: Wilhelm Knapp 1899, 203-4; G. Pizzighelli, and Baron A. Hübl, *Platinotype*, J.F. Iselin, Trans., London: Harrison and Sons 1886, 35; Capt. W. de W. Abney and L. Clark, *Platinotype, its Preparation and Manipulation*, London: Sampson Low, Marston & Co. 1895, 156; Chapman Jones, *The Science and Practice of Photography*, London: Iliffe and Sons 1904.

74 Larry J. Schaaf, *Out of the Shadows*, New Haven & London: Yale University Press, 1992, 63.

"Had Herschel continued this swing towards the noble metals, it is likely that a much larger proportion of early photographic prints would have survived."[74]

75 Mike Ware, 'Prints of Gold: The Chrysotype Process Re-invented', *Scottish Photography Bulletin*, 1 (1991) 6-8; *idem*, 'Photographic Printing in Colloidal Gold', *Journal of Photographic Science*, 42:5 (1994) 157-161.

However, it is the underlying purpose of the present work to provide the vindication, 150 years later, of Herschel's visionary concept of printing in pure gold.[75]

Table 3.2 *List of chrysotypes by Sir John F.W. Herschel*

Engraving Title Engraver and Author of the original image	Publication Year Plate p	Annotation by JFWH on verso	Collection holding a chrysotype print	Description by JFWH in his "Lists of Specimens"	Comments on appearance and provenance
The Honourable Mrs. Leicester Stanhope Engraved by Charles Rolls; from the original portrait, painted by F. Stone	*Friendship's Offering* 1836 III 36	[?]	Harry Ransom Humanities Research Center University of Texas at Austin Sheet IV no 19	"Mrs. Stanhope - Chrysotype"	From Sheets of Photographic Specimens exhibited at Royal Society in Nov 1842
Rosolia Engraved by P. Lightfoot; from a painting by A. Penley	*Friendship's Offering* 1837 X 289	[...] "1842 Chrysotype"	HRHRC Sheet IV no 21	"Rosolia - Chrysotype"	Idem
A Scene in Italy Engraved by H. Cook; from a painting by J.W. Wright*	*Friendship's Offering* 1839 VIII 289	[...] "Herschel Photogr. 1842 Chrysotype"	HRHRC Sheet IV no 23	"Italian Landscape - Chrysotype"	Idem
Original unidentified Engraved by John Cochran c.1830	see Simcock	"724" [?]	HRHRC Sheet V 29	"Lute Playing Lady + Chrysotype"	Idem Dull purple white border. Positive image printed from internegative
Donna Elena Engraved by R. Staines; from a Painting by W. Penley*	*Friendship's Offering* 1837 III 28		Library of the Royal Society, London PT26.11	"Helena"	Submitted to RS with MS of JFWH paper, 14 June 1842
Portrait of Miss Louisa H. Sheridan Engraved by H. Cook; from the original painting by J. Wood	*Friendship's Offering* 1838 IV 73		RS PT26.11	"Miss Sheridan"	Idem
The Royal Prisoner Engraved by S. Bull; from a Painting by J. Nash*	*Friendship's Offering* 1839 IX 325		RS PT26.11	"Royal Prisoner"	Idem
Still in My Teens Engraved by H. Cook; from a Painting by H. Richter	*Friendship's Offering* 1838 VIII 217		RS PT 26.11	"In My Teens"	Idem

Table 3.2 (continued) *List of chrysotypes by Sir John F.W. Herschel*

Engraving Title Engraver and Author of the original image	Publication Year Plate p	Annotation by JFWH on verso	Collection holding a chrysotype print	Description by JFWH in his "Lists of Specimens"	Comments on appearance and provenance
Still in My Teens Engraved by H. Cook; from a Painting by H. Richter [3 copies]	Friendship's Offering 1838 VIII 217	"724" "Permitr. Iron - Ch Gold 716"	Museum of the History of Science, Oxford #17722, #30155, #22573	"In My Teens"	Herschel archive presented to the Museum by his daughters in 1928
The Countess Engraved by H.T.Ryall; from the Original Portrait, Painted by E.T.Parris* [2 Copies]	Friendship's Offering 1836 VII 181	"724"	MHS Oxford #21524, #22081	"The Countess"	Idem
The Royal Prisoner Engraved by S. Bull; from a Painting by J. Nash* [5 copies]	Friendship's Offering 1839 IX 325	"hydri" "724"	MHS Oxford #13201, #18946, #20979, #28753, #97670	"Royal Prisoner" or "Royal Captive"	Idem
Donna Elena Engraved by R. Staines; from a Painting by W. Penley*	Friendship's Offering 1837 III 28		MHS Oxford #20066	"Helena"	Idem Pale brownish purple probably a chrysotype
Original unidentified*	Source unknown	"774"	MHS Oxford #23662	[Mother and baby]	Idem
Original unidentified	Source unknown	"724 Dec 19 5m Good O greenish glass"	MHS Oxford #27213	"Letter of bad news" [?] "Reading the letter"	Idem
The Honourable Mrs. Leicester Stanhope Engraved by Charles Rolls; from the original portrait, painted by F. Stone	Friendship's Offering 1836 III 36		Whereabouts unknown	"Mrs Stanhope"	To Sir William Robert Grove 15 June 1842
Original unidentified	Source unknown		Whereabouts unknown	"Lady and Lute"	
Donna Elena Engraved by R. Staines; from a Painting by W. Penley*	Friendship's Offering 1837 III 28		Whereabouts unknown	"Helena"	To Mrs Julia M. Cameron 22 August 1842

Table 3.2 (continued) *List of chrysotypes by Sir John F.W. Herschel*

Engraving Title Engraver and Author of the original image	Publication Year Plate p	Annotation by JFWH on verso	Collection holding a chrysotype print	Description by JFWH in his "Lists of Specimens"	Comments on appearance and provenance
The Children of Lady Burghersh Engraved by S. Bull; from a Painting by Lady Burghersh	*Friendship's Offering* 1840 VII 252		Whereabouts unknown	"Burghersh family"	Idem
Rosolia Engraved by P. Lightfoot; from a painting by A. Penley†	*Friendship's Offering* 1837 X 289		Whereabouts unknown	"Rosolia"	To Robert Hunt 2 October 1842
A Scene in Italy Engraved by H. Cook; from a painting by J.W. Wright*	*Friendship's Offering* 1839 VIII 289		Whereabouts unknown	"Italian Landscape"	Idem
The Honourable Mrs. Leicester Stanhope Engraved by Charles Rolls; from the original portrait, painted by F. Stone	*Friendship's Offering* 1836 III 36		Whereabouts unknown	"Mrs Stanhope"	Idem
Original unidentified	Source unknown		Whereabouts unknown	"Letter of Bad News"	To J.F.Goddard 22 December 1842
Donna Elena Engraved by R. Staines; from a Painting by W. Penley*	*Friendship's Offering* 1837 III 28		Whereabouts unknown	"Helena"	Idem

Notes

(1) An asterisk * indicates that the actual engraving used by Herschel, usually rendered more translucent by waxing, is in the collection of the Museum of the History of Science, Oxford, UK.

†The engraving of "Rosolia" that Herschel used is in the collection of the NMPFT, Bradford.

(2) The reference is to the annual 'gift-book' *Friendship's Offering, A Literary Album and Annual Remembrancer*, published by Smith, Elder & Co., 65 Cornhill, London. The volume year, plate number, and facing page number are given for each engraving used.

(4) The annotations on the versos of the mounted prints at HRHRC have only been discerned imperfectly by examination under transmitted light; more information may be obtainable if the specimens can be released from their glue.

[?] indicates that the reading is uncertain;

[...] indicates that text is present but illegible.

The 3- and 4-digit serial numbers that crop up in the annotations refer to Herschel's "List of Prepared papers" which may be found at WO 268 in the Herschel Collection in the MS Archive, HRHRC.

(5) Herschel's titles come from his own experimental memoranda in the HRHRC.

4 The Photohistory of Gold

A word fitly spoken
is like apples of gold
in pictures of silver.

The Bible
Proverbs 25:11

Throughout the recorded history of photography, gold printing was several times re-invented – sometimes acknowledging Herschel, sometimes not – but it never yielded results that afforded any of its 'discoverers' much satisfaction, in the face of that ever-improving, and highly-developed competitor, silver photography. This chapter, and the one that follows on gold toning, relate the history, in approximate chronological order, of some other attempts to apply gold in photography. But first let us recall briefly the history of that competitor.

Henry Talbot's Silver Invention

William Henry Fox Talbot (1800–1877) invented the first process of camera photography in 1834, using sheets of paper impregnated with silver chloride.[1] His exposures at first were lengthy, taking an hour or so to produce a small negative, usually underexposed and bearing little more than a featureless outline of the subject against the sky. With some improvements to his "photogenic drawing paper", as he named it, Talbot was able to make camera negatives of brightly sunlit landscapes, still life, and architectural subjects, but not portraits or pictures of moving objects, because exposures still ran to many minutes.[2] It was probably this inadequacy that inhibited Talbot from announcing his achievement to the public for several years, until he was forced to do so by the revelation on 7 January 1839 that Louis Daguerre, in France, had also independently succeeded in making camera images. Talbot's results on paper were displayed at the Royal Institution on 25 January, 1839, but seemed unimpressive compared with the exquisite photographs recorded on silvered metal plates by the process of his French rival, whose invention had been made public two weeks earlier.

1 For an engrossing account of this discovery see Larry J. Schaaf, *Out of the Shadows: Herschel, Talbot & the Invention of Photography*, New Haven: Yale University Press 1992.

2 Mike Ware, "Luminescence and the Invention of Photography", *History of Photography*, 26:1 (Spring 2002) 4-15.

A year and a half later, however, on 20 September 1840, Talbot came upon the rare property, almost unique to silver iodide, that confers on this salt an astonishingly high sensitivity to light. Talbot discovered in it the capacity for rapidly recording and retaining an invisible latent image that could subsequently be developed by suitable chemical reducing agents to produce a visible image of silver. The effect of the light was thus amplified enormously, shortening his early camera exposures from an hour to a minute or less for the new process, which Talbot named "calotype". Photographic portraiture on paper finally became possible, and could compete with the miniatures on metal provided by the Daguerreotype. By the discovery of this development process on paper, Talbot set negative-positive silver photography on the road that leads directly to the camera films of the modern era, in which photoscience has improved and refined the sensitivity by a factor of about ten million times – to the point that we can now shorten our camera exposures to a hundredth of a second, or less. No viable *chemical* alternative to the gelatin-silver halide development emulsion has yet been found for capturing a negative image almost instantaneously in the camera.[3]

But when it comes to making positive photographic prints from those camera negatives, the circumstances are much less demanding. Speed is not a paramount consideration; printing exposures can be lengthy and light sources intense, so less sensitive materials may be adopted for making the print without serious disadvantage. Talbot was content to make his prints using his slow photogenic drawing paper, because he preferred its warmer colours to the neutral greys of the developed silver image. The more relaxed exposure requirements for photographic printing also bring into play as possible photochemical systems many other substances, which are much less responsive to light than developed silver halides. These processes, to be described in Chapter 6, constitute the practices of 'alternative' photographic printing.

3 The *physical* alternative for imaging - the charge coupled device used to create a scanned digital file - has only recently begun to compete with analogue photography, as will be discussed later.

Talbot and Gold

In the years immediately preceding the announcements, in January of 1839, of the polygenic invention of photography by Daguerre and by Talbot, the salts of gold had played a role as light-sensitive agents almost as significant as those of silver. In that uncertain dawn of photographic science, it was recognised that gold had potential as a substance well-suited for permanent images. Most of the pioneers of photography gave it some attention. For instance, Henry Talbot himself wrote a memorandum in his *Notebook P*, on 18 February 1839, to make a test of gold:

> "Try paper washed with oxalic acid, and then with chloride gold: or with sulph. iron & chl. gold."[4]

4 W.H.F.Talbot, *Notebook P*, Entry for 17 February 1839, National Museum of Photography, Film & Television, Bradford, England. See Larry J. Schaaf, *Records of the Dawn of Photography: Talbot's Notebooks P & Q*, Cambridge: Cambridge University Press, 1996.

But we can find no record that Talbot did actually follow up his own recommendation in this regard. Again later, on 15 April 1839, he noted the possible benefits of the inertness of the noble metal:

> "Metallic gold finely divided, as a black powder, not soluble in nitric acid (Brande *ibid.*) a photogenic picture made with gold might perhaps be easy to fix."[5]

5 Idem. The reference to Brande is a standard chemical text of the day.

There are several instances on record of attempts by other pioneers of photography to employ gold for photochemical imaging, so these early endeavours will now be related in their approximate chronological order.

Antoine Florence in Brazil 1833

One of the more obscure early claimants for the title of "independent inventor of photography" is the Frenchman, Antoine Hércules Romuald Florence (1804–79), who spent most of his working life in Brazil, where he experimented in isolation from the mainstream of Western science. What we know of his work is owed entirely to the researches of Professor Boris Kossoy,[6] who has studied Florence's original manuscript journals which record his discoveries, and are still in the hands of Florence's descendents. Since 1972, Kossoy has championed Florence's right to be

6 Boris Kossoy, 'Photography in 19th Century Latin-America: the European Experience and the Exotic Experience', in Wendy Watriss and Lois Parkinson (Eds.), *Image and Memory: Photography from Latin America 1866-1994*, Austin: University of Texas Press in association with Fotofest Inc., 1998, 23-51.

counted among the pioneers of photography, the claim
being based solely on the evidence of Florence's datings of
his unpublished writings; regrettably, there appear to be no
surviving camera photographs, although Kossoy has found
silver photographic reproductions, made by contact, of
pharmacy labels and diplomas. It is unfortunate that
Florence did not publish his claims until October 1839,
some months after the announcements by Talbot and
Daguerre. Kossoy also cites evidence claiming that
Florence was the first to coin the word *photographie* in
1832, when he conceived the idea of printing by light.
Although Florence's initial experiments in 1832 used silver
salts, the matter of interest to the present work is that, in the
following year, apparently, he also tried gold. Kossoy
describes this procedure, in which delicate contact prints
were achieved by means quite indelicate, as follows:

> "On April 8, 1833, in Manuscript I, on p. 141 and under the
> heading of "Interesting Findings", Florence describes the use
> of nitro-hydrochloride of gold. Then explaining that by
> combining nitric acid with muriatic acid in equal proportions
> and pouring a small quantity of gold powder over the mixture,
> by wetting one side of the paper with the resulting solution
> (in this case he used a sheet of stationery), a sensitive emulsion
> would have been formed. Next, if this paper were placed in
> sunlight, taking care to cover part of it with an opaque object,
> the surface reached by the light would darken. Then, wetting
> the paper in urine for fifteen minutes and drying the excess
> with a cloth, putting it back in the sunlight for a few hours, he
> obtained a result that he considered to be very satisfactory:
> the white part that had been protected by the opaque object
> never altered.
>
> The combination of gold chloride and urine (p.48 of *L'Ami des
> Arts*...) seemed to him to be the most satisfactory because of
> the quality of the "printing" obtained: "I printed by means of
> photography, drawings as clear, as delicate as the finest
> engraving." Florence captured the images by the effect of
> light alone on the light sensitive surfaces (no chemical
> development) in a way similar to printout papers." [7]

7 Boris Kossoy, 'Hercules Florence,
Pioneer Photography in Brazil',
Image, 20:1 (March 1977) 12-21;
idem, 'Hercules Florence', *Camera
(Lucerne)*, 57:10 (October 1978) 39-42.

In a footnote, Kossoy adds: "According to Florence the tones were very black with a touch of blue.... The use of gold chloride as a light sensitive material was confirmed by experiments at Rochester Institute of Technology." He does not say if the RIT also found the urine to be an essential component in the photochemistry.

William O'Shaughnessy in India 1839

Sir William Brooke O'Shaughnessy (1809–1889) was a distinguished Victorian who devoted most of his career to service in India. For the following biographical information I am indebted to John Falconer, who has made a particular study of early photographers in India.[8]

8 John Falconer, curator of photographs, Oriental and India Office Collections of the British Library, unpublished MS.

O'Shaughnessy qualified as an M.D. in Edinburgh in 1829. Like many medical students of his time, he had received a good grounding in chemistry, and he went to London to specialise in forensic work. He first came to professional notice in 1831 with a crusading article in *The Lancet* entitled "Poisonous Confectionery", in which he denounced the widespread use of toxic artificial colorants, such as lead chromate, to adulterate sweetmeats. However, O'Shaughnessy did not find the London medical fraternity particularly congenial, so in 1833 he took up an appointment with the East India Company as Assistant Surgeon in the Bengal Medical Service; he was promoted to Surgeon in 1848, and Surgeon-Major in 1859. After conducting toxicological research at the Medical College in Calcutta, he eventually relinquished medical practice to become Director-General of the Indian Electric Telegraph Service from 1852 to 1861; in this post he contributed new designs for electric telegraph instruments, and during 1853–56 he supervised the laying of a line to connect the major cities of the sub-continent. He was elected FRS in 1843, and knighted in 1856, returning to England in 1861. Between 1837 and 1853, he authored several handbooks on chemistry, electricity, and pharmacology. His scientific interests also naturally drew him to the new practice of photography, with the consequence that on 2 October 1839

he described the results of his experiments to a meeting of the Asiatic Society of Bengal: "Dr. O'Shaughnessy exhibited several photogenic drawings prepared by himself, and in which a solution of gold was the agent employed."[9]

His gold version of Talbot's process of photogenic drawing was reported more fully in *The Calcutta Courier* of 3 October 1839:

> "Dr. O'Shaughnessy next called the attention of the meeting to a series of experiments he had lately made on the art which was exciting so much attention at home – namely Photogenic Drawing – and his experiments were all successful. To prepare the photogenic paper at home, a solution of silver had been used, but he had made it from a preparation of gold, which though the dearest of metals, in this preparation was cheaper than that of silver. He had succeeded in obtaining, besides all other colours, that of a green from a mixture of purple and yellow, which had not been obtained at home by the preparation from silver; he had also discovered another advantage of this method over that adopted in Europe, which all the experimenters there had been unsuccessful in obtaining, namely, that by merely washing the drawing on the photogenic paper with a little water, the picture would become fixed, and be preserved for any length of time without the colours being affected by light. In taking off a picture, which occupied eight seconds only, he had found the gold preparation not so sensible as the silver."[10]

A brief report of the same meeting also appeared in *The Englishman and Military Chronicle*, and was later reprinted in the *Asiatic Journal* and the *Literary Gazette*:

> "Dr. O'Shaughnessy obliged the meeting with some details, accompanied by specimens, of a new kind of Photographic Drawing, by means of the sun's light – of which the principle wholly differs from that of Europe, – we mean from that used in England, where Nitrate of Silver is the colouring agent. Professor O'Shaughnessy uses, it seems, a solution of gold, and produces many various tints from a light rose colour, through purple down to a deep black, and, what is more extraordinary, a green! He also uses a lens, which expedites

9 *Journal of the Asiatic Society of Bengal*, 92 (August 1839) 691.

10 *Calcutta Courier* (3 October 1839).

11 *The Englishman and Military Chronicle* (4 October 1839); *The Asiatic Journal*, 31 part ii, (new series) (January-April 1840) 14-15. Reprinted in *The Literary Gazette* 1198 (4 January 1840) 12-13. O' Shaughnessy's gold process was also reported to the *Académie des Sciences* in Paris by M. Biot, where it "excited a good deal of attention", *The Literary Gazette* (22 January 1840) 123.

the process, and gives different shades. We hope this interesting discovery will be followed up, for it promises much and we have here such sun and light that our means in this respect are far above those of Europe." [11]

It is most probable that O'Shaughnessy, like all the other early experimenters, used as his sensitiser a dilute solution of 'chloride of gold', which is highly soluble and could be washed out after exposure, hence the remarkable ease of fixing the images. Colloidal gold also has a very high covering power – a little goes much further than silver – which may account for his comment on the relative cost. Gold chloride, like silver nitrate, is not light-sensitive in isolation; to become so, it requires the presence of an oxidisable substance: either the paper itself or, more likely, its sizing agent, which was probably gelatine if the paper were English.[12] So the results from this kind of photographic material are uncertain and highly dependent on the composition of the paper, as the range of colours obtained would seem to demonstrate. The brevity of the exposure is remarkable: partly attributable to the intensity of the Indian sun, it may also be connected with the mention of a lens; it seems unlikely that this was employed in a camera obscura, but rather used to concentrate the rays of the sun in a contact-printing process. His expression "in taking off a picture" and reference to photographic drawing suggests contact printing rather than camera photography.

12 Gelatin would also have helped stabilise the gold image.

However, O'Shaughnessy did also make very effective use of the camera: by early 1840, he had mastered the daguerreotype process. The *Calcutta Courier* published what is probably the first definite record of daguerreotype images taken in India, which are minutely and admiringly described,[13] and were first shown by O'Shaughnessy to the meeting of the Asiatic Society of Bengal on 4 March 1840.

13 *Calcutta Courier* (5 March 1840).

Robert Hunt's Gold Processes 1841–54

In his first book, *A Popular Treatise on the Art of Photography*, which in 1841 was also the first published manual on photography, Robert Hunt noted some early experiments:

"On the Use of the Salts of Gold as Photographic Agents.

It is well known that gold is revived from its etherous solution by the action of light,[14] and that the same effect takes place when the nitro-muriate of gold is spread on charcoal. Considering it probable that the required unstable equilibrium might be induced in some of the salts of gold, I was induced to pursue a great many experiments on this point. In some cases, where the paper was impregnated with a mordant salt, the salt of gold was darkened rapidly, without the assistance of light; in others, the effect of light was very slow and uncertain. By washing paper with muriate of barytes, and then with a solution of the chloride of gold, a paper, having a slight pinky tint, is procured; by exposing this paper to sunshine it is at first whitened, and then, but very slowly, a darkening action is induced. If, however, we remove the paper from the light, after an exposure of a few minutes, when a very faint impression, and oftentimes not any, is apparent, and hold it in the steam of boiling water, or immerse it in cold water, all the parts which were exposed to the light are rapidly darkened to a full purple brown, leaving the covered portions on which the light has not acted, a pure white, producing thus a fine negative drawing. If, while such a paper, or any other paper prepared with the chloride of gold, is exposed to the sun, we wash it with a weak solution of the hydriodate of potash,[15] the oxidation is very rapidly brought on, and the darkness produced is much greater than by the other method; but this plan is not often applicable. I have not yet been enabled to produce with the salts of gold, any paper which should be sufficiently sensitive for use in the camera obscura." [16]

14 Hydrogen tetrachloroaurate (acid 'gold chloride') is soluble in diethyl ether.

15 Potassium iodide.

16 Robert Hunt, *A Popular Treatise on the Art of Photography*, Glasgow: Richard Griffin and Co., 1841.

17 Robert Hunt, *Researches on Light*, 1st Edn., London: Longman, Brown and Green, 1844.

18 Formula: $K[Au(CN)_2]$

19 Much beloved of the alchemists.

Following Herschel's great innovation of 1842, described in the previous chapter, Hunt extended his account of gold printing in his next publication of 1844, *Researches on Light*.[17] The compound he employed was the "protocyanide of potassium and gold", which today we would call potassium dicyanoaurate(I).[18] This substance was prepared at the time by a rather daunting method due to Karl Himly, in which fulminating gold, a dangerously sensitive explosive,[19] was reacted with potassium cyanide, whose toxicity is notorious. This preparation offers a challenging combination of hazards, not recommended for the amateur chemist today! When mixed with silver nitrate the sensitiser was said to blacken rapidly in the light. The problem with interpreting this observation by Hunt is that we have no means of knowing the extent to which the blackening is owed to gold or to silver. The relative proportions of these two metals in the image were not reported, so it cannot be considered a true gold print. The image, according to Hunt, could be fixed in sodium chloride then weak sodium thiosulphate. In the second edition (1854) of his *Researches on Light* Robert Hunt also commented on his experiences with Herschel's oxalate/gold sensitiser described above, as follows:

> "I have found it exceedingly difficult to arrive at the best proportions: generally speaking 30 gr. of the oxolate [*sic*] of ammonia and a saturated solution of the chloride of gold, has been the most successful in practice. These papers must be dried in the dark without heat. After the picture has been obtained, I have succeeded in fixing it, by soaking it in cold water, and then washing it over with the ferrocyanate of potash."[20]

20 Robert Hunt, *Researches on Light*, 2nd Edn., London: Longman, Brown and Green, 1854, 138-9, 117-125.

21 Robert Hunt, *A Manual of Photography*, 4th Edn., *Encyclopaedia Metropolitana* 2nd Edn., London: Richard Griffin and Company, 1854

In his 1854 revision of *A Manual of Photography*[21] Hunt re-printed verbatim the passage from his *Treatise* of 1841, and supplemented it with the quotation from Herschel given above. In the *Manual*, however, Hunt added a footnote in press, to describe a gold version of his "chromatype" process, using sodium chloroaurate (neutralised "gold chloride") and potassium dichromate:

"If a neutral solution of the chloride of gold is mixed with an equal quantity of the solution of bichromate of potash, paper washed with this solution, and exposed to light, speedily changes, first to a deep brown, and ultimately to a bluish black. If an engraving is superposed, we have a negative copy, blue or brown, upon a yellow ground. If this photograph is placed in clean water, and allowed to remain in it for some hours, very singular changes take place. The yellow salt is all dissolved out, and those parts of the paper left beautifully white. All the dark portions become more decided in their character, and according as the solarisation has been prolonged or otherwise, or the light has been more or less intensive, we have either crimson, blue, brown, or deep black negative pictures."[22]

22 Hunt, ibid., 163-4.

There is a very striking specimen of this process by Hunt in the Photography Collection of the Harry Ransom Humanities Research Center: the image is deep indigo blue on a near black background; it shows two positive prints that have been made from calotype negatives of statuary. The print has subsequently been mounted and captioned "Chromate of Gold" by John Spiller. Following Hunt's death in 1887, Mrs. Hunt gave to Spiller on 26 September 1888 an entire set of her husband's experimental prints, which Spiller curated for subsequent exhibition.[23] In the collection of the NMPFT there is a less successful Hunt specimen by the same process: the image, which is negative, made by contact from a steel engraving positive, is pale purplish brown; but on the verso the print carries the annotation in Hunt's hand: "Gold & bichrom Pot. Rob Hunt Feby 20/44".

23 *The Photographic Journal*, (26 April 1889) 87; *Photographic News*, (1889) 411; *Year Book of Photography*, (1890) 193.

A photochemical interpretation of Hunt's "gold chromatype" process has never, as far as I know, been offered, and its possible mechanism is not obvious: presumably, the photoproduct of the reduction of dichromate on paper must be capable in turn of reducing the gold salt to metal. Now, the usual end-product of the reduction of chromium(VI) is a compound of chromium (III), which would not seem to be capable of reducing gold, so it is possible that a reactive intermediate of chromium(V) or chromium(IV) may be the cause. A modern re-investigation of this process is clearly called for.

Thomas Hennah's 'Gold Prints' 1852

The first dedicated exhibition of photographs in Britain was held under the aegis of the Society of Arts, at Adelphi, in 1852. It provided the stimulus which led to the establishment in the following year of the Photographic Society of London (eventually to become the Royal Photographic Society). Item number 236 in this show, "Six Specimens of tones of Printing" was exhibited by Thomas H. Hennah, though the work actually belonged by then to P. H. Delamotte and not to Hennah. The critics preferred to discuss the aesthetic merits of the pictures and not the tones of the prints, so there is not a single reference to Hennah's works in any of the many contemporary reviews of this exhibition – but his images must have made an enduring impression because his "gold prints" were still being referred to as late as 1883 in an article by John Spiller "On the gold printing process".[24]

Thomas Henry Hennah was a photographer from Brighton, who by 1860 had formed a partnership with a Mr. Kent to operate a portrait studio. He appears to have joined the Photographic Society from its foundation (1853) because he is listed in the 1854 membership pamphlet.[25] Possibly because he felt that it had value for his commercial enterprise, Hennah did not disclose his "gold printing" method until twelve years later in 1864, when he finally consented to publish the details to the Photographic Society.[26] The recipe turned out simply to include gold chloride in the salting bath of an ammonio-silver nitrate paper, so was not a pure gold printing process at all, but a "self-toning" silver process (see Chapter 5), in which the relative proportions of gold and silver in the final image are indeterminate, but are likely to consist largely of the latter. A similar procedure had been earlier recommended by the Edinburgh photographer, Thomas Rodger, a one-time pupil of the Scottish pioneer of photography, Dr. John Adamson.

24 *The Year Book of Photography and Pictorial News Almanac* (1883) 63-4.

25 I am indebted to Roger Taylor for this information on Hennah.

26 *The Photographic Journal,* (9 May 1864) 36.

John Mercer's 'Chromatic Photographs' 1854–8

John Mercer (1791–1866) was a self-taught colour chemist and calico-printer of Manchester, and is remembered today for inventing in 1850 the process to which his name has been attached: mercerisation, that is, the strengthening and shrinking of cotton fabric by treatment with caustic alkali. He was also one of the first experimental photochemists, and in a previous book I have noted that he has the distinction of being the earliest observer (in 1828) of the formation of Prussian blue by light.[27] Mercer's business commitments allowed him little time to progress his photographic experiments until 1854, when he began to produce striking, richly-coloured prints, both on paper, and on cotton fabrics especially, which were exhibited at the annual meeting of the British Association for the Advancement of Science, in Leeds in 1858.[28] The short note in the BAAS *Transactions* outlining Mercer's address to the meeting seems to be the entire extent of his publication, but fortunately Parnell's biography of Mercer contains details of his work and formulae,[29] taken from Mercer's own notebooks and memoranda.[30]

Out of a whole range of chemically-inventive processes, Mercer's most remarkable achievement, which is germane to the present study, was to transform a cyanotype image into purple of Cassius: the Prussian blue was first converted into silver ferrocyanide by treatment with silver nitrate, after which it was reduced to silver metal by sodium stannite.[31] Finally, by treating this in a bath of gold chloride, it was substantially converted into colloidal gold in the form of purple of Cassius, due to the presence of the tin salt. Examples of portraits made by this process on cloth, may be seen in fine condition, in the Mercer Archive at Lancashire County Record Office.[32] One bears the inscription in Mercer's hand: "Purple of Cassius".

27 Mike Ware, *Cyanotype: the history, science, and art of photographic printing in Prussian blue*, London: Science Museum and National Museum of Photography, Film & Television, 1999, 23, 56-7.

28 John Mercer, "On Chromatic Photographs", *Report of the Meeting of the British Association for the Advancement of Science*, Transactions of the Sections, (Leeds: 1858) 57.

29 E.A. Parnell, *The Life and Labours of John Mercer*, London: Longmans, Green & Co., 1886, 220-230, 328-337.

30 I acknowledge the late Harry Milligan FRPS, former Curator of Photographs at the Greater Manchester Museum of Science and Industry, for first drawing my attention in 1984 to the unpublished photographic endeavours of John Mercer.

31 Sodium stannite is a salt of tin(II): $Na_2[SnO_2]$.

32 'Box of Experiments in Chromatic Photography by John Mercer', UDCL-8/19, Lancashire County Record Office, Bow Lane, Preston.

Charles Burnett's Uranium Processes 1855–7

Charles John Burnett (1820–1907) of Edinburgh was a prolific photochemical experimenter, and a frequent correspondent to the photographic periodicals of the day. He was a founder-member in 1856 of the short-lived Photographic Society of Scotland, which was subsequently displaced by the more dynamic Edinburgh Photographic Society, formally established in 1861.[33]

Among Burnett's several justifiable claims as an innovator, were the first photographic prints employing uranium salts, whose light-sensitivity had originally been observed in 1804 by Adolph Gehlen (1775–1815). Burnett first described his various "photographic researches" in a paper read to the 1855 annual meeting of the British Association for the Advancement of Science, held in Glasgow, and he illustrated his processes with a number of prints shown in the accompanying exhibition. The catalogue explicitly summarises his sensitiser recipes,[34] from which we can now infer that his images must have been constituted of silver, or of uranyl ferrocyanide,[35] depending on his chosen method of development. None of the prints shown at this time involved the use of gold, and he had three more "uranium" prints hung at the exhibition of the Edinburgh Photographic Society in 1856.[36] In early 1857 Burnett published some further developments of his uranium processes.[37] As with iron-based printing, to which it is closely analogous,[38] the uranium sensitiser could be used with several image-making substances, including gold. Burnett was particularly impressed with the quality of the images he obtained by this means, and appreciated their benefits in these terms:

> "I have succeeded in getting very beautiful impressions by development of the Uranic papers, by Chloride of Gold alone. There can be little or no doubt of the permanence of such photographs, and I cannot help thinking that this, and the Ainslee development, of the paper prepared by the sesqui-salts of iron, as described by Sir John Herschel, under the name of Chrysotype, are deserving of trial as practical printing processes."[39]

33 The Photographic Society of Scotland was not finally wound up until 1871.

34 Catalogue of the Exhibition staged for the British Association Meeting, Glasgow, 1855. The formulae are also recorded in a letter dated 1 September 1855 from Burnett to William Church of the Glasgow Photographic Association. I am indebted to Sara Stevenson for a copy of this document.

35 $(UO_2)_2[Fe(CN)_6]$, a stable, dark reddish-brown insoluble pigment.

36 Roger Taylor, *Photographs Exhibited in Britain 1839-1865: A Compendium of Photographers and Their Works*, Ottawa: National Gallery of Canada 2002.

37 C.J. Burnett, 'On the application of Uranium and other matters to Photography', *Photographic Notes*, 2:23 (15 March 1857) 97-101, (15 April 1857) 160-4; (15 May 1857) 181-4.

38 In iron printing the photoreduction is from Fe(III) to Fe(II); in uranium printing the reaction is from U(VI) to U(IV). Both products are capable of reducing noble metals and of forming coloured ferrocyanides.

39 C.J. Burnett, *Photographic Notes*, 2:27 (15 May 1857).

This notion met with the approval of Thomas Sutton, the editor of *Photographic Notes*, who deemed it "…worthy of further investigation … because it appears to offer the promise of a high degree of permanence in the proof."[40] However, it was Burnett's misfortune not to be blessed with the kind of temperament which allowed him to settle on one process, and perfect it for producing a significant body of work; the consequence was that no specimens of his printing are now known. As he himself admitted:

40 Editorial, *Photographic Notes*, 2:27 (15 May 1857) 175.

"The fact is, I cannot well find time for the prosecution of discovery, and for pretty specimen making, and as soon as I see unmistakable indications of what are the real capabilities of any process, I am generally off to something else."[41]

41 C.J. Burnett, *Photographic Notes*, 2 (1857) 345-6.

True to his word, he abandoned the promising uranium-gold print in favour of dabbling with at least a dozen other different processes,[42] but he was soon given cause to regret his lack of single-mindedness. One year later, in March 1858, Abel Niépce de Saint-Victor (1805–1870), a cousin of the photographic pioneer, Nicéphore Niépce, presented to the *Académie des Sciences* details of uranium salt printing processes, which he rather curiously claimed as a "new action of light", but which proved to be identical to Burnett's.[43] The English report of Niépce's claims in *Photographic Notes* contains many critical interpolations by the editor, Thomas Sutton (1819–1875), who ends by pointing out that: "… this supposed new process of M. St. Victor's was published a year ago in this Journal and no credit is therefore due to that gentleman."[44] In spite of Burnett's clear priority, Niépce de Saint-Victor also sought a British patent through intermediaries, and received much acclaim, not only within French photographic circles, which was to be expected,[45] but more surprisingly from some notable figures of the British photographic establishment, such as James Glaisher. Understandably, the affronted Burnett was thrown into a state of indignant outrage, and sought to re-assert rights to his own published invention with accusations of: "… most monstrous and systematic plagiarism."[46] Glaisher, in his own defence, could only plead ignorance of Burnett's work.[47] The correspondence in the

42 C.J. Burnett, 'On the production of direct positives - on printing by the salts of the uranic and ferric oxides, with observations climetic and chemical', *The Liverpool and Manchester Photographic Journal*, (April 1859) 99-101, (1 May 1859) 111-112, (15 May 1859) 127-129, (15 June 1859) 155-157.

43 Abel Niépce de Saint-Victor, *Comptes Rendues*, 46 (1858) 448-9; 47 (1858) 860, 1002; 48 (1859) 470; 49 (1859) 815.

44 Abel Niépce de Saint-Victor, 'On a New Action of Light', *Photographic Notes*, 3 (1858) 85-8.

45 It is frequently observed that when spurious claims are asserted with sufficiently brazen effrontery, the claimant invariably does succeed in acquiring some credit from supporters who are less than impartial. However, even the French turned rather critical of Niepce's process, see: 'The Photographic Value of the Uranium Printing Process', *The Photographic News*, (24 September 1858) 27-9.

46 C.J. Burnett, 'Salts of Uranium &', *The Photographic Journal (Liverpool)*, (15 July 1859) 181; (15 October 1859) 55-6; (16 January 1860) 134-5.

47 James Glaisher, 'M. Niépce''s Uranium Process and Mr. Burnett', *The Photographic Journal*, (16 August 1859) 15; (15 November 1859) 83-4.

48 Thomas Sutton and George Dawson, Eds., *A Dictionary of Photography*, London: Sampson Low, Son & Marston 1867, 363; W.K. Burton, *Practical Guide to Photographic & Photo-Mechanical Printing*, London: Marion and Co., 1892, 169-171; T. Sutton, 'On M. Niépce de St. Victor's Experiments on the action of Light', *The Photographic and Fine Art Journal*, 11:7 (1858) 172.

British photographic periodicals of the time turned distinctly acrimonious, and now provides quite an entertaining parable to illustrate the futility of trying to assert one's priorities in the face of "the furacious attempts of the prowling plagiary" as Elizabeth Fulhame had earlier described them (Chapter 2). Subsequently, several treatises and manuals have featured the uranium-gold printing process, usually with a clear acknowledgement of Burnett as its originator, so history has finally made a correct judgement on this issue.[48]

I have tested Burnett's uranium-gold process, using a number of different uranium(VI) salts mixed with sodium chloroaurate, and have found uranyl acetate to be the best. The sensitiser is stable, unlike the simple chrysotype sensitiser using iron, and yields maroon-coloured prints of good tonal gradation and quality, but requires rather long exposure times, of an hour or so. The final gold print, if properly processed, contains no uranium at all, so is not itself radioactive. However, the toxicity and radioactivity (albeit relatively low-level) of all uranium compounds, and the current legislation concerning their release into the environment, now seriously inhibit their use outside of institutions with special facilities for handling and disposal; I have therefore not pursued this otherwise promising process any further as a practical option for gold-printing.

John Muir Wood's 'Uranium Prints' *ca.* 1857

The accomplished amateur photographer, John Muir Wood (1805–1892), was a contemporary, fellow-Scot, and probable colleague of Charles Burnett. The range and strength of Muir Wood's images, and their rightful place in the traditions of Scottish photography, have only recently been brought to light in a public exhibition, curated by Sara Stevenson, Julie Lawson and Michael Gray, following the donation of Muir Wood's entire *oeuvre*, by his descendents, to the Scottish National Photography Collection. The elegant Catalogue (1988) is a valuable source of information, and includes illustrations of four remarkable

prints, made *ca.*1857 by Muir Wood from calotype negatives.[49] These images display an extraordinary colour, much more characteristic of gold than of silver, described as "a purple inky tint". There is evidence in the rather cryptic annotations on some of Muir Wood's other prints that he used gold toning and possibly experimented with uranium salts. The authors reasonably infer that Muir Wood must have been aware of Burnett's innovations with process, and may have tried a uranium-based gold printing method to achieve this extraordinary chromatic intensity. This conjecture was tested in 2002 by non-destructive analytical studies at the Museums of Scotland by Katherine Eremin and her co-workers using X-ray fluorescence spectrometry, which revealed that the image substance of this print contains gold – but also significant amounts of silver (see Chapter 7 for details of this research).[50] Regrettably, therefore, these unique photographs canot be claimed to be pure chrysotypes.

49 Sara Stevenson, Julie Lawson and Michael Gray, *The Photography of John Muir Wood, Scottish National Portrait Gallery*, London: Dirk Nishen Publishing, 1988.

50 Dr. Katherine Eremin, National Museums of Scotland, private communication.

John Draper's Gold Actinometry 1859

John William Draper (1811–1882) was born in Britain, but in 1831 he emigrated to the USA where he achieved distinction as a man of science and early daguerreotypist, a colleague of the famous inventor, Samuel Morse. Draper's name is attached to the First Law of Photochemistry; he is credited with taking the oldest surviving photographic portrait in June 1840, and with being the first to make astronomical photographs. In 1839 he was appointed professor of analytical chemistry in the University of New York. In 1857 he pointed out the usefulness of ferric oxalate as a means for measuring the quantity of daily light.[51] His method involved the precipitation of gold by the same reaction as in the chrysotype process, except that the metal was filtered off, purified by strong heat, and weighed.[52] The weight of gold provided a comparative measure of the total dose of actinic light received during the period of exposure, and the technique stands as an early example of the use of a chemical actinometer for making photometric measurements.

51 John William Draper, *Philosophical Magazine* (1857).

52 John C.[*sic*] Draper, 'Determination of the Diurnal Amount of Light by the Precipitation of Gold', *Photographic Notes*, (1 August 1859) 192.

Duc de Luynes' Experiments 1859

Honoré d'Albert, 8th Duc de Luynes (1802–1867), was an archaeologist and noted patron of photography, chiefly remembered for his instituting in 1856 an award of medals and a monetary prize for new inventions in photomechanical printing and permanence in photographic processes. In 1860 the Duke addressed the *Société Française de Photographie*,[53] describing experiments on gold printing that he had carried out as a consequence of Alphonse Poitevin's tests on mixed iron-uranium sensitisers described the previous year.[54]

One of the three methods is interesting in representing yet another re-discovery of Burnett's uranium-gold printing. Translated into modern chemical terms, the Duke's experiments were as follows:

1) Paper was coated by flotation on a equal mixture of iron(III) chloride and gold(III) chloride solutions (both of strength *ca.* 10%).[55] After drying it was exposed to sunlight through a negative for about an hour. A brown image resulted, which was first washed in water acidified with a little dilute hydrochloric acid, then finally in water.

2) Paper was coated with a mixture of platinum(IV) chloride (*ca.* 10%) and iron(III) chloride (*ca.* 9%). The exposure in this case was for 2–3 hours. The print-out image appeared white on a yellow background and was developed by floating on a gold chloride bath (5–6%) to yield a vigorous grey/black image. Washing was in acidifed water, as before.

3) Paper was floated on one side on a bath consisting of equal volumes of solutions of uranium(VI) nitrate (33% w/w) and gold chloride (*ca.* 10%). After drying in the dark it was exposed for 1.5 hours. The print-out image appeared brown on yellow, and turned sepia when the print was washed in acidified water.

The Duke observed that the images so obtained penetrated the paper, and only appeared beautiful by transmitted light or by the application of varnish.

He also noted that the use of gelatinised paper gave rose-coloured half-tones – an early observation of the significant effect that the sizing agent can have on the "protection" of the gold colloid.

53 Duc de Luynes, 'Gold Printing Process', *Photographic News*, 3 (3 February 1860) 258.

54 Poitevin won the Duke's prize, which was finally awarded in 1867, for his pigment printing and collotype processes.

55 The Duke's solution strengths were expressed as *degrees of the acid hydrometer*. This probably refers to the Baumé scale, in which the number of degrees is the concentration, expressed as %*w/w*, of a solution of sodium chloride having the same relative density (specific gravity).

Chapman Jones's Experiments 1885

In a paper to the Royal Photographic Society in 1911,[56] Chapman Jones described experiments that he had performed in 1885:

> "I show a gold print made by coating one surface of the paper with ordinary gold chloride solution, drying it, and exposing it under a negative for one hour in the shade. No effect was visible, but after remaining apart from the negative for nine days in the dark the detail began to show, and after remaining for four months in the dark the image had good density. This was in the middle of the year 1885, and now after twenty-six years the image is still visible, though the surface of the paper is covered all over with a good deposit of gold. The gold is mostly purple, though reddish in parts, while gold itself is yellow. In another example the gold has been reduced by ferrous oxalate after the manner of preparing a platinum print.... "[57]

From this he obtained red or blue images, depending on the conditions. Apart from showing these specimens, his paper of 1911 is not concerned with image-making, but goes on to discuss at length his experimental method for investigating the colours of metal colloids suspended in gelatin layers. The work is further elaborated in another paper the following year.[58] It is surprising to read his conclusions concerning the relationship between particle size and wavelength of scattering, which are quite erroneous, yet were arrived at several years *after* the correct mathematical analysis of this problem had been published (admittedly in the German scientific literature) by Gustav Mie.[59]

Alfred Jarman's 'Aurotype' 1897

In 1911, a short article in the American Amateur Photographer by Alfred J. Jarman described experiments in gold printing he had made 14 years previously.[60] The writer acknowledged Herschel's chrysotype as the basis for his method, but preferred to substitute the recently-discovered green form of ammonium ferric citrate for the brown form,

56 Chapman Jones, "On the relationship between the size of the particle and the colour of the image", *Photographic Journal*, 51 (April 1911) 159-174.

57 Chapman Jones, *Photographic Journal*, 57 (1917) 158.

58 Chapman Jones, "Some effects of the scattering of light by small particles", *Photographic Journal*, (December 1912) 349-356.

59 Gustav Mie, *Annalen der Physik*, 25 (1908) 377.

60 A.J. Jarman, 'Aurotype', *American Amateur Photographer*, 5:12 (1911) 722-3.

which had been the only one available to Herschel. A 14% solution of the iron salt was used, mixed in a volume ratio of 3:1 with a 1.8 % solution of gold chloride. After coating, drying, and exposing in the usual way, "just the same as for platinum paper", the print was developed in a hot solution of potassium oxalate (*ca.* 6%): "The image developed instantly, presenting two colors, a brilliant red merging into blue, quite unsatisfactory as a picture". A cold solution of Rochelle salt (12%) was no better as a developer, "the image being very hard and contrasty." All the prints were cleared of excess iron salt in three baths of dilute hydrochloric acid. Jarman also tried printing on the iron salt alone, then developing in a gold chloride solution (*ca.* 1%), obtaining fairly uniform blue images, "but in no instance did the result equal platinum." After 14 years, one of his prints, he stated, "has not altered in the least."

Gold Photography Discounted

The various attempts at gold printing outlined above appeared sporadically in the photographic literature, and were all deemed by their authors to be in some degree unsatisfactory, suffering either from unacceptable levels of instability, contrast, or what were then considered to be 'unnatural' colours. The chemical difficulties of gold printing were widely acknowledged by the leading photoscientists of the day, and these difficulties together with the expense of the endeavour led them unanimously to discount the chrysotype process in their published works. For instance, the *Liverpool Photographic Journal* in a "Glossary of Terms" published in 1854, had the following (rather inaccurate) observations:

> "Chrysotype. A camera process, by Sir John Herschel, in which salts of iron and gold are employed. The results of this process are very beautiful, but until gold becomes a great deal cheaper it may be considered practically valueless on the score of expense."[61]

61 *Liverpool Photographic Journal*, (1854). See *British Journal of Photography* (29 January 2003) 12.

Other influential authorities on photographic process unanimously dismissed gold printing as the following quotations drawn from their writings will show.

In Pizzighelli and Hübl's 1882 treatise *Platinotype*, the authors state, in the translation by J.F. Iselin:

"As regards Gold, most compounds of this metal are reduced by solutions of the oxalate to metallic gold, even in the cold. On this account, the employment of gold chloride and its double salts seemed not to be feasible. One of the salts of gold, the hyposulphite, might perhaps be used with effect. This compound is not reduced by ferric [*sic*] oxalate in the cold; but the reaction takes place when hot solutions of potassium ferrous oxalate are employed. Our experiments, however, with this substance added to the sensitising solution gave no results worthy of mention; so that we refrained from pursuing our investigations further in this direction."[62]

Abney and Clark, in an appendix to their comprehensive manual *Platinotype*, commented on the possible use of several metals other than platinum for the formation of a permanent image, including gold:

"The compounds of gold are, with the exception of the hyposulphite, all reducible by oxalate solutions when cold, and even the hyposulphite does not withstand the action of hot oxalate; on this account gold also is not a feasible agent of which to form the positive image, as it could be reduced on the high lights as well as on the shadows...if gold in the form of an aqueous solution of the terchloride be applied, it is at once thrown down without the addition of any other substance as a developer. The colour assumed by the print is a purplish blue, almost a slate, but unfortunately the result is marred by a very slight reduction of gold that also takes place over the high lights. The gold here is thrown down in the pinky state, and, to portraits, gives almost a natural colour to the high lights of the flesh. The above process is almost identical with the chrysotype process of Sir John Herschel, the only difference being in the salt of iron used to form the provisional image, the ferrous [*sic*] oxalate being substituted for the ammonio-citrate of iron of this worker...."[63]

62 Giuseppi Pizzighelli, and Baron Arthur von Hübl, *Platinotype*, Trans. J.F. Iselin, Ed. W. de W. Abney, London: Harrison and Sons, 1883 (reprinted 1886) 35.

63 Capt. W.de W Abney and Lyonel Clark, *Platinotype, its Preparation and Manipulation*, London: Sampson Low, Marston & Co., 1895, p156.

64 Francis G. Eliot. 'What Prospect is there of totally abandoning Albumenised Paper for Printing?', *Anthony's Annual Bulletin of Photography,* 1 (1888) 181-183.

65 Which he attributes to Paul Pretsch "not finding it all he could wish." I have been unable to find any reference to this person using it.

In 1888, *Anthony's Annual Bulletin of Photography* carried a rather whimsical piece by one Francis Eliot entitled: "What Prospect is there of totally abandoning Albumenised Paper for Printing?"[64] In his idiosyncratic review of the alternatives to "our present printing Sovereign, King Albumen", as he dignifies it, Eliot considers that "the direction to look for, until Lord Platinotype has perfected his constitution, is to find one who can put on his purple robes at once, without wasting his time with so much swimming about and recreation in his bath". He recalls past endeavours to print by the uranium-gold process,[65] but he concludes (quite erroneously) "that gold alone is too transparent and thin to give a print by itself, as it has not the depth and opacity of platinum black." Elliot's final recommendation is "that a good printing-out process in silver and gold, doing away with all the trouble of toning, should be looked for." This is reminiscent of the self-toning printing process of Thomas Hennah, thirty six years before.

By 1913, on the basis of his earlier experience with gold printing recounted above, Chapman Jones discounted its feasibility in these decisive terms:

> "Instead of a platinum salt which gives an image in metallic platinum, a silver salt may be used and the image obtained in metallic silver, or a gold salt will give an image in metallic gold. These processes have been dignified with names, but the silver method is not used because other methods of getting silver images are preferable, and the gold method is useless because gold images have so little substance or body in them, and they are generally of unsuitable colours. For such methods as these last a citrate instead of an oxalate of iron is often preferred, but the principle of the method and the character of the change produced by light is exactly the same." [66]

66 Chapman Jones, H, *Photography of Today*, London: Seeley Service & Co. Ltd. 1913, 197.

By 1922, E.J. Wall, in an otherwise comprehensive review of the iron-based printing processes, could only acknowledge the chrysotype process with this summary dismissal:

"Of the dead and gone processes we have chrysotype, one of the very earliest of all printing processes, in which ferric citrate was used as the sensitive salt, the image being obtained in metallic gold."[67]

67 E.J. Wall, "The Iron Salts", *American Photography*, 16:11 (November 1922) 678.

Thus, chrysotype was laid to rest in an unmarked grave – or so it was thought. But, seventy years later, enabled by modern chemistry, a viable gold printing process became both technically and economically feasible, as I shall describe in the chapters to come.

Latterday Practitioners of Chrysotype

Although Herschel's chrysotype was long thought "dead and gone", the recrudescence of alternative processes, to be described in Chapter 6, has stimulated a few attempts in recent years to re-create chrysotype, more or less in its original form. Unfortunately, Herschel's account of his process has left us uncertain of the concentration of his gold chloride solution, which he only described as "the colour of sherry wine". However, history does not disclose Herschel's particular taste in sherry: whether for *oloroso*, *amontillado*, *fino*, or *manzanilla* – each having its own characteristic colour. The exploration of this question could constitute a very attractive research project for any oenophilic photochemist, and there have been a few precedents.

In a series of studies of early iron-based processes at the Harry Ransom Center, University of Texas, where the photograph collection includes some Herschel chrysotypes (Chapter 3), William Russell Young in 1981, made chrysotypes by an interpretation of Herschel's original method, using a 12% solution of ammonium ferric citrate as sensitiser, on Fabriano papers, and a 1% solution of gold chloride neutralised with sodium bicarbonate as the developing bath.[68] Blue-purple images were obtained, of rather low gradation, and with a tendency to pink fogging of the highlights, due to residual gold salts. Young notes that the contamination of the gold developing bath was problematic, worsening with each successive print.[69]

68 Herschel's fixing solution of "hydriodate of potassium" was here interpreted as meaning potassium iodate, KIO_3. However, it may be that Herschel's chemical name was referring to potassium iodide, KI.

69 William Russell Young III, *Chrysotype Portfolio: A series of experiments in Photo Processes*, Dissertation, HRHRC, University of Texas 1981.

At Oxford in 1997, a student in the Honour School of Chemistry, Owain Davies, having access to some of Herschel's original chrysotypes in the Museum of the History of Science, studied and attempted to replicate the process, also with moderate success.[70]

The alternative process worker, Liam Lawless, in 1999 adapted Herschel's method in a more economic version by premixing the gold choride with green ammonium ferric citrate as the sensitiser; he maintains that decomposition of the mixed solution is not so rapid as to prevent coating the paper, and prints of variable quality have been obtained, some of them very good.[71] It is possible that these later workers may owe their success to an advantage they have over Herschel, of a greater purity of the chemicals available to them; in particular the "ACI", whose ill-defined and varied chemical properties are notorious.

70 Owain Davies, *The Chrysotype Process*, Part II Thesis, Honour School of Natural Science in Chemistry, Oxford University, 1997.

71 Liam Lawless, Private communication.

5 Gold Toning

To gild refinéd gold, to paint the lily,
To throw a perfume on the violet,
To smooth the ice, or add another hue
Unto the rainbow, or with taper light
To seek the beauteous eye of heaven to garnish,
Is wasteful and ridiculous excess.

William Shakespeare (1564–1616)
King John (1591–8) act 4, sc. 2

Although innovators of photographic process failed to harness gold as a satisfactory imaging medium *per se*, they did succeed in employing it extensively as a toning agent for silver images from the very first days of photography.[1] Gold toning was seen as conferring two benefits on the picture: greater permanence, and an aesthetically satisfying colour.[2] This chapter reviews the historical development of gold toning methods for the various monochrome silver media. It may be noted that the word 'toning' itself was not introduced in this context until about 1855 – before which, early photographers had referred to such transformations of the silver image as 'colouring' or 'gilding'.

1 Philip Ellis, 'Gold in Photography', *Gold Bulletin*, 8:1 (1975) 7-12.

2 William E. Lee, 'Toning: Its Invention and Expanding Role in Photography', in Eugene Ostroff (ed.), *Pioneers of Photography: Their Achievements in Science and Technology*, Springfield VA: Society for Imaging Science and Technology 1987, 72-78.

Chemical Background

Until about 1905, when development printing papers were becoming widely available, almost all previous photographic positives had been made by 'printing-out', in which the silver image was more-or-less fully-formed during the exposure, by the action of light alone on a silver chloride emulsion. Regardless of the vehicle for the silver chloride – whether it was embedded within the fibres of plain paper, or suspended in a colloidal layer of albumen, collodion, or gelatin binder on the surface – the printed-out image is always formed as photolytic silver, which is nanoparticulate in nature. When fixed, this exhibits a yellowish-brown colour that many viewers find rather unpleasant for their images. A further consequence of the nanoparticles is that the surface area of the image substance

becomes relatively enormous,[3] so rendering it a highly vulnerable target for hostile substances that attack silver, especially those containing sulphur: hydrogen sulphide or sulphur dioxide from the air, or even certain thio-aminoacids, such as methionine or cysteine, which are present in the colloidal binding agents, egg albumen and gelatin.[4] The complete conversion of nanoparticle silver into silver sulphide greatly weakens the density and colour of the image, which accounts for the characteristic putty-coloured, faded look of many early photographs.[5]

When toned with gold, the image silver is partially replaced by elemental gold which tends to coat the silver nanoparticles, protecting them and modifying their colour, usually to a rich purplish-brown in the case of albumen prints, although gelatin chloro-bromide papers can be gold-toned blue. For the present discussion it is important to appreciate that, in the process of reducing the gold salt to deposited gold metal, a chemically equivalent amount of metallic silver is dissolved out of the image. It follows that if the gold salt used is in the oxidation state gold(III), then for each atom of gold precipitated upon the image three atoms of silver must be lost from it, because silver is only oxidised to the state silver(I).[6] It is clearly advantageous that the gold salt in a toner should be in the state of gold(I), when the equivalence of silver dissolved to gold precipitated will be 1:1, and the loss only one third as great. All useful gold toners therefore employ gold(I). Now, this is not commonly a stable oxidation state of gold, and suitable compounds of it cannot easily be purchased, so the making-up of gold toners usually involves some chemistry to reduce the widely available form of gold(III), so-called 'gold chloride' or preferably sodium tetrachloroaurate(III), to gold(I).[7] As we shall see, the same chemical logic is adopted in the formulation of the new chrysotype process. There are two broad categories of gold toner which use gold(I). In the first, the reduction of gold(III) is assisted, and the resulting gold(I) is stabilised, by the use of sulphur-containing molecules, which may be thiosulphate,[8]

3 A 1 cm cube of substance has a surface area of 6 cm^2. If this same amount is dispersed as cubes of edge 10 nm (one millionth of a centimeter), their total surface area is increased a millionfold - to 6,000,000 cm^2, which is 600 m^2 - twice the area of a tennis court.

4 Hen's-egg albumen contains the thio-amino acids methionine and cysteine; these also arise in gelatin, but vary according to source.

5 The vulnerability of early silver images to sulphiding is discussed in: Mike Ware, *Mechanisms of Image Deterioration in Early Photographs*, London: Science Museum and National Museum of Photography, Film & Television, 1994.

6 The balance of electrons must be conserved, so the equation is: $Au^{3+} + 3Ag \rightarrow Au + 3Ag^+$

7 'Gold chloride' as was generally sold, is actually highly acidic: tetrachloroauric acid. $HAuCl_4.3H_2O$. As such it does not make a good toner for silver images, and should be neutralised with alkali. Early users simply shook it up with excess chalk (calcium carbonate).

8 Once known as hyposulphite. Formula $(S_2O_3)^{2-}$.

9 Once known as sulphocyanide. Formula SCN^-

10 Once known as thiocarbamide. Formula $SC(NH_2)_2$

11 For gold(III) to oxidise water the solution needs to be slightly alkaline. The reaction tends to be slow, taking several hours for complete decolorisation.

12 L.P. Clerc, *Photography, Theory and Practice*, (3rd English edition edited by A. Krasna-Krausz), London: Sir Isaac Pitman & Sons 1954, 393-7; Pierre Glafkides, *Photographic Chemistry*, (trans. K.M. Hornsby) Vol. 1, London: Fountain Press 1958, 195-8; Grant Haist, *Modern Photographic Processing*, Vol.2, New York: John Wiley and Sons 1979.

13 The ingredients in the formulae are given, for conciseness and comparability, as weight percent volume (% w/v); that is the number of grams of the substance contained in a final volume of 100 cm^3 of the toning bath. For other volumes of solution, these amounts can be scaled appropriately: *i.e.*, to make 1 litre of the toning bath the % weights should all be multiplied by 10. The use of intermediate 'stock solutions' for the convenient storage of the reagents will not be described here.

14 D.F.J. Arago, *Comptes Rendus des Séances de l'Académie des Sciences, Paris*, 10 (1840) 488.

15 A.H.L. Fizeau, *Comptes Rendus des Séances de l'Académie des Sciences, Paris*, 11 (1840) 237, 824, 906.

16 Wolfgang Baier, *Quellendarstellungen zur Geschichte der Fotografie*, Fotokinoverlag Halle 1964; Ludwig Hoerner, 'Photohistorica Gottingensis', *History of Photography*, 6:1 (January 1982) 59-63.

17 M.A. Gaudin, *Traité de Photographie Exposé Complet des Procèdes Relatifs au Daguerreotype*, Paris: JJD 1844, 94-7.

18 Correctly, the acid, hydrogen tetrachloroaurate; the same name 'gold chloride' was also used for the neutral salt, sodium tetrachloroaurate. See ref. n.7. The quality of the toning depends on which was employed; much better results are usually obtained with the neutral salt.

thiocyanate,[9] or thiourea.[10] There was also a second, less chemically sophisticated form of gold toner, in which sodium tetrachloroaurate(III) is simply dissolved in a mild alkaline buffer, such as sodium acetate, borate, carbonate, or phosphate, or even calcium carbonate (chalk), under which conditions the gold(III) slowly (over as much as 24 hours) reduces to gold(I) by oxidising water.[11] If the solution is made too alkaline, however, it becomes ineffective.

In all, about nine variations of gold toning may be distinguished, and these will be summarised later in a tabular form. Numerous recipes may be found, fully detailed for use, in the standard texts, of which the best is the second volume of Haist's *Modern Photographic Processing*,[12] but the following account, which prioritises the historical evolution of gold toning, will include all the important formulations, concisely described.[13] In some of the popular procedures, gold toning is mixed in with simultaneous sulphide toning, using complex baths which result in a rather indeterminate composition for the final image – although its colour may be very satisfactory.

Daguerreotypes 1840–65

Armand Hippolyte Louis Fizeau (1819–1896) is usually credited with being the first to discover the use of gold salts for gilding daguerreotypes. This technique was announced to the *Académie des Sciences* on 23 March 1840 by Dominique François Jean Arago,[14] and Fizeau subsequently published his method in August 1840.[15] But there is evidence that this idea had already been put into use by 19 October 1839, by August Friedrich Karl Himly (1811–1885), a professor of chemistry at Göttingen.[16] Fizeau's method is reported *verbatim* in Gaudin's 1844 manual of daguerreotypy.[17] To prepare the gilding bath, he slowly added, with stirring, a 0.2% solution of 'gold chloride'[18] in pure water to an equal volume of a 0.6% solution of 'hypo' (sodium thiosulphate). The slightly yellowish liquid rapidly became quite colourless. This was then poured onto the surface of the daguerreotype plate,

held horizontally, which had been very carefully washed, and was heated from beneath by a spirit burner, to accelerate the toning action. This method is still used to good effect by latterday daguerreotypists.

The reaction just described between gold(III) and a soluble thiosulphate produces a complex salt of gold(I), known as 'Fordos and Gélis' Salt'[19] after the chemists who first isolated it from the solution as colourless crystals. Its historical French name, *sel d'or*, is usually preferred for its elegance and brevity.[20] However, Thomas Hardwich later pointed out in 1855 that this preparation of *sel d'or* also yields a byproduct, sodium tetrathionate,[21] which is a sulphiding agent towards silver, so any image that is gold-toned in this mixed bath may also be partially sulphide-toned.[22] To avoid this possibility of concomitant sulphiding, the pure crystalline *sel d'or* can be isolated from a concentrated solution,[23] and re-dissolved in pure water to be used on its own as the toning agent. For this reason it became an item of commerce with apothecaries. Gaudin does note some differences in colour between the results of using Fizeau's mixed toning bath and a solution of pure *sel d'or*, the latter was said to produce "less warm" colours.

In 1996 a remarkable find was made in the Netherlands archive of the possessions of the exiled Kaiser Wilhelm II (1859–1941): two *golden* daguerreotypes.[24] These were identified as portraits by the Berlin photographer Philipp Graff, of children of the Prussian royal family, dating from 1845.[25] These sixth-plate daguerreotypes are exceptional for their specular golden appearance, quite unlike 'gold-toned' daguerreotypes,[26] which is confirmed by the high concentration of gold revealed by X-ray fluorescence spectrometry. The plates are still the subject of on-going research to determine how they were originated; it is suspected that an electrolytic process of 'galvanisation' may have been employed to plate them with gold. A worldwide appeal has produced evidence of the existence of half a dozen more examples of this rare method of 'golden photography'.

19 Maturin Joseph Fordos and Amadée Gélis, who called it 'hyposulphite of gold and sodium'; later it was called 'sodium auro thiosulphate'. *Annales de Chimie et de Physique*, 3rd series, 13 (1843) 394.

20 A name which is also greatly to be preferred to the full title imposed by the exigencies of modern chemical nomenclature: trisodium bisthiosulphatoaurate(I) dihydrate; formula $Na_3[Au(S_2O_3)_2].2H_2O$.

21 Formula $Na_2S_4O_6$.

22 T.F. Hardwich, *A Manual of Photographic Chemistry*, 1st Edn. London: John Churchill 1855, 180.

23 It is precipitated by ethyl alcohol.

24 Hans de Herder, 'Gold fever: two unique gold daguerreotypes from the collection of the German Kaiser', in: *Topics in Photographic Preservation*, 8, Boston: American Institute for Conservation, Photographic Materials Group Conference, (12-13 March 1999) 17-22.

25 Liesbeth Ruitenberg, 'Two Golden Daguerreotypes: A Research Report', trans. Ingrid Grunnill, *The Daguerreian Annual* 2001, 2-12.

26 M. Susan Barger and William B. White, *The Daguerreotype: nineteenth-century technology and modern science*, Baltimore: 1991. As Barger remarks; "The reports that gilded daguerreotypes appear gold colored are part of the myth of the process."

Salted Paper Prints 1839–58

There is no evidence that the originator of the silver salted-paper processes, Henry Talbot, ever applied gold toning to his prints; which is all the more remarkable in view of the problems of impermanence that were, by the mid-1840s, already besetting the commercial prints produced by Talbot's erstwhile employee Nicolaas Henneman at his photographic establishment in Reading. Thomas Malone, a chemist in Reading, later revealed that he was not convinced of the value of gold toning, and that he favoured the 'old-hypo colouring bath', attributed to Blanquart-Evrard,[27] and which subsequently became notorious for its destructive inconsistency. This was prepared by adding an oxidant to the normal hypo fixing bath,[28] which generated substances, called polythionates, that could partially sulphide-tone the silver image to a satisfying dark brown. If the excess substances were not thoroughly washed out, serious deterioration of the image by fading set in later. By comparison with the 10000 prints commercially-produced at Reading for Talbot, the 3000 or more salt prints made between 1844 and 1847 by David Octavius Hill and Robert Adamson in Scotland have survived much better. However there is no evidence that the early Scottish photographers were users of gold-toning either,[29] and the stability of their prints may probably be attributed to the great care they exercised in the fixing and very thorough washing of the prints, to minimise the residual thiosulphate.[30]

Although the silver salted paper print was invented in England, its toning with gold was pioneered in France. The first published account of gold-toning salt prints appears to be in the work *Autophotographie* (1847) of P.F. Mathieu, who used *sel d'or*.[31] In 1850 the celebrated French photographer, Gustave Le Gray (1820–82), briefly recalled this use of *sel d'or* for toning positive prints on silver salted paper in his popular *Traité pratique de photographie*, describing it in the following terms: "*J'obtiens aussi des fort jolis tons veloutés en mettant, au sortir de l'hyposulfite, l'épreuve sur un bain de sel d'or (4 g. sel d'or dans un litre d'eau)*."[32] However, in the second edition of his treatise, [33]

27 Louis-Désiré Blanquart-Evrard, *Traité de Photographie sur Papier*, (Paris: Libraire encyclopédique de Roret 1851) 130.

28 A variety of oxidants is possible, including: nitric acid, ferric chloride, iodine, and silver nitrate itself.

29 Katherine Eremin, James Tate, and James Berry, 'On the Chemistry of John and Robert Adamson's Salted Paper Prints and Calotype Negatives', *History of Photography*, 27:1 (Spring 2003) 25-34.

30 Mike Ware, 'On the Stability of Robert Adamson's Salted Paper Prints', *History of Photography*, 27:1 (Spring 2003) 35-39.

31 P.F. Mathieu, *Auto-photographie ou Méthode de Reproduction par la Lumière des Dessins, Lithographies, Gravures, etc., sans l'Emploi du Daguerréotype*, Paris: 1847, 14. Re-published much later by Louis-Desiré Blanquart-Evrard (1802-1872) in his treatise *La Photographie, ses Origines, ses Progrès, ses Transformations*, Lille: 1870.

32 Gustave le Gray, *Traité Pratique de Photographie sur papier et sur verre*, Paris: Germer Baillière, June 1850, 22. Translated as *A Practical Treatise on Photography upon Paper and Glass*, London: 1850.

33 Gustave le Gray, *Nouveau Traité de Photographie*, Paris: Lerebours et Secretan, July 1851. Translated as *Plain Directions for obtaining Photographic Pictures*, London: T&R Willats 1851. English edition, *Photographic Manipulation. The waxed paper process of Gustav Le Gray*, London: 1855.

which was translated into English by Thomas Hennah in 1853,[34] Le Gray surprisingly switched his allegiance from *sel d'or* to the cruder method using unreduced acidic gold(III) chloride. This process employed a 0.1% solution of gold chloride, further acidified with hydrochloric acid, and it required heavy overexposure of the print, because much image silver was inevitably dissolved and the image greatly weakened, for the reason explained earlier. The method was criticised by Thomas Sutton in 1855, who speculated that, in order to employ this procedure, Le Gray must have overexposed his prints to a "prodigious intensity".[35]

In 1851, Humbert de Molard also used gold chloride – but neutralised with excess chalk (calcium carbonate) – as a toner bath for salt prints before fixing, which had the advantage of maintaing a constancy of composition because calcium carbonate has very low solubility.[36] However, a saturated solution of calcium carbonate is perceptibly alkaline, with a pH of about 9.4, so it is likely that the gold in this solution would, over 24 hours, have been reduced to gold(I), a conjecture which is supported by the description that the bath becomes colourless.[37] It could therefore be argued that de Molard's 'gold chalk toner' actually anticipated the later invention of the 'alkaline gold toning bath', which is usually ascribed to Waterhouse and Hardwich in 1855 (see below).

The practice of gold-toning salt prints was not entertained widely within British photographic circles until 1855,[38] as can be inferred from the first volume of the *Journal of the Photographic Society* (March 1853 – June 1854), which makes no mention whatever of gold-toning, despite the fact that this new publication provided a welcome forum for many lively and detailed exchanges of information on all the experiences of photographic practice that had been accumulating over the previous decade. Robert Hunt's *Manual* of 1854 failed to carry any instructions for gold toning, apart from a brief quotation of Le Gray's method. The likely explanation for this lack of serious interest in gold among the British photographic establishment is that most preferred to ignore the issue of permanence at this time.

34 T.H. Hennah (trans.), *Directions for obtaining both positive and negative pictures upon glass, also Gustave le Gray's recently published method of obtaining black & violet colors in the positive proofs*, London: Delatouche and Co. 1853, 35.

35 Thomas Sutton, *Journal of the Photographic Society*, 2:28 (20 March 1855) 133.

36 L.P. Clerc, *Photography Theory and Practice*, Ed. A. Kraszna-Krausz, London: Sir Isaac Pitman & Sons, 3rd Edn., 394.

37 The colour of gold(III) chloride is an intense yellow, whereas gold(I) salts are generally colourless.

38 Although there were one or two exceptions, *e.g.* Joseph Sidebotham in Manchester was using gold toning experimentally as early as 1852. See Harry Milligan, 'Joseph Sidebotham: a Victorian amateur photographer', *The Photographic Journal*, (March/April 1978) 83-7.

39 T.F. Hardwich, 'On the Chemistry of Photographic Printing', *Journal of the Photographic Society*, 2:22 (21 Sept 1854) 35; ibid., 2:24 (21 November 1854) 60; ibid., 'On Printing Positives', 2:25 (21 December 1854) 78.

40 Thomas Sutton, 'Gold versus Old Hypo', *Journal of the Photographic Society*, 2:27 (21 February 1855) 121, 133.

41 Louis-Désiré Blanquart-Évrard, *Traité de Photographie sur Papier*, (Paris: Libraire encyclopédique de Roret 1851) 130. The author makes no mention of toning with gold in this treatise.

42 Thomas Sutton, *The Calotype Process: A Handbook to Photography on Paper*. London: J. Cundall 1855.

43 Thomas Hardwich, 'Remarks on the Fading of Positive proofs', *Journal of the Photographic Society*, 2:35 (22 October 1855) 240; ibid., 'On Mr. Sutton's Process for Toning Positives', 244.

44 Thomas Sutton, ibid. n.42; [J. Adamson] 'Photography', in William & Robert Chambers, Eds., *Information for the People*, London: W. & R. Chambers 1848-9, 735.

They still felt that equally good-looking tones could be obtained with the 'old hypo colouring bath' which, instead of the expensive gold chloride, called only for cheap additives such as: ferric chloride, iodine, sulphur dioxide, silver nitrate, or cupric chloride, any of which had the effect of converting some of the thiosulphate fixer to polythionates, which would then partially sulphide-tone the image.[39] But in the February 1855 issue of the second volume of the *Journal of the Photographic Society*, an important debate was initiated by Thomas Sutton under the title 'Gold versus Old Hypo', when he announced his wholehearted adoption of gold toning, and abandonment of the 'old hypo colouring bath', because he admitted that his prints treated by the latter had "totally perished or grievously faded."[40] Sutton put forward his own modification of a pure *sel d'or* toner, applied before the fixing bath. He remarked that, although it was Blanquart-Evrard who had first publicised the colouring qualities of the 'old hypo bath',[41] he had also immediately abandoned it, in preference to gold toning. An on-going dialogue then ensued in the *Journal* between Thomas Sutton and the chemist Thomas Hardwich, the former becoming a firm advocate of the *sel d'or* method for salted paper prints.[42] The latter was persuaded to repudiate his former advocacy of the 'old hypo colouring bath', and he was soon championing Sutton's method of gold toning over Le Gray's, but Hardwich continued to express reservations concerning the purity of the result, maintaining that some sulphiding still occurred even with pure *sel d'or*: " … I now consider the presence of sulphuret of silver in proofs toned by gold salts to be an ascertained fact."[43] Because crystalline *sel d'or* was very expensive, a popular version of gold toning employed a combined 'fixing and colouring bath' by simply adding gold chloride to the concentrated sodium thiosulphate fixing bath, in order to form *sel d'or in situ*.[44] However, as Hardwich pointed out, this was just like the 'old hypo colouring baths', and was even more likely to lead to an indeterminate degree of concomitant sulphiding from tetrathionate, especially as the bath aged.

In response to the widely acknowledged problem of impermanence in silver prints, the Photographic Society of London appointed a Committee on 21 May 1855 with the remit: "to take into consideration the Question of the Fading of Positive Photographic Pictures upon paper". The first report of this "Fading Committee", as it became informally known, appeared on 21 November 1855. It identified the most common cause of fading as residual thiosulphate left in the print by imperfect washing, but held that sulphurous gases in the London atmosphere could also have an effect. Gold-toned prints were deemed to be more resistant, so the Committee recommended, though not unanimously, that: "…gold, in some form, should be used in the preparation of pictures."[45]

Joseph Sidebotham of Manchester, writing in 1861, summed up this unfortunate history in the following words:

"Those who have collected photographs for the last eight or ten years, cannot look over their portfolios without feeling considerable annoyance; many of the once beautiful specimens are now mere shadows in yellow and brown, many are spotted and partially faded, and comparatively few are in their original state. Fortunately the cause of this destruction is now well known, and we need not fear the fading of our photographs if the printing be properly conducted. This is not the place to enlarge on the causes of fading; it will be sufficient to say that photographs toned or coloured with choride of gold appear unalterable, and those coloured with sulphur, from the decomposition of the hyposulphite of soda bath, are almost certain to fade in time.

The writer has some prints he toned with chloride of gold in 1852, which are as beautiful as on the day they were printed; whilst of those toned with hyposulphite of soda, or, as it was called, "old hypo," few are in existence, and none are in their original state. Unfortunately the latter process was used extensively from 1852 to 1858, being cheaper and easier to work than the other, consequently a large proportion of the prints produced between these periods have already faded, or will sooner or later do so."[46]

45 P.H. Delamotte, H.W. Diamond, T.F. Hardwich, T.A. Malone, J. Percy, H. Pollock, G. Shadbolt, 'First Report of the Committee appointed to take into consideration the Question of the Fading of Positive Photographic Pictures upon Paper', *Journal of the Photographic Society*, 2:36 (21 November 1855) 251-2. Malone and Percy dissented from the recommendation regarding the use of gold.

46 Joseph Sidebotham, 'The Printing Process in Photography', in *Recreative Science: a Record and Remembrancer of Intellectual Observation*, Volume 2, London: Groombridge and Sons, 1861, 119-121. See also ref. n.38.

It was observed by Hardwich that the complication of sulphiding that accompanies gold-thiosulphate toners could be avoided by the use of simple alkaline gold-toning baths using gold chloride, at a concentration of about 0.1%, in a mild alkali at a concentration of 5% to 10%. This type of gold bath had been anticipated in 1851 by Humbert de Molard, as noted above. In 1858, Waterhouse of Halifax introduced a bath neutralised by sodium carbonate,[47] and in 1859 Maxwell Lyte recommended trisodium phosphate for this purpose.[48] Several other alkalies were also suggested, as shown in the table. The gold chloride for this purpose was often prepared by dissolving a gold sovereign in *aqua regia* (see Chapter 1). Although the law prohibited defacing any current coin of the realm, it was a moot point whether complete dissolution of a coin, so that it ceased to exist, could legally constitute a defacement.[49] In any event, the unabated enthusiasm for gold toning was well-expressed by Linnaeus Tripe, the official Government Photographer in Bombay, with his injunction "not to spare the sovereigns!"

Albumen Prints 1850–95

The use of hens' egg albumen as a binder for the silver chloride layer in printing papers had been tried at an early stage by several experimenters including Henry Talbot, but it was first exploited commercially by Louis-Desiré Blanquart-Evrard in 1850.[50] This was soon followed by the development of the collodion wet-plate negative in 1851 by Frederick Scott Archer, following original experiments by Le Gray.[51] These two innovations complemented one another to make a pair of well-matched negative-positive processes, which had the effect of greatly increasing public enthusiasm for the practice of photography, and by 1855 they were in wide use. Collodion dry plates became commercially available in that year, and albumen paper in 1861. These processes established themselves as the dominant photographic media for the rest of the century, and their use persisted until 1895 or so, when they were displaced by gelatin-based emulsions.

47 "Waterhouse of Halifax" is not the same person as Colonel Waterhouse of the India Photographic Survey, noted for his contributions to photohistory.

48 *The Photographic News*, 1:26 (4 March 1859).

49 The standard gold used in British coinage was alloyed with copper only, which could be separated out chemically. Jewellers' gold was alloyed with silver, but the presence of silver inhibits the dissolution reaction in *aqua regia* because of the formation of a coating of insoluble silver chloride.

50 L.D. Blanquart-Evrard, *Comptes Rendus* (27 May 1850); idem, 'Photography on Paper', *The Chemist* (August 1850) 502-3; idem, *Traité de Photographie sur Papier*, Paris: Libraire encyclopédique de Roret 1851.

51 Frederick Scott-Archer, 'On the use of collodion in photography', *The Chemist*, 2 (March 1851).

Collodion print-out papers were introduced in 1865 by
G Wharton-Simpson. The significant sulphur content of
egg-white[52] made sulphiding a particular risk with the
albumen medium unless the image silver was gold-toned,
so this became an essential part of the standard practice.
However, albumen paper proved slow to tone by the
sel d'or method, where the low reactivity required long
immersion times, and the combined thiosulphate-gold,
fixing-toning bath caused an indeterminate degree of
sulphide toning; so in 1858 Hardwich recommended that
the more energetic alkaline gold toners based on the
method of Waterhouse be applied *before* thiosulphate
fixing, which also had the advantage of avoiding any
possibility of sulphiding the albumen print.[53] This became
the standard method for toning albumen prints, of which
many owe to it their survival today.

Later Printing-out Papers

Gold toning was a particularly important adjunct for the
printing-out papers which became popular by 1900.
These were constituted of silver chloride in a binder of
gelatine or collodion, with excess silver nitrate and a halogen
absorber such as sodium citrate. The orangey-brown colour
of the image as printed-out was generally deemed to be
unpleasant, so was usually transformed by gold toning
before the fixing bath.[54] In addition to the alkaline gold
toning baths, the most-used formulae employed ammonium
thiocyanate as the reagent to complex and reduce gold(III)
to gold(I). This salt, which is described as a 'silver halide
solvent', had first been used on print-out papers by Meynier
in 1863 and by Liesegang in 1868.[55] Later, the gold-
thiocyanate toner came into its own. Typical formulae used
solutions of ammonium thiocyanate at a concentration of
1–2%, and gold chloride at 0.2%, which were mixed only
when needed by adding the latter slowly to the former; the
stability of the bath could be improved by the presence of a
weak acid such as tartaric acid, as in the formulation due to
Namias, which contained: gold chloride 0.02%, ammonium
thiocyanate 2.5%, tartaric acid 0.2%, and sodium chloride 0.5%.

52 The thio-aminoacid, cysteine, complexes silver(I) ions far more strongly than does thiosulphate.

53 T.F. Hardwich, 'Toning by alkaline chloride of gold', *Journal of the Photographic Society* (11 December 1858) 96; T.F. Hardwich, *A Manual of Photographic Chemistry, Theoretical and Practical*, 7th Edn. Edited by George Dawson and Edward Hadow, London: John Churchill 1864, 306-313.

54 Pierre Glafkides, *Photographic Chemistry*, vol.1, trans. K.M. Hornsby, London: Fountain Press 1958, 195-9.

55 P. E. Liesegang, 'Toning and Fixing in One Bath', *British Journal of Photography*, 15 (1868) 232.

Silver-Gelatin Development Papers

The early development papers of the 20th century sometimes yielded unsatisfactory print colours, having an olive-greenish tinge. This could be converted to an acceptable blue-black by gold toning baths such as recommended by A.J. Jarman, which used gold chloride at 0.02% in 0.2% ammonium thiocyanate.[56]

In the 1920–30s the warm-tone development of slow chlorobromide enlarging papers became popular, which yielded a small silver particle size. With gold toning, this provided the possibility of obtaining a blue colour which became quite in vogue, and highly esteemed for exhibition prints of subject matter that was thought compatible with the colour, such as snow and ice scenes, seascapes, and glassware. The best toning formulae used thiourea to reduce and stabilise the gold(I). Thiourea was not new, even at the time its use was discussed by A. Hélain in 1902,[57] and it subsequently found success at the hands of D.J. Ruzicka in the 1930s, who used 0.03% gold chloride treated with 0.11% thiourea, and slightly acidified with sulphuric acid. In the most popular formulation, the latter was replaced by citric acid and this became the preferred method for blue-toning. The most highly-recommended formulation used three stock solutions: 0.4% gold chloride, 1.2% thiourea, and 1.2% citric acid. Just before use, the three solutions were combined in equal amounts and the whole mixture diluted about four times with water to make the final bath, which therefore contained ca 0.03% gold chloride and 0.1% thiourea and citric acid.[58]

Because the blue result depended critically on the particle size of the original silver image, both the silver halide emulsion and the composition of its developer were crucial factors for success. It was stressed that the slow chloro-bromide papers such as Kodalure or Veltura gave much finer results than the faster bromide papers, and they should not be hardened in the fixing bath. D.J. Ruzicka made particular use of a chlorohydroquinone developer for this purpose,[59] although Adurol and Glycin developer was also recommended by P. Phyllides.[60]

56 A.J. Jarman, 'Improving the Color of Prints by Toning with Gold', *American Photographer*, 24 (1930) 584.

57 A. Hélain, 'A New Toning Bath', *British Journal of Photography*, 49 (1902) 402.

58 Alvin W. Lohnes, 'Blue Toning De Luxe', *American Photographer*, 36:6 (1942) 38; Wiegleb, *British Journal of Photography*, 76 (1929) 377.

59 D.J. Ruzicka, 'Gold Toning', *Photo Art Monthly*, 5 (1937) 379.

60 Philip Phyllides, 'Gold Toning with Glycin Development', *American Photographer*, 37:3 (1943) 22.

Gold Toning of Sulphided Images

If a sulphide-toned silver original is treated in a gold-toning bath, a crimson colour is obtained, supposed to be due to the formation of a double sulphide of gold and silver.[61] The silver sulphide image was usually toned in a solution containing ca 0.1% gold chloride and 1.2% thiourea to convert it to a red-chalk colour.

Sulphide toning and gold toning can be carried out simultaneously in a single alkaline bath to give excellent brown tones, by a modification of the 'hypo-alum' sulphiding toner invented by Leo Baekeland in 1888.[62] A hypo-alum toner was first prepared by boiling 12% sodium thiosulphate with 1.5% alum,[63] to form a colloidal sol of sulphur, then buffered with 1.5% disodium phosphate and 'ripened' with added silver bromide; finally gold chloride was added to a level of 0.013%.[64] In 1932 Walter C. Nelson patented such a gold toning bath, which became the popular Kodak Gold Toner T-21.[65] The potassium alum was replaced with ammonium or potassium persulphate (3%) to oxidise the 17% thiosulphate and generate colloidal sulphur and assist the oxidation and sulphiding of the silver. Silver chloride was added, then gold chloride to give a concentration of 0.012%. The bath was used at an elevated temperature (110–130° F). Although this toner was highly esteemed for the rich brown colour it generated, there is no record of prints toned by this means having been analysed to determine the relative proportions of gold and silver sulphide in the final image.

Similar mixed toning-fixing baths have even incorporated lead salts, which were themselves toning agents – forming black, insoluble lead sulphide. When mixtures become this complicated, and the composition of the resulting image is correspondingly uncertain, the value of the whole enterprise is called into question, and further details of these over-elaborated treatments will not be entered into here.

61 A. and L. Lumière and A. Seyewetz, 'The Chemistry of the Red Toning of Sulphide-Toned Prints', *Transactions of the Faraday Society*, 19:391 (1923).

62 Leo Baekeland, *Association Belge Photographique Bulletin*, 16:2 (1889) 5. This formulation became Kodak Hypo-Alum Sepia Toner T-1a.

63 Potassium aluminium sulphate.

64 Sigismund Blumann, *Photographic Workroom Handbook*, 3rd Edn. San Francisco: Camera Craft Pub. Co. 1930, 36.

65 Walter C. Nelson, *Toning Bath for Photographic Prints*, US Patent 1,849,245 (1932).

Bromide Enlarging Papers

In modern bromide papers, the colour change brought about by gold toning is very slight, or even imperceptible, because the silver formed in developed bromide papers has a filamentary structure much larger than nanoparticle silver, and appears neutral black, offering little scope for shifting its colour. Today, gold 'protection' rather than toning of silver-gelatin images is recommended when archival stability is paramount. The Kodak Gold Protective Solution GP-1 is a popular example: it contains 0.01% gold chloride and 1% sodium thiocyanate. Toning for 10 minutes can shift the colour slightly towards a bluish-black, and is reputed to increase the permanence of the image. There is also a Kodak Gold Protective Solution GP-2, which has been formulated with a replenisher, and is especially intended for the preservation of microfilm.[66] It contains 0.05% gold chloride, 0.5% thiourea, 0.1% tartaric acid, and 1.5% anhydrous sodium sulphate. In recent years, Kodak have recommended a blue toner T-26 for use with their Panalure paper, which contains 0.04% gold chloride, 0.2% ferric EDTA, 0.1% tartaric acid, and 1.5% sodium sulphate.[67]

Permanence of Gold Toning

We have seen that the survival of many of the wonderful images in our photographic heritage is owed to the widespread practice, over the last 150 years, of toning silver prints with gold in order to improve their appearance and longevity. While this history tacitly acknowledges the excellence of gold as an image substance, to employ it in this way is, metaphorically, to build one's castle upon foundations of sand, because the underlying material, silver, although protected to a degree, is still susceptible to deterioration. This residual vulnerability is witnessed by the fading even of some historic gold-toned photographs. How much better would it be to choose secure foundations in the first place, and build one's picture entirely of gold? It must be stressed here, in view of an oft-repeated misapprehension, that chrysotype is *not* gold toning,

66 R.W. Henn and Bernadette D. Mack, 'A Gold Protective Treatment for Microfilm', *Photographic Science and Engineering*, 9 (1965) 378.

67 *Kodak Handbook for the Professional Photographer, vol.5 Formulary*, Kodak Ltd., 1982.

which, as described above, has been standard practice since the beginnings of photography as one of the ways of retrospectively manipulating and stabilising an existing silver image. On the contrary, chrysotype is what photographers call a 'straight' printing medium in its own right – no silver is involved in making the positive image.

Table 5.1 *Chronological summary of gold toning methods*

Year	Inventor	Formula Type	Used for
1839	Himly	sel d'or	Daguerreotypes
1840	Fizeau	sel d'or	Daguerreotypes
1847	Mathieu	sel d'or	Salt prints
1850	Le Gray	sel d'or	Salt prints
1851	Le Gray	acidic gold chloride	Salt prints
		alkaline gold toners	
1851	Molard	calcium carbonate	Salt prints
1855	Waterhouse	potassium carbonate	Salt & albumen
1857	Hardwich	sodium carbonate	Salt & albumen
1858	Lyte	trisodium phosphate	Salt & albumen
1858	Heywood	borax	Salt & albumen
1859	Jobard	sodium bicarbonate	Salt & albumen
1860	Laborde	sodium acetate	Salt & albumen
		silver solvent toners	
1863	Meynier	ammonium thiocyanate	Albumen papers
1868	Liesegang	ammonium thiocyanate	Albumen papers
1902	Hélain	thiourea	Chlorobromides
1928	Namias	ammonium thiocyanate	Chlorobromides
1934	Ruzicka	thiourea	Chlorobromides
1982	Kodak	blue toner T-26	Bromides
		sulphiding gold toners	
1932	Nelson	hypo-alum T-21	Chlorobromides
		gold protective solutions	
1960s	Kodak	GP-1 and GP-2	Bromides

Mortensen's Metalchrome Process

'Metalchrome' is a proprietory process, devised and taught privately by William Mortensen (1897–1975), who kept its details confidential during his lifetime; they were recently

68 Grey L. Silva, 'The Metalchrome Story', *Photographic Society of America Journal*, March 1970.

published by the Photographic Society of America, with the permission of Mortensen's widow.[68] The process is elaborate, multi-staged, and selective, using masks; an essential early step is the well-known use of gold-toning of a sepia (sulphide-toned) silver print, as mentioned above, to achieve red colours; but these are subsequently modified to pink flesh tones by the application of water-soluble aniline dyes.

Gold Toning of Platinotypes

To tone a platinum print with gold – or, indeed, with any substance at all – is a latterday example of the totally superfluous gesture that was ridiculed most memorably by Shakespeare: "To gild refinèd gold, to paint the lily… is wasteful and ridiculous excess."[69] An illustration of the lengths to which this excess may be taken can be found in volume 4 (1902) of *The Photominiature*, which provides instructions for toning platinum prints to every colour of the rainbow.[70] As Chapman Jones reflected, in 1903:

69 William Shakespeare, *King John*, act 4, scene 2. See the epigraph prefacing this chapter.

70 John A Tennant (ed), *The Photominiature*, London: Dawbarn & Ward 1902, vol 4, 153-193.

> "A fine platinum print is so excellent and unique in its characteristics that it is with a feeling almost akin to that engendered by sacrilege that one hears of any suggestions to tamper with it. The best advice that can be given is to leave it alone. But photographers never will let good alone…"[71]

71 Chapman Jones, 'The Modification of Platinum Prints', *Journal of the Camera Club*, 17 (1903) 110.

And Chapman Jones was no exception to his own rule, because he succeeded in suppressing his finer feelings sufficiently to describe the method of toning platinotypes due to A.W. Dolland,[72] in which a moist platinotype is first coated with glycerin, then treated with a very weak solution of gold chloride, in order to deposit gold in a blue-black form onto the print surface. No platinum is lost, because here the platinum black of the image is acting only as a catalyst, to promote the reduction of the gold(III) to gold metal by the glycerin, which is itself oxidised. If subsequent staining is to be avoided with this process, it is particularly important to remove all traces of excess gold salt by means of a conventional alkaline paper developer. But if such a blue-black image is sought, how much better it would have been to make the print in pure gold in the first place.

72 A.W. Dolland, Photographic Journal, 1894, 189; see also: *British Journal of Photography*, 58 (1911) 339, 381; *Journal of the Photographic Society*, 18, 190.

Finally, although they are not strictly toning procedures, we may note here two examples of the use of gold in photography where the metal is applied to the image by physical rather than chemical means, and in the bulk or specular state.

Goldtones, Orotones, or Curtones

Belying its various names, this is not a process for gold-toning, but refers rather to a particular style and method of mounting a silver diapositive on a glass plate: gold leaf or paint, or an alloy of similar appearance, is used to back the image, thus producing a rich, warm, metallic background for the transparent highlights, which is said to impart a sense of luminosity and depth to the image. Sometimes a gold or bronze powder paint mixed with resin was used for the backing. It is believed that the silver image itself was often toned with gold and/or sulphide. Orotones are usually found mounted in elaborate gilt frames which echo their character. The process is attributed to Edward Sheriff Curtis (1868–1952), who is acclaimed for his extensive and beautiful ethnographic studies of Native North Americans.[73] Practising during the opening decades of the 20th century, he said of the process: "…in the goldtones all the translucency is retained and they are as full of life and sparkle as an opal." While it was Curtis's favorite process, only a small proportion of his negatives were printed in goldtone because of the complexity and expense. The process has recently been recreated, despite some uncertainties about Curtis's original methods, by Christopher Cardozo of Cardozo Fine Art, in collaboration with the Ilford Company of Mobberley, England, who developed the proprietary glass plates coated with a warm-toned silver emulsion. These were used to print contemporary goldtones in limited editions:

> "Centennial Edition Goldtones are created exclusively from Curtis' original glass plate negatives and thus are considered original prints, not reproductions. Goldtones are printed directly on an optical glass plate, which has been coated with

73 Luis Nadeau, *Encyclopedia of Printing, Photographic, and Photomechanical Processes*, Fredericton: Atelier Luis Nadeau, 1989.

a unique, specially formulated emulsion. The exposed sensitised glass plates are processed with traditional photographic chemistry and then toned twice for superb archival permanence and a warm sepia tonality. Each goldtone is then backed with multiple micro fine layers of a mixture of non-precious metallic particles and finally treated with an inert archival sealant." [74]

The 'Doretype' or 'Doretone' is a derivative of the process, using a paper or silk backing tinted with bronze powder.[75] Another interesting, and possibly related type of photograph using metallic gold, or a gold-like alloy, has recently come to light in the form of an 'Auratype' by the New York commercial photographer George S. Barlow. The only specimen known so far – a portrait of President Lincoln – proclaims itself to be a "carbon gold painting" on the printed label, which also carries the explanation: "Genuine carbon print, hand painted in actual metal colors… carbon cloisenne will not tarnish nor fade…" There are also annotations in the hand of the photographer, declaring this the first specimen to be made, but the date is as yet unknown.[76]

Japanese 'Dust-on' Photographs in Gold

A completely different form of 'gold photograph' – using specular gold metal – is known to have been used to embellish some highly ornate Japanese photograph albums from the 19th century:

"Japanese Photographs in Gold
Professor W.K. Burton closes an article in the Photographic Times of New York – I have reserved for the last notice of what is an exhibit perhaps the most interesting of any, because it is quite new.
The exhibitor is A.H. Mizuno, of Yokohama, and what is shown is a series of photographs in gold on dark coloured lacquer. The intention is to produce, photographically, the equivalent of hand-done pictorial work in gold in lacquer – one of the fine arts in which Japan far excels any other country in the world. The effect, considered decoratively, is very pleasing. The process has, as yet, been kept secret."[77]

74 I am indebted to Peter Bernardy of Christopher Cardozo Fine Art for this information on Goldtones. See the Cardozo gallery website: http://www.edwardcurtis.com/goldtone/gt.html

75 Sarah Brown, 'Gold Rush', *British Journal of Photography*, (October 6 1999) 16, 17.

76 Judy Goddard, private email communication, May 2003.

77 *The Year-Book of Photography and Photographic News Almanac*, 1892 p. 182.

Alan Donnithorne has drawn attention to one album in the British Museum collection with a Japanese cover, dating from *ca.* 1902, "made of lacquer-coated wooden boards with a photograph inset on the front cover. ... The highlight areas consist of particles of gold..." [78] From an analysis both structural (by microscopy) and spectrochemical (by X-ray fluorescence spectrometry), Donnithorne concludes that this image is an example of a 'dusting-on' or 'powder' process, in which light exposure through a negative diminishes the tackiness of a hygroscopic medium (dichromated gum plus sugar) on a dark-coloured substrate, so dusting with a light-coloured pigment, in this case gold powder, causes it to adhere in the highlight regions, giving a positive picture with a typically golden-yellow appearance.

[78] Alan Donnithorne, 'The Conservation of Historical Photographs at the British Museum', *The Paper Conservator*, 12 (1988) pp 72-79.

Gold as Sensitiser for Silver

Finally, mention must be made of a use of gold in photography that is by far the most important commercially, but of the least relevance to the present work: the sensitisation of silver halide-gelatin emulsions. Early photographic plates of this type had shown great variability in speed which appeared to be caused by the differing origins of the gelatin. For instance, cow gelatin yielded emulsions which were much faster than those using rabbit gelatin. It was surmised that something in the animals' diet might be responsible for the effect. In a *tour de force* of analytical chemistry, carried out in the Eastman Kodak Research laboratories in the 1920s, Samuel E. Sheppard identified the substances that were responsible for the sensitisation: they proved to be organosulphur compounds derived from plants of the genus *brassica alba*: thiosinamin (allyl thiourea) and mustard oil (allyl isothiocyanate).[79] Sheppard suggested in 1925 that these substances were responsible for forming sensitivity centres, possibly of silver sulphide or silver, on the surfaces of the silver halide crystals, and thereby improved their sensitivity to development. The surprising nature of this discovery has

[79] S. E. Sheppard, *Photographic Journal*, 65 (1925) 380; *British Journal of Photography*, 72 (1925) 481.

been encapsulated in the conundrum: "If cows had disliked mustard plants, we wouldn't be going to the cinema." The low activity of rabbit gelatin was attributable to the kind of foliage that the animals preferred to browse on. There is an apocryphal story that the tragic wholesale slaughter of the buffalo of the American plains was driven, in part, by the gainful prospect of selling their gelatin to the burgeoning photographic industry. Ironically, due to the grazing preferences of the beasts, buffalo gelatin turned out to be useless for this purpose – which proved, however, of little comfort to the buffalo.

Soon after Sheppard's discovery, a number of researchers found that an even greater sensitising effect could be produced in silver halide gelatin by the addition of trace amounts of gold salts to the emulsion, but this was accompanied by a disadvantageous increase in fog. It was not until 1936 that Koslowsky, working for Agfa, found that the use of gold(I) as dithiocyanatoaurate(I), the same substance that is formed in the gold toner mentioned above,[80] could increase the emulsion speed while avoiding the problem of fogging. Gold sensitising of silver-gelatin emulsions was kept secret for several years before any information was published, and the topic continues to be subject to close commercial confidentiality. The sensitisation is thought to involve replacement of some of the silver atoms of the latent image with gold atoms, which are more readily reducible by the developer, but the mechanism is still a problem at the frontiers of photochemical research, which takes it beyond the scope of this book.[81]

80 As the ammonium salt of formula: $NH_4[Au(SCN)_2]$

81 Wolfgang F. Berg, 'Gold Sensitization in Photography', *The Gold Bulletin*, 12:3 (1979) 97-98; Philip Ellis, *The Gold Bulletin*, 8:1 (1975) 7-12.

6 Re-invention of Chrysotype

The iterating of these lines brings gold.

Christopher Marlowe (1564–93)
The Tragical History of Dr. Faustus (1604)

Proto-photography

Prior to Talbot's discovery in September 1840 of the developable latent image in silver, his earlier version of photography on paper, which he called "photogenic drawing", was of the type we now refer to as a printing-out process; one in which the image is generated during the exposure, entirely by the action of the light alone. The term 'proto-photography' is convenient to describe this general class of photographic process, in which there is no amplification by development of the effect of the light, although there may subsequently be some chemical transformation of the resulting image, such as toning, in order to render it more visible or permanent. This name does not presuppose the precise chemical nature of the light-sensitive substance involved, for several quite distinct means were discovered in the earliest days of photography.[1]

The definition of proto-photography can be given a scientific gloss by calling on the idea of the quantum yield (also termed the quantum efficiency) of a photochemical process. This is a ratio, defined as the number of molecules transformed divided by the number of photons (quanta of light) that constituted the dose of light absorbed.[2] A theoretically ideal value for the quantum yield is 1.00, implying that each photon absorbed causes one molecule to react: "Everyone a coconut!" at the fairground shie. However, values of the quantum yield for proto-photographic processes are usually less than 1.00, owing to competing back-reactions which negate the chemical effect of the light. Less commonly, on the other hand, if the absorption of a photon can trigger a sequence of reactions, or a chain reaction, then the value of the quantum yield can take a value greater than one.[3]

1 Mike Ware, 'On Proto-photography and the Shroud of Turin', *History of Photography*, 21:4 (Winter 1997) 261-269.

2 A photon is the fundamental particle of light.

3 Such as occurs in certain polymer-hardening and free-radical reactions, but is not usual in photographic processes.

Proto-photography is strongly differentiated from the sophisticated, and vastly more sensitive development processes of modern photographic materials. Here, the exposure produces only a latent image, in which each light-struck grain of silver halide sprouts a 'sensitivity speck' on its surface, consisting of a cluster of a few silver atoms, which is totally invisible to the naked eye. This result is subsequently amplified more than ten million-fold by the specific process of development, where a chemical reductant seeks out the sensitivity specks as its points of attack, and transforms entire grains into shreds of metallic silver.

Given the same light source – the sun, in all early work – the exposures needed for these different photographic practices will have vastly differing relative durations, which are indicated approximately in Table 6.1, which also includes the relative exposure for the early development processes of daguerreotype and calotype. The column labelled "by projection" refers to any photographic recording process mediated by a lens, that is, in a camera or enlarger, where the aperture necessarily accepts only a small fraction – commonly about $1/100^{th}$ to $1/1000^{th}$ – of the light incident on the object.[4] The column labelled "by contact" refers to a direct projection of the object's shadow onto the sensitive material, simply obscuring the light source; that is, a contact print or a photogram.

Table 6.1 *Relative orders of magnitude for exposure times by methods of photography.*

Procedure	by Projection	by Contact
Modern Development	1	0.001
Calotype and Daguerreotype	10,000	10
Proto-photography	10,000,000	10,000

4 It may be shown from the Jones-Condit Equation that the relative intensities of light falling directly on the sensitised paper in a contact print, I_s , and on the paper at the focal plane of a camera, I_f, focussed at infinity, is given approximately by $I_s/ I_f \approx 5 A^2$, where A is the lens aperture (or 'f/stop' = focal length / aperture diameter). So, for a nominal value of f/4, $I_s/ I_f \approx 80$, and for f/16, $I_s/I_f \approx 1280$, etc.

From the table it becomes evident why proto-photographic processes are almost impossible to use in the camera, and are very rarely employed for enlargement printing. The early development processes of rather low camera speed, such as daguerreotype, calotype, ambrotype, and tintype, are still disadvantageously slow compared with

modern development materials, but nonetheless continue to be used and explored by latter-day practitioners within the wider artistic practice of alternative photography.

Historical Exploration of Alternatives to Silver

During the first 60 years of photography (1839–1899), cameras and their negative formats were necessarily large because nearly all prints were made by contact exposure. The light source invariably employed was the sun,[5] which is sufficiently intense to enable the use of alternative, proto-photographic processes for print-making. Throughout this period, many photosensitive materials, both inorganic and organic, were tested for their potential as photographic printing agents. These included certain salts of silver, iron, and uranium; the colouring matter of flowers; and colloidal substances such as gelatin, casein and resinous gums, which can be chemically hardened by light in the presence of dichromates. Such early discoveries provided the sources of the three principal categories of photographic printing practice that have come down to us today, based respectively on silver salts, on photochemical hardening of dichromated colloids, and on iron salts.

Silver halides provided the mainstream of photographic practice as it became realised commercially, and this subject is fully dealt with in many comprehensive texts.[6] The light-induced hardening of dichromated colloids, and the similar, more modern technology of photopolymers, provide alternatives for photographic print-making which offer certain painterly qualities, because they employ artists' pigments as the image substances.[7] These practices – gum bichromate, carbon, Artigue and Fresson printing – are generally grouped together as the 'pigment processes', and entail a particular type of photochemistry and practical *modus operandi*. It is only the last of these three principal categories, the iron-based processes, that will be considered in this book.

Some of these alternative printing process were welcomed into general photographic practice during the 19th century, because they could guarantee images having a

5 Only towards the end of this era were electric arc lamps made available.

6 T.H. James, Ed., *The Theory of the Photographic Process*, 4th Edn., New York: Macmillan 1977; Grant Haist, *Modern Photographic Processing*, Vol.2, New York: John Wiley and Sons 1979.

7 David Scopick, *The Gum Bichromate Book*, Boston: Focal Press 1991.

greater permanence than silver, which was beset with the problems of image fading. To work these insensitive processes, contact exposure to the negative was essential in order to transmit enough light, which had to have a substantial ultraviolet content. Sunprinting then was the order of the day, but the customary negative formats were much larger than they are now, so the whole plate (8.5 x 6.5 inches), or even larger negatives of the period could yield satisfying contact prints of the same size.

However, the adoption of compact cameras providing miniature format negatives on roll film demanded printing by enlargement, so for reasons of expediency and profitability, the printing technology marketed by the photographic materials industry during the 20th century has been almost exclusively based on the development of silver halide papers, because only they have sufficiently high sensitivity for projection printing. Consequently, a major manufacturing industry was founded around the end of the 19th century, and went on to dominate the commercial photographic market for the next hundred years. Within a few decades, both the iron-based processes and the pigment processes were forced into commercial obsolescence owing to their inconvenient limitation to contact-printing.

Iron-based Alternative Processes

In the dawn of photography, it was by no means obvious which system of photochemistry might provide the well-spring for successful technical development. In the first written account of his early experiments in 1839, Sir John Herschel remarked on his difficulties:

> "...I was on the point of abandoning the use of silver in the enquiry altogether and having recourse to Gold or Platina...".[8]

True to his word, Herschel investigated a large range of light-sensitive materials for their possible use in photography, and discovered several new processes, most of them based on iron salts, as described in Chapter 3.

Most alternative processes still bear the picturesque, classically-derived names coined by their originators:

8 Sir J.F.W.Herschel, 'Note on the Art of Photography or the Application of the Chemical Rays of Light to the purposes of Pictorial Representation', read before the Royal Society, 14 March 1839. A summary was published in *Proceedings of the Royal Society*, 4:37 (1839) 131-3, but Herschel voluntarily withdrew the full paper from publication in the *Transactions*. The unpublished MS has been rediscovered by Dr. Larry Schaaf in St. John's College, Cambridge, and transcribed in his paper, 'Sir John Herschel's 1839 Royal Society Paper on Photography', *History of Photography*, 3:1 (January 1979) 47-60.

Herschel, besides his chrysotype process, also invented anthotype or phytotype, based on light-bleaching of plant dyestuffs; cyanotype, the forerunner of the commercial blueprint process; kelaenotype, otherwise known as amphitype, which used mercury; and argentotype which gave a silver image, but via the iron photochemistry.[9] Later, in 1873, William Willis invented platinotype and, when platinum supplies dwindled during the Great War, he devised its analogue, palladiotype. Rival processes using silver, but based on Herschel's argentotype, were called kallitype and vandyke. The main iron-based proto-photographic processes, which were collectively dubbed "siderotypes" by the etymologically-inventive Herschel,[10] are summarised in Table 6.2 with their dates and inventors.

More than twenty iron(III) salts are now known to form iron(II) salts under the action of light, but only a few were commonly employed photographically, and the manner of their use can be categorised according to the three main ways in which they can be made to yield permanent images:

⊙ By reducing a salt of a noble metal to the metal itself in a finely-divided state. The noble metals are platinum, palladium, gold, mercury, and silver, which give rise, respectively, to the platinotype, palladiotype, chrysotype, kelaenotype and argentotype processes. (The use of other noble metals, such as rhenium, ruthenium, rhodium, osmium, and iridium, is possible in theory, but has not yet been achieved in practice because their reactions are inconveniently slow, and some are prohibitively expensive.)[11]

⊙ By coupling the iron(II) with a ferricyanide to yield ferric ferrocyanide,[12] which is otherwise known as the artist's pigment, Prussian blue. This is the basis of the cyanotype or blueprint process.[13]

⊙ By reacting with gallic or tannic acid to form images of iron-gall ink, a substance which has been used for writing since mediaeval times.[14]

9 The names mostly originate with classical Greek: *e.g.* cyano - κυάνεος- (kyaneos) - dark blue.

10 Deriving from the Greek σίδηρος (sideros) - Iron.

11 Michael J. Ware, 'Noble Metals for Common Images' in *Photochemistry and Polymeric Systems*, Eds. J.M. Kelly, C.B. McArdle, and M.J. de F. Maunder, Cambridge: Royal Society of Chemistry 1993, 252-265.

12 Now correctly named iron(III) hexacyanoferrate(II).

13 Mike Ware, *Cyanotype: The history, science and art of photographic printing in Prussian blue*, London: Science Museum and National Museum of Photography, Film & Television, 1999.

14 Lois O. Price, 'The History and Identification of Photo-Reproductive Processes Used for Architectural Drawings Prior to 1930', *Topics in Photographic Preservation*, 6, American Institute for Conservation Photographic Materials Group, 1995, 41-49. See also: www.ccaha.org/arch_records.php

Eleanor Kissel and Erin Vigneau, *Architectural Reproductions: A manual for Identification and Care*, Oak Knoll Press and The New York Botanical Garden, 1999.

Table 6.2 *Historical iron-based processes: 'siderotypes'*

Year	Inventor	Process name	Iron salt	Image substance
1842	Herschel	Cyanotype	Citrate	Prussian blue
1842	Herschel	Chrysotype	Citrate	Gold
1842	Herschel	Amphitype	Tartrate	Mercury
1842	Herschel	Argentotype	Citrate	Silver
1843	Herschel	Breath print	Tartrate	Silver
1858	Mercer	Chromatic Photo	Oxalate	Vegetable dyes
1861	Phipson	Phipson's process	Oxalate	Manganese dioxide
1873	Willis	Platinotype	Oxalate	Platinum
1877	Pellet	Pellet print	Tartrate	Prussian blue
1878	Willis	Sepia Platinotype	Oxalate	Platinum & mercury
1886	Colas	Ferrogallic process	Tartrate	Iron gallate ink
1887	Pizzighelli	Printout platinum	Oxalate	Platinum
1889	Nicol	Kallitype	Oxalate	Silver
1889	Arndt	Vandyke	Citrate	Silver
1889	Shawcross	Sepiatype	Citrate	Silver
1895	Arndt/Troost	Brown Line	Citrate	Silver
1895	Nakahara	Nakahara's process	Tartrate	Iron gallate ink
1897	Jarman	Aurotype	Citrate	Gold
1913	Willis	Satista print	Oxalate	Platinum & silver
1916	Willis	Palladiotype	Oxalate	Palladium

All these ferric processes have a similar *modus operandi*, but the characteristics of the image substances differ, and the relative merits of the most important of them, as media for fine prints, deserve a brief review.

The cyanotype furnishes an uncompromisingly blue image, and was formerly widely used for commercial plan-copying, but it also has a history of pictorial applications in photography, in spite of its strident colour. I have discussed at length elsewhere the attitudes to its aesthetic suitability.[15] The Prussian blue image colour may be modified by a variety of chemical toning methods, but the results of these are sometimes unstable. The unmodified cyanotype itself has good archival properties, provided it is kept in an alkaline-free environment and not subjected to very high light levels. Many historic specimens have survived well from the 1840s.

15 Mike Ware, op. cit., n.13.

Herschel's chrysotype is among the least-known of these processes, because it was completely by-passed in the mainstream of photographic development. Unlike the platinotype, for example, it was never carried into successful practice in the nineteenth century, as related in Chapters 3 and 4, owing to technical difficulties in controlling the quality and characteristics of the image, and the enormous expense of its consumption of the precious metal, which had to be employed in the developing bath. The only historical specimens of the chrysotype process that have been identified today were made in 1842–3 by Herschel himself.[16] They have survived extremely well as vigorous purplish-magenta images, completely undimmed, which can now be seen in the collections of the Museum of the History of Science in Oxford, the Library of the Royal Society, London, and the Harry Ransom Humanities Research Center at the University of Texas at Austin.

16 To these should be added one or two experiments by Robert Hunt and Hippolyte Bayard.

The amphitype (earlier called kelaenotype) was totally evanescent, as Herschel discovered to his chagrin, because the metallic mercury of the image is volatile and evaporates within a few days.[17] Specimens made by Herschel can be identified in the collection of the HRC; they are authenticated by his own handwritten annotations on the verso, and were apparently once of an excellent quality, as he described enthusiastically in his experimental notes, but all that remain today are stained scraps of paper bearing no clearly-discernable images.

17 Also spelt 'celaenotype'. The etymology of Herschel's process names is usually obvious, but 'kelaenotype' is a little obscure. He may have had the Greek κελαινός (kelaenos) in mind, meaning 'gloomy' or 'black' - such prints were "of an excellent inky blackness". Celaeno the Atlantid was one of the Harpies, perhaps reflecting Herschel's difficulty with the process! Talbot suggested that it should be re-named 'Amphitype' because it was capable of both positive- and negative-working.

The argentotype provides a brown silver image, consisting of nanoparticles which have a large surface area, unprotected from the atmosphere, and which are consequently very susceptible to attack by sulphur-containing compounds and oxidising acids. Stability is poor, especially if residual iron(III) is present, unless the silver is toned by gold, so very few identifiable specimens have survived from the early days of photography, and these are mostly very faded.

The later iron-based silver processes, kallitype, brownprint, and vandyke, are no more than re-inventions of Herschel's argentotype. Despite their popularity, which is

evident from the contemporary literature of the early 1900s, these processes appear to have generated very few surviving historical specimens. In response to a wide-ranging enquiry by the author,[18] only a handful were reported by curators and conservators to have been positively identified in collections dating from 50 to 100 years ago, when the processes were enjoying their heyday. Differing explanations have been put forward to account for this extreme rarity. It is possible that specimens were rejected as uncollectable, like cyanotypes, because the process was deemed to be in some respect inferior. This is an improbable reason if the process was sound, because kallitypes did not suffer from an aesthetically unacceptable colour like the cyanotype, and other types of brown/black, plain-paper silver print were keenly collected.

Alternatively, specimens may have been collected, but they may have faded and been disposed of or de-accessioned; this seems unlikely in view of curatorial scruples and the thoroughness of museum record-keeping. There is also the extravagant claim that has been repeatedly put forward by devotees of these processes that there are multitudes of historic kallitypes and vandykes "out there" in collections – but they have not been identified as such because they are masquerading as bogus platinotypes or palladiotypes. As yet, not a shred of substantive evidence has been offered to support this speculation. The myth appears to originate from a letter to the periodical, *Photographic News*, *ca*. 1900, in which the writer complained that a few unscrupulous commercial photographers were cheating their customers by supplying prints described as platinum which were actually on a matte silver bromide paper (not, it should be noted, kallitypes).[19] To propagate the canard that such fraudulent misrepresentation of platinotype was a widespread practice, unjustifiably demeans the ethics of the commercial photographers of the time.

The dearth of surviving historical specimens of kallitype and vandyke is the strongest indication we have that these processes, as practised at the time, were unreliable, and that

18 On the Photohistory List and the Alternative Photo Process List of the www.

19 *Amateur Photographer*, 34 (1901); 36 (1903) 143-4; 39 (1906) 401.

the prints they yielded must have been short-lived; they certainly acquired this reputation among photography writers of the day. There are many contemporary comments to this effect. Paul Anderson, for example, in his 1913 review of photographic printing media, states that:

> "…the [kallitype] image is so unstable that the process should be used for only the most ephemeral work.
>
> This statement will doubtless provoke violent protest from enthusiastic Kallitype workers, but it is true nevertheless … this medium is not advised for work of any importance."[20]

20 Paul L. Anderson, 'The Choice of a Printing Paper, with especial Reference to Platinum', *American Photography*, 7:6 (June 1913) 336-344.

The condemnation by R Child-Bayley, writing early in the 20th century, has an almost poetic sardonicism:

> "Kallitype is another printing process – or rather was, for nothing is heard of it now – and a batch of kallitype prints turned out of a drawer the other day bore no sign to distinguish the front of the paper from the back. The image which once had been vigorous enough, had folded its tents like the Arab and had silently stolen away."[21]

21 R. Child Bayley, *The Complete Photographer*, London: Methuen, 1932.

A few probable specimens of kallitype that the present writer has identified in early 20th century amateur archives, are mostly very deteriorated, showing severe iron stains, fogging, and fading. Latterday practitioners of kallitype and vandyke tend to hedge their bets by toning these prints with platinum, palladium, or gold; indeed, most workers today insist that this is essential to their permanence, but they may yet discover that they are building their houses of noble metal upon foundations of silver sand.

At the other end of the archival scale, pure platinum printing can justly claim to be the finest, most successful, and – with one proviso – the most permanent of all these iron-based processes.[22] William Willis's platinotype was in universal use a century ago, and every major photography collection today can boast of many fine specimens. Platinotypes even occur commonly as commercially-produced prints in domestic albums, dating from the period 1890 to 1910. The images are usually in perfect condition,[23] but it is the paper base that may suffer from embrittlement

22 Mike Ware, 'The Eighth Metal: the rise of the platinotype process', in *Photography 1900: The Edinburgh Symposium*, edited by Julie Lawson, Ray McKenzie, and A.D. Morrison-Low, Edinburgh: National Museums of Scotland and National Galleries of Scotland 1993.

23 Although the opposing page may bear an offset positive image, due to the platinum catalysing the decomposition of lignins in the paper.

by acid buildup and occasional yellow iron stains or foxing. Some platinotypes have a brown image due to Willis's invention of the sepia platinotype, which incorporated mercury salts in the sensitiser or developer. During the Russian Revolution and World War I there was a platinum 'famine' and platinotype papers became scarce, and were replaced by Willis's invention of the palladiotype, providing naturally warm-toned images. These also survive well and do not fade.

Willis's Satista process, on the other hand, represents an uneasy chemical compromise. There are incompatibilities in the relative solubilities of the silver and platinum salts, and doubts about the relative metallic composition of the image, which appears to consist mostly of silver. Examples are rare and hard to identify with confidence, except when the author of the work leaves an unambiguous indication of the material used, or when non-destructive analytical instrumentation is available. Even with recourse to X-ray spectrometry, there is no basis for distinguishing between a Satista print and a platinum-toned kallitype, or other silver print on plain paper.[24] Some historic specimens that have been positively identified as Satista prints are showing signs of deterioration, exhibiting the fading, discoloration, and mirroring typical of silver images.[25]

Characteristics of Siderotypes

Hand-made iron-based prints differ from prints on factory-manufactured silver-gelatin papers in a number of ways that have consequences both practical and aesthetic. It will be useful to summarise them here, also pointing out the divergences from that other major area of alternative photographic practice, the colloid-hardening pigment processes. The major characteristics of siderotypes are as follows:

⊙ The sensitiser is simply applied to plain paper as an aqueous solution, not as a suspension of solids. It may be 'washed over' in the manner of the

24 Jacqui Rees and Megan Gent, 'A conservation treatment to remove residual iron from platinum prints', *The Paper Conservator*, 18 (1994) 90-95.

25 Lisa Barro, 'Paul Strand's Silver-Platinum and Platinum Photographs', MFA Dissertation, 2002, Institute of Fine Arts, New York University.

watercolorist with a wide brush, or more controllably and economically spread by means of a glass rod.

⊙ There is no binder layer of colloid – such as gelatin or gum – so a totally matte surface results. The image in a siderotype lies within the uppermost fibres of the paper, and may be viewed from any angle without suffering reflective glare from the illumination.
The coated paper may be folded or blind-stamped without causing the unsightly cracking that occurs in a gelatin-coated paper. The absorbent surface remains ideally receptive to hand-colouring or re-touching with watercolour pigments.

⊙ There is no amplification of the light exposure as there is in the development of a latent image; the speed of these proto-photographic materials is therefore so low that contact-printing must be used. They will barely respond to projection printing by an enlarger, using ordinary technology. Moreover, the light source must have a substantial ultraviolet content. In compensation, there is no need for a photographic darkroom with safelighting to make the print.

⊙ The requirement for a large negative is technically demanding, and may impose its own limitations on the subject-matter. The preparation of enlarged internegatives by either analogue or digital means can overcome this problem.

⊙ Several noble metals can be chosen for the image, dispersed as nanoparticles, viz. platinum, palladium, silver, mercury, and gold, which all generate different image colours. The optical spatial resolution of siderotypes is in principle very high and the tonal gradation can be extremely subtle.

⊙ Printing-out of the image occurs with the methods used here, which makes the estimation of correct exposure a very simple matter of inspection during the printing. A long scale of negative density can be accommodated, owing to the self-masking effect of

the process, in which the darkened regions tend proportionally to resist further darkening by absorbing the incident light.

⊙ There is choice of surface texture and base colour for the paper of a siderotype. Nor is one restricted to the predetermined formats of commercial photographic papers, so the binding-in of images as an integral part of a book becomes possible, without the need for adhesives for 'tipping in'.

⊙ Images made in platinum, palladium and gold should be archivally permanent on a time-scale of many centuries.

Such characteristics may not be relevant, or even desirable, for the majority of everyday photographic printing, but their benefits in the areas of archives and fine art should be self-evident.

Revival of Alternative Processes

For much of the 20th century, the alternative printing processes languished in obscurity, eclipsed by the speed, convenience, and economy of industrially-produced photographic enlarging papers using the development of silver halide emulsions. But as the photographic materials industry progressed, so the range of factory-made printing papers tended to become ever narrower, supposedly in response to market forces. Contrary to the commercial stream of photographic practice, however, a few dedicated artists, in the USA particularly, sought to challenge the homogeneity of the commercial medium by re-juvenating the obsolete processes. For a well-illustrated review and critique, which places its main emphasis on the contemporary use of the alternative silver-based camera media, such as daguerreotype, ambrotype and wet collodion, the reader is referred to Lyle Rexer's aptly-named book with its oxymoronic title: *Photography's Antiquarian Avant Garde*. Rexer identifies the activity as a somewhat amorphous movement, in these perceptive terms:

"By 1995 and the apparent triumph of antiphotographic (or photocritical) art, camera artists with a wide variety of attitudes and motives were deliberately re-engaging the physical facts of photography, that is, its materials and processes, and turning to the history of photography for metaphors, technical insight, and visual inspiration. We call the movement to return to old photographic processes the antiquarian avant-garde."[26]

26 Lyle Rexer, *Photography's Antiquarian Avant-garde: the New Wave in Old Processes*, New York: Harry N. Abrams Inc., 2002.

The present chapter, as its title implies, is restricted to a rather narrower aspect of alternative photographic practice than those which interest Rexer: rather than the means of capturing the image in the camera, the present concern is only with the various iron-based methods of making the positive print from a camera negative, however acquired. Of all these methods, the platinum thread has proved most enduring. Although it died out completely in Britain, where it was invented, platinum printing was kept alive in the intervening years in the USA, by a few artists who had learned to hand-coat their own papers with the appropriate chemicals according to the traditional method. A brief chronological review is appropriate here, to acknowledge the achievements of these pioneers.

In 1937 the Platinotype Company in England, which had been the major commercial supplier of papers for nearly 60 years, was voluntarily wound up, and by 1938 the import of platinum papers into the USA was discontinued. In the same year, Paul Anderson, a quondam teacher at the famous Clarence H. White school of photography, re-published the 19th century platinum and palladium recipes. With the disappearance of the commercial papers, a few artists who were dedicated to the medium, most notably Laura Gilpin (1891–1979),[27] and Imogen Cunningham (1883–1976),[28] continued to hand-coat their own papers when occasion demanded over the next four decades. Nonetheless, the use of the process became very rare. In the early 1970s the noted American photographer George A. Tice re-discovered how to make platinum prints by the traditional method, and in 1972 the book series

27 Paul Hill and Thomas Cooper, *Dialogue with Photography*, London: Thames and Hudson 1979, 289.

28 Idem. 293.

141

Life Library of Photography published an illustrated account of his method.[29] In 1977 Nancy Rexroth gave impetus to the use of platinum printing by her study conducted at the Smithsonian Institute, published as *The Platinotype 1977*.[30] In the same year, the highly fashionable photographer, Irving Penn, exhibited large platinum-palladium prints of "street material" which attracted the attention of the widely-read critic A.D. Coleman.[31] William Crawford's seminal publication on early and alternative photography, *The Keepers of Light*, appeared in 1979, and remains to this day the most articulate introduction to the subject. In the same year, John Hafey and Tom Shillea published *The Platinum Print*.[32] 1984 marked the publication of the first edition of Luis Nadeau's scholarly *History and Practice of Platinum Printing*.[33] Although platinum-palladium printing was by then being taught in several institutions in the USA, the first practical workshop in the UK was conducted in 1986, at Paul and Angela Hill's Photographers' Place, in Bradbourne, Derbyshire, by Pradip Malde and the present author, who based their teaching on their revised and up-dated method.[34]

Stemming from these roots, the last two decades of the 20th century witnessed a minor renaissance – though some might term it a recrudescence – of alternative photographic printing, brought about by photographers who were dissatisfied with the monotony of the commercial silver-gelatin medium. These artists desired to exercise more control over the making of a print, which could be viewed, and hopefully collected, as an art-object *sui generis*.[35] The factors motivating them have been summarised by Luis Nadeau as follows: the finest quality silver bromide papers were disappearing from the market and their replacement by resin-coated papers left much to be desired for photographs that presumed to be valued as art objects; a range of hues could be achieved with relative ease by means of platinum-palladium printing; and teaching of the process was expanding in fine arts courses in the USA.[36] Alternative printing is now better-known, and is taught and

29 *Caring for Photographs*, Life Library of Photography, Time Life Books 1972.

30 Nancy Rexroth, *The Platinotype 1977*, Smithsonian Institute. Now available at: http://www.kimeia.com/pdf/platinotype77.pdf

31 A.D. Coleman, *Light Readings; a photography critic's writings 1968-1978*, Oxford: Oxford Univerity Press 1979, 261-5.

32 John Hafey and Tom Shillea, *The Platinum Print and the History of the Platinum Process*, Rochester NY: Graphic Arts Research Center, Rochester Institute of Technology 1979. Now available at: http://www.kimeia.com/pdf/history.pdf

33 Luis Nadeau, *History and Practice of Platinum Printing*, 3rd revised edition, Fredericton: Atelier Luis Nadeau, 1994.

34 Pradip Malde and Mike Ware, *The Ammonium System: a contemporary method for making platinum and palladium prints*, self-published, revised edition 2002.

35 A.D. Coleman, PhotoHistory List, 28-29 December 1999.

36 Luis Nadeau op.cit., n. 33, p.52

37 William Crawford, *The Keepers of Light*, New York: Morgan & Morgan 1979; John Barnier (ed.) *Coming into Focus*, San Francisco: Chronicle Books 2000; Richard Farber, *Historic Photographic Processes*, New York: Allworth Press 1998; Christopher James, *The Book of Alternative Photographic Processes*, New York: Delmar 2002; Dick Arentz, *Platinum & Palladium Printing*, Boston: Focal Press 2000; Robert Hirsch and John Valentino: *Photographic Possibilities*, Boston: Focal Press 2001; John P. Schaefer, *The Ansel Adams Guide: Basic Techniques of Photography, Book 2*, Boston: Little Brown and Company 1998; James M. Reilly, *The Albumen & Salted Paper Book*, New York: Light Impressions 1980; Dick Stevens, *Making Kallitypes*, Boston: Focal Press 1993; Luis Nadeau, *History and Practice of Platinum Printing*, 3rd edn., Fredericton: Atelier Luis Nadeau 1994; Luis Nadeau, *Modern Carbon Printing*, Fredericton: Atelier Luis Nadeau 1986; Luis Nadeau, *History and Practice of Oil and Bromoil Printing*, Fredericton: Atelier Luis Nadeau 1985; Randall Webb & Martin Reed, *Spirits of Salts*, London: Argentum 1999.

38 *The World Journal of Post-factory Photography*, Ed. Judy Seigel,

39 The Alternative Photo Process List of www.

40 Published as a practical manual: Pradip Malde and Mike Ware, *A Contemporary Method for Making Photographic Prints in Platinum and Palladium*, published by the authors, 1988. See also, n. 34.

41 M .J. Ware, 'An Investigation of Platinum and Palladium Printing', *Journal of Photographic Science*, 34 (1986) 165-177; Mike Ware, 'Platinum Reprinted', *British Journal of Photography* (10 October 1986) 1165-1167; (17 October 1986) 1190-1194.

practised among a growing constituency of specialised artist-photographers. This expanding interest is reflected in the spate of recently-published manuals on alternative photography, which will provide the reader with an introduction to any or all of the whole range of practices.[37] There has also been an occasional journal running to nine issues on the topic,[38] and there is still an active internet discussion list of more than 500 subscribers.[39]

Search for the Lost Chrysotype

In 1983, it was my chief ambition, through an improved understanding of the platinotype process, to make it more accessible and economic.[40] The fact, obvious to any chemist, that gold closely resembles platinum (the two metals are adjacent in the periodic table of the elements) led me also to test, *en passant*, the possibility of printing in pure gold. At that time I was totally ignorant of the history of photography, and was unaware of Sir John Herschel's researches and that he had already thought of gold printing 140 years previously. Preliminary results that I obtained with a sensitiser consisting of sodium chloroaurate and ammonium iron(III) oxalate were dramatic but unattractive, characterised by unacceptably high contrast and chemical fogging of the high values, which discouraged me from further experiment at the time.

In July of 1984, at the instigation of photographically-informed friends, I applied for, and was awarded a Kodak Photographic Bursary "to extend research into the iron-based processes of non-silver photographic print making; to finalise improved methods for publication and to prepare for exhibition a set of images in platinum, palladium and gold." The Kodak Bursary was completed by July 1985, and was subsequently marked by an exhibition of non-silver prints at Oldham Art gallery, and the publication of papers on platinum-palladium printing in the *Journal of Photographic Science* and the *British Journal of Photography*.[41]

Assisted by the grant, my research returned to gold in early 1985; I changed the sensitiser to ammonium ferric citrate, thus unwittingly re-inventing Herschel's chrysotype; the contrast this produced was less harsh, and I soon discovered that the chemical fogging could be prevented by processing the exposed print in a sodium sulphite solution, (present in Kodak Hypoclearing Agent) and clearing in disodium EDTA. The importance of the relative humidity of the sensitiser layer before exposure, and its effect on colour soon became apparent. However, the use of Herschel's chrysotype formula unmodified led to a disappointing quality compared with the platinotype, and the expense of employing gold in a development bath, or as a 'wash', as Herschel did, is exorbitant. I therefore began to apply some 20th century chemistry to the problem, in order to tame the vigorous and unpredictable behaviour of the gold salts, and achieve an economy in their use by incorporating a stabilised gold compound in a ferrioxalate sensitiser solution. A variety of reagents were tried at first to complex the gold,[42] but the most promising results were obtained by July of 1986, using the sodium and ammonium salts of orthobenzoic sulphimide, more familiarly known as 'saccharin'.[43] The print gradation and tonality achieved with this ligand were sufficiently good that a patent application was filed in 1987, under the aegis of the University of Manchester, then my employer, in case there might be commercial applications.

The development of this new process involved more than just finding a satisfactory sensitiser formulation: among the many parameters that had to be tested were the choice of paper, the effects of pH, double coating, pre and post humidifying, the action of wetting agents or surfactants, developing and clearing agents, the iron to gold molar ratio, and the effects of colloid protecting agents such as gelatin, and flocculants such as alum. If every possible combination of parameters had been systematically tested, the number of tests would have run to millions – in all, exceeding a lifetime's work. Scientific research in this area cannot afford to be totally methodical

42 These were mostly nitrogen donor ligands, giving soluble gold(III) complexes, among them: Diethylenetriamine; succinimide; pyridinedicarboxylic acid, iminodiacetic acid.

43 Also known as 2-sulphobenzoic acid imide, or more correctly: 3-oxo-2,3-dihydro-benz[d]isothiazole-1,1-dioxide.

Plates 1.1–1.4 The gold pigment 'Purple of Cassius' as applied to (clockwise from top left) 1.1 – stained-glass window, France; 1.2 – Cranberry glass; 1.3 – door in Buxton, U.K.; 1.4 – Crown Derby porcelain (courtesy of the Derby Museum and Art Gallery).

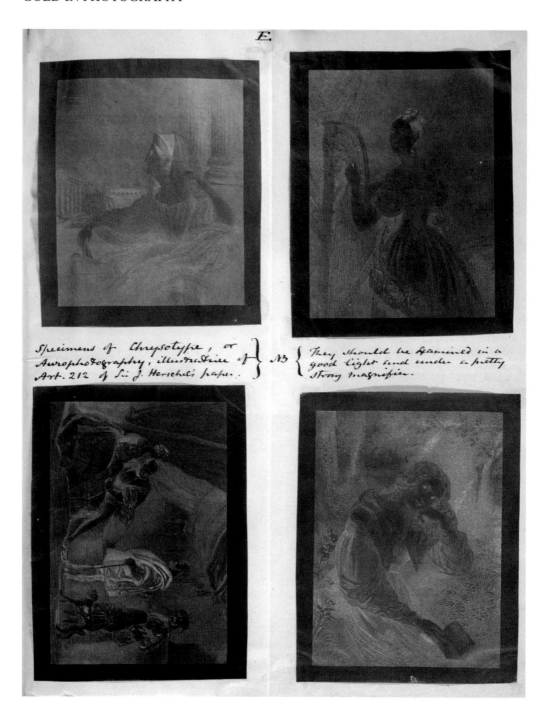

Plate 2 Sir John Herschel, *Specimens of Chrysotype or Aurophotography*, chrysotype prints, 1842, from engravings, 193 x 249 mm, courtesy of the Library of the Royal Society, London.

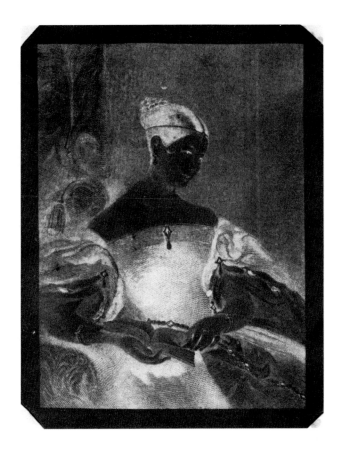

Plate 3 Sir John Herschel, *Mrs. Stanhope*, chrysotype print, 1842, from an engraving, 79 x 107 mm, courtesy of the Photography Collection, The Harry Ransom Humanities Research Center, University of Texas at Austin.

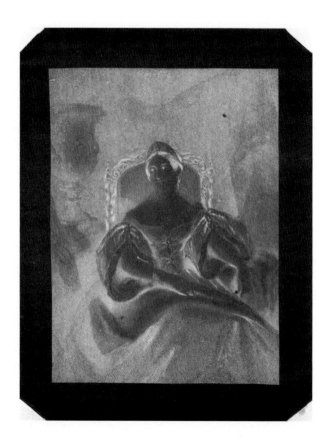

Plate 4 Sir John Herschel, *Rosolia*, chrysotype print, 1842, from an engraving, 78 x 104 mm, courtesy of the Photography Collection, The Harry Ransom Humanities Research Center, University of Texas at Austin.

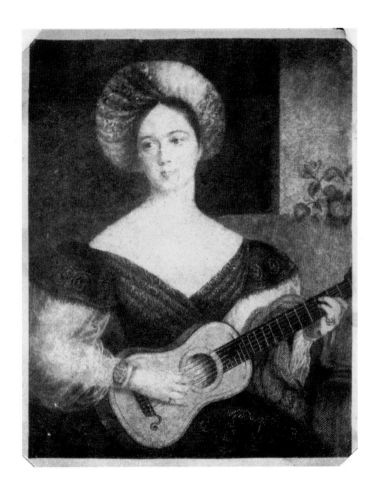

Plate 5 Sir John Herschel, *Lady and lute*, chrysotype print, 1842, from an engraving, 91 x 116 mm, courtesy of the Photography Collection, The Harry Ransom Humanities Research Center, University of Texas at Austin.

Plate 6 Sir John Herschel, *A Scene in Italy*, chrysotype print, 1842, from an engraving, 111 x 78 mm, courtesy of the Photography Collection, The Harry Ransom Humanities Research Center, University of Texas at Austin.

Plate 7 Dan Donovan, *Pataki Ruins, Sedona, Arizona*, new chrysotype print on Cranes Parchmont Wove, 190 x 241 mm.

151

Plate 8 Dan Donovan, *Untitled*, new chrysotype print on Simili Japon, 190 mm diameter.

Plate 9 Dan Donovan, *Untitled*, new chrysotype print, 190 mm diameter.

Plate 10 Tom Hawkins, *Salt Mound, Evening, Bonaire*, new chrysotype print, 100 x 100 mm.

Plate 11 Tom Hawkins, *Coast, Bonaire*, new chrysotype print, 100 x 103 mm.

Plate 12 Tom Hawkins, *Lemon House, Villa Gamberaia*, new chrysotype print, 91 x 120 mm.

Plate 13 Tom Hawkins, *Ancient Jewish Cemetery, Venice*, new chrysotype print, 85 x 115 mm.

Plate 14 Tom Hawkins, *Church of the Frari, Venice*, (version 1), new chrysotype print, 98 x 135 mm.

Plate 15 Tom Hawkins, *Church of the Frari, Venice*, (version 2), new chrysotype print, 98 x 135 mm.

Plate 16 Tom Hawkins, *Monastery of the Certosa, Florence*, new chrysotype print on vellum, 68 x 68 mm.

Plate 17 Tom Hawkins, *December Moonrise*, new chrysotype print on vellum, 254 x 58 mm.

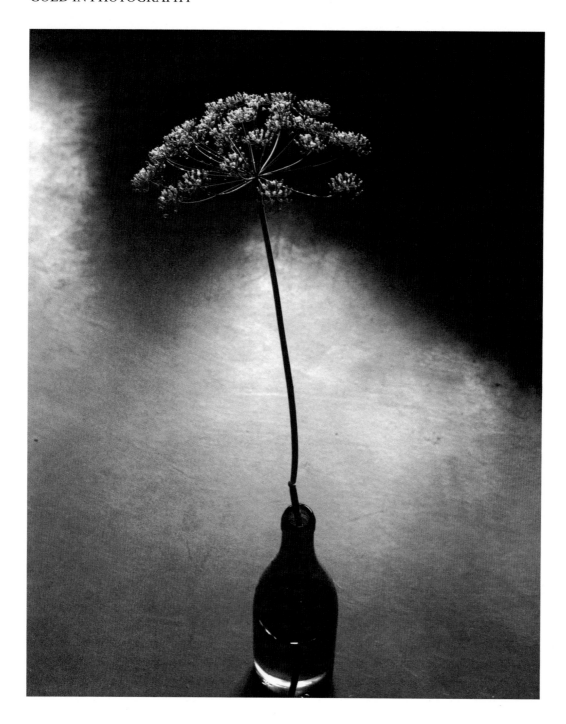

Plate 18 Pradip Malde, *Dill Flower*, new chrysotype print on Cranes Ivory Cover #5789, 190 x 240 mm.

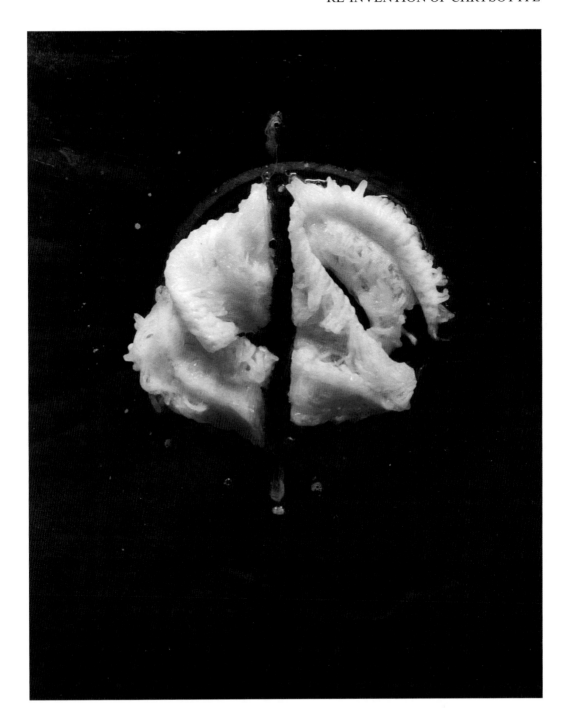

Plate 19 Pradip Malde, *Dragon Forming. Melon Seeds* (from the 'Dragon' series), new chrysotype print on Cranes Ivory Cover #5789, 230 x 290 mm.

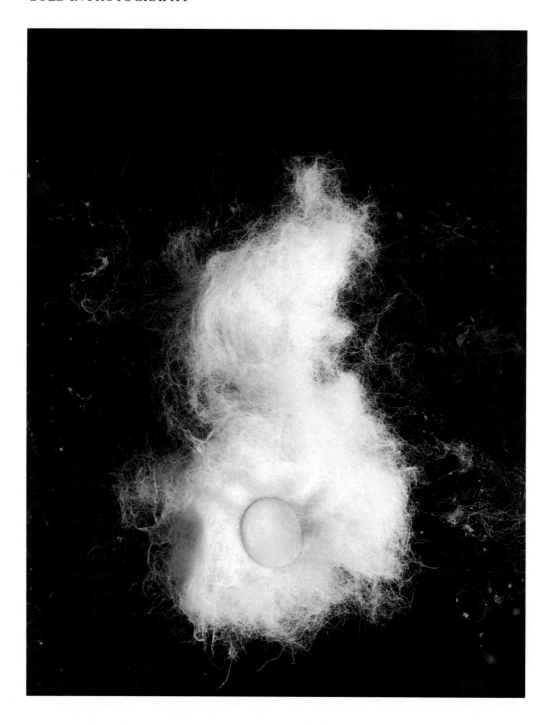

Plate 20 Pradip Malde, *Dragon Forming. Soap and Kozo Hair* (from the 'Dragon' series), new chrysotype print on Cranes Ivory Cover #5789, 260 x 340 mm.

Plate 21 Pradip Malde, *Photogram with finger protectors*, new chrysotype print on Buxton paper, 120 x 170 mm.

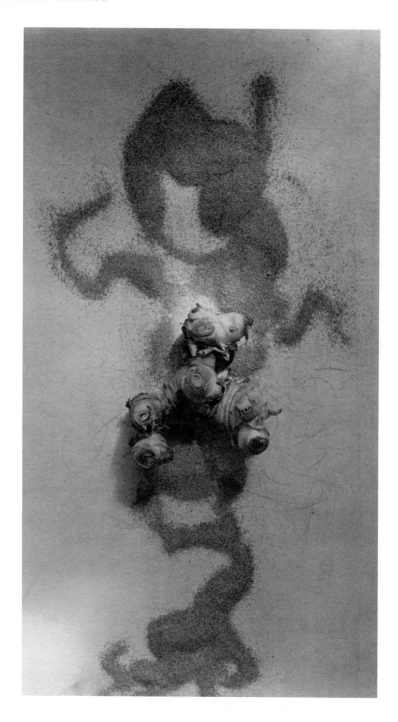

Plate 22 Pradip Malde, *Dragon Forming. Ginger and Sand* (from the 'Dragon' series), new chrysotype print on Cranes Ivory Cover #5789, 185 x 338 mm.

Plate 23 Pradip Malde, *Photogram with dendelion seeds*, new chrysotype print on Fabriano 5 paper, 55 x 245 mm.

Plate 24 Anjuli Raychaudhuri/Paul Daskarolis, *6 A.M.*, new chrysotype print on Buxton paper, 156 x 75 mm.

Plate 25 Anjuli Raychaudhuri/Paul Daskarolis, *Number 2*, new chrysotype print on Buxton paper, 169 x 106 mm.

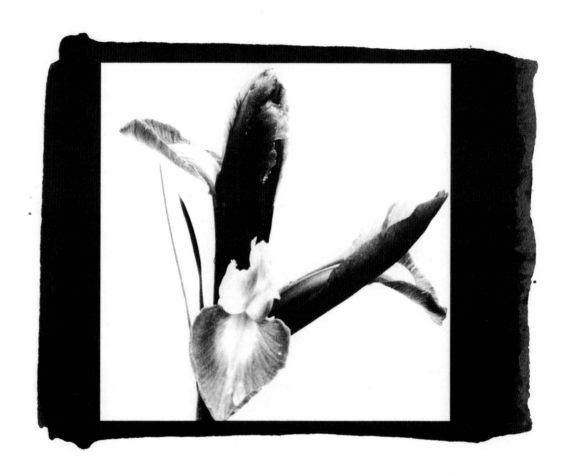

Plate 26 Anjuli Raychaudhuri/Paul Daskarolis, *Iris*, new chrysotype print on Buxton paper, 164 x 137 mm.

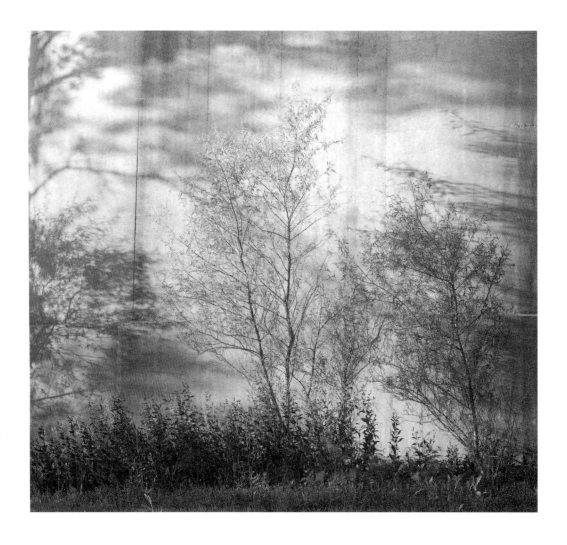

Plate 27 Roger Vail, *Tree & Wall*, new chrysotype print on Fabriano 5 paper, 183 x 168 mm.

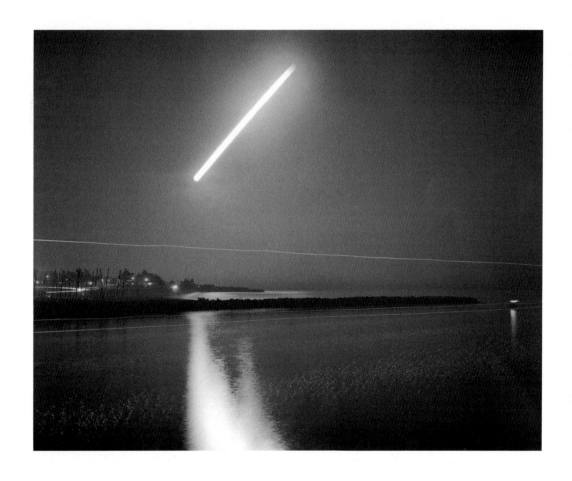

Plate 28 Roger Vail, *Santa Cruz Harbor*, new chrysotype print on Buxton paper, 243 x 190 mm.

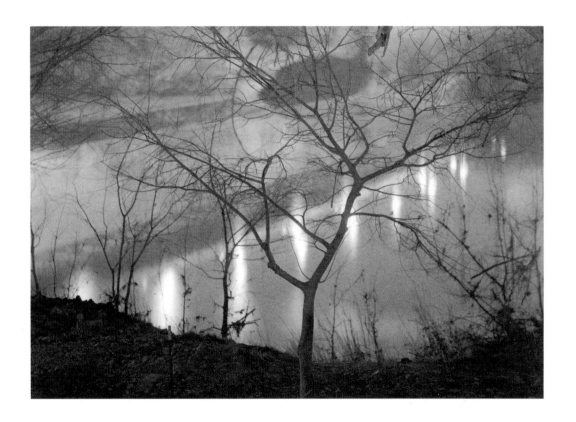

Plate 29 Roger Vail, *Untitled*, new chrysotype print on Fabriano 5 paper, 169 x 120 mm.

Plate 30 Roger Vail, *Untitled*, new chrysotype print on Fabriano 5 paper, 243 x 190 mm.

Plate 31 Roger Vail, *Easter Rainforest Sunrise*, new chrysotype print on Fabriano 5 paper, 243 x 190 mm.

Plate 32 Roger Vail, *Tower Bridge 3–18–96*, new chrysotype print on Crane's Cover *Natural White* card stock, 190 x 243 mm.

Plate 33 Mike Ware, *Monastery Bells, Patmos*, new chrysotype print on Buxton paper, 191 x 243 mm.

Plate 34 Mike Ware, *Apokalypsis,Patmos*, new chrysotype print on Buxton paper, 242 x 191 mm.

Plate 35 Mike Ware, *Iconostasis, Monastery of Chrysoroyyatissa, Cyprus*, new chrysotype print on Buxton paper, 242 x 191 mm.

Plate 36 Mike Ware, *Il Salvatore, Noto Antica*, new chrysotype print on Buxton paper, 193 x 242 mm. *Large format digital capture courtesy of www.artisan-digital-services.co.uk*

Plate 37 Mike Ware, *Deposition, Sicily*, new chrysotype print on Buxton paper, 240 x 190 mm.

Plate 38 Mike Ware, *Castello, Sperlinga, Sicily*, new chrysotype print on Buxton paper, 241 x 191 mm.

Plate 39 Mike Ware, *Confessional, Sicily*, new chrysotype print on Buxton paper, 241 x 192 mm.

Plate 40 Mike Ware, *Fragment from a crucifix, Sicily*, new chrysotype print on Buxton paper, 193 x 242 mm.

Plate 41 Mike Ware, *Ossuary, Noto Antica, Sicily*, new chrysotype print on Buxton paper, 242 x 193 mm.

Plate 42 Mike Ware, *Gull at Moi Geo, South Ronaldsay*, new chrysotype print on Buxton paper, 243 x 193 mm.

Plate 43 Mike Ware, *Starpool, South Ronaldsay*, new chrysotype print on Buxton paper, 241 x 191 mm.

Plate 44 Mike Ware, *Poppies at Woodrising*, new chrysotype print on Buxton paper, 193 x 243 mm.

Plate 45 Mike Ware, *Greenhouse,Balfour, Shapinsay*, new chrysotype print on Buxton paper, 241 x 191 mm.

Plate 46 Mike Ware, *"Snow Joke", Didsbury*, new chrysotype print on Buxton paper, 240 x 191 mm.

Plate 47 Mike Ware, *Cemented Timber, Castellana Sicula, Sicily*, new chrysotype print on Buxton paper, 240 x 192 mm. *Large format digital capture courtesy of www.artisan-digital-services.co.uk*

Plate 48 Mike Ware, new chrysotype 'colour palate', 125 x 220 mm. Created using a step tablet to print six tests on a single coated sheet, cut into strips, and processed at different RH values and/or with different developing agents.

– it is necessary to make intuitive jumps and assumptions to diminish the number of experiments merely into the thousands.

The major breakthrough came in March 1987 when, for stabilising the gold, I shifted attention from nitrogen ligands, like saccharin, to sulphur ligands. Previously, I had religiously avoided these because many organosulphur compounds are notorious for their evil stench, and any process, however beautiful, that was also extremely malodorous could not hope to find acceptance among artist-practitioners. However there are some benign organosulphur compounds, and my first test of thiodiglycolic acid[44] brought an excellent result, with a gradation of tone comparable with platinum-palladium. Other water-soluble sulphur ligands successfully tested included the amino acids methionine,[45] and cysteine.[46] Thiodiglycol[47] also showed great promise, but suffered from the stigma of being an immediate precursor in the synthesis of that infamous chemical weapon, mustard gas.[48] This enjoys such notoriety that, at the time, the availability of thiodiglycol was somewhat restricted; today its private possession could probably end one up in gaol. The best substance by far was the inoffensive thiodipropanoic acid,[49] which was readily and cheaply available from commercial chemical supply houses like Aldrich, and was free of any obnoxious or hazardous characteristics; indeed, it was recommended as an anti-oxidant additive for soap products and ethylene polymers, and has even been considered as an additive for edible fats, oils and other foods. From April 1987 onwards, this benign substance has been the only ligand that I have used for gold printing, feeling that it is not imperative to explore this option further, though doubtless there are many other ligands yet untested that would also 'work'. After much further experimentation, I arrived at formulations for making gold prints that displayed a good tonal gradation in a relatively wide range of colours, including neutral monochrome grey images having a quality that could compare favourably with platinotypes.

44 $S(CH_2COOH)_2$

45 $CH_3S(CH_2)_2CH(NH_2)COOH$
46 $CH_2(SH)CH(NH_2)COOH$
47 $S(CH_2CH_2OH)_2$
48 Dichlorodiethyl sulphide, $S(CH_2CH_2Cl)_2$

49 $S(CH_2CH_2COOH)_2$

1989 was the sesquicentenary year of Talbot's announcement of photography on paper, and was marked by several exhibitions across Britain celebrating his early achievement. By this time, the new chrysotype process had progressed to the point of producing exhibitable prints, so its potential was made public with a small exhibition of work by the author at the National Museum of Photography, Film & Television, Bradford, UK.[50] The Royal Photographic Society awarded me its Hood Medal in 1990, citing that I had "perfected formulae for iron-based gold printing sensitisers."[51]

The patent application was modified in 1988 to include thiodipropanoic acid; and searches by the patent office revealed no 'prior art', so the granting of the patent was set to take place. However, in the meantime, the lack of any commercial takeup or industrial interest in licensing the process had indicated that the expense of taking out a full UK patent (£1000) and perhaps seeking protection in other countries too, would not be worthwhile, so the patent application was withdrawn by the University. In consequence, I took the decision to disclose the process publicly, so that it could not be patented by anyone. Accordingly, the chemistry was published in 1992 in a paper to the Royal Photographic Society's Conference *Imaging the Future*,[52] and was followed by articles in the professional scientific literature in 1993[53] and 1994.[54]

Although the technical details had now been placed in the public domain, and were accessible to, and interpretable by anyone with chemical training, no attempt was made to provide a 'do it yourself' version for the amateur alternative process worker. The first publication of a version carrying detailed instructions is therefore the accompanying work, *The Chrysotype Manual*, with a format intended for the workroom rather than the coffee table. As an indicator of the practicability of a process, it is unwise to judge solely by one's own specialised experience (the phenomenon of the "self-instructed hand") so the method was tested privately in the first Chrysotype workshop, which was conducted by the author in July 2000 in Monterey County, California, with

50 'Gold Prospects', *The British Journal of Photography* (2 March 1989) 20-21; Bill Bishop, 'Mike Ware's Gold Standards', *The Photographic Journal*, 130:9 (October 1990) 410-2; Mike Ware, 'Prints of Gold: the chrysotype process re-invented', *Scottish Photography Bulletin*, 1 (1991) 6-8.

51 *The Photographic Journal*, April 1991, 166.

52 Michael J. Ware, 'Photographic Printing in Colloidal Gold', Royal Photographic Society, Imaging Science and Technology Group Symposium, *Imaging the Future*, Cambridge September 1992.

53 M.J. Ware, 'Noble Metals for Common Images', in John M. Kelly, Ciaran B. McArdle and Michael J. de F. Maunder (Eds.), *Photochemistry and Polymeric systems*, Proceedings of a Symposium held at Trinity College, Dublin, 1992, Cambridge: The Royal Society of Chemistry 1993.

54 M.J. Ware, 'Photographic Printing in Colloidal Gold', *Journal of Photographic Science*, 42 (1994) 157-161.

Pradip Malde and Roger Vail as co-tutors and nine participants. In the course of two days the students, who were already highly proficient platinum printers, produced without difficulty over eighty striking new chrysotypes between them, and some have continued to use the process for their personal work (see plates 7–47).

The virtues originally attributed to platinotype printing in the 19th century were often cited as "simple, beautiful, and permanent".[55] By the same token, it might be claimed of new chrysotype that it is "not-quite-so-simple, amazingly beautiful, and even more permanent".

Chromatic Considerations

The colours obtainable in new chrysotype images include pink, magenta, brown, purple, violet, and dull blue and green. This is not of course a natural rendition of colour, in the sense of being true to life. The colour might be described as surreal, or non-literal, because this is still essentially a monochrome printing process, using a conventional black and white silver-gelatin or digital negative. One of my purposes in developing this medium is to challenge the current presumption that monochrome photographs should invariably be black and white. In the later 19th century, brown and cream was, as an inevitable consequence of the materials, the fashionable colour scheme! When true black and white was first introduced in the 1870s, provided by the matte neutral tones of the platinotype, it proved so contrary to popular taste that William Willis had to return to his workbench in order to extend his process, so that he could also oblige the public with a more acceptable semi-glossy brown image, by means of his 'Sepia Japine' platinotype paper. Today, our visual aesthetic is more sophisticated and tolerant of a wider range of non-literal colour in photographic images. The self-appointed doyen of the Victorian photographic aesthetic, Peter Henry Emerson, will always be remembered for his splenetic dictum: "No-one but a vandal would print a landscape in red or in cyanotype."[56] This narrow-minded

55 Mike Ware, op. cit., n.22.

56 P.H. Emerson, *Naturalistic Photography for Students of the Art*, London: Sampson Low, Marston, Searle and Rivington 1889.

195

conceit appears to us now amusingly typical of this irascible, but paradoxically sensitive man;[57] it was also symptomatic of the general attitude that prevailed a century ago. Prejudice like this inhibited the major photographic collections in Britain from acquiring any cyanotypes during the nineteenth century,[58] and Emerson's proscription of red pictures furnished a reason for rejecting the chrysotype too, as a serious print medium.

Since Wolfgang von Goethe first published his *Theory of Colours* in 1810,[59] it has been widely accepted that colour, in the abstract, may carry its own emotive connotations, which can reinforce an artist's expressive intent by offering an extra psychological dimension for the image-maker to explore. To draw an analogy with music: the chromatic choice for a monochrome print can be likened to the composer's choice of key in which to set a piece. Much has subsequently been written on this topic, most of it deriving from Goethe's ideas; for instance, the colour aesthetics of the painter Wasilly Kandinsky[60] and the more analytical ideas of psychologist Dr. Max Lüscher,[61] who employed colour preferences as an index for his somewhat egregious method of personality testing.

The apt choice of colour for a monochrome image is far from being a new idea; it lay behind the use of the multifarious toning baths devised for silver images. In chapter 5, only gold toning was described, but there have been numerous other processes employing varied chemistry to achieve a whole spectrum of colours.[62] Moreover, despite its name, the Carbon process was not confined to lampblack, and pigmented papers in a wide range of hues were commercially available from the Autotype Company.

Justifying the Use of Gold

The objective of the work described in this book was to realise Herschel's vision of a chrysotype process, by creating a practical, economic method of printing in pure gold. It is reasonable to object to this aim: can there be any justification for re-inventing such an extravagant use of gold to make

57 As evidenced by his last work, *Marsh Leaves*.

58 Mike Ware, *.Cyanotype: the history, science, and art of photographic printing in Prussian blue*, London: Science Museum and National Museum of Photography, Film & Television, 1999, 23, 56-7.

59 Johann Wolfgang von Goethe, Trans. Charles Lock Eastlake, *Theory of Colours*, London: John Murray 1840. Reprinted by MIT Press, Cambridge, Mass. 1970.

60 W. Kandinsky, *Concerning the Spiritual in Art*, New York: Wittenborn Art Books Inc. 1947, 58.

61 M. Lüscher, *The Lüscher Colour Test*, I.A. Scott, trans. London: Pan Books 1987, 15-16.

62 Sigismund Blumann, *Photographic Workroom Handbook*, 3rd Edn. San Francisco: Camera Craft Pub. Co. 1930, 36.
Grant Haist, *Modern Photographic Processing*, Vol.2, New York: John Wiley and Sons 1979.

photographic images in the modern era? Or does it amount to nothing more than a costly romantic indulgence in an historical curiosity? At a time when printing even in silver itself is becoming increasingly expensive, and the traditional photographic materials industry is being displaced commercially by the more economic alternative of ink-jet printing, it may seem both profligate and irrelevant to seek a method of printing in gold. In justifying such a project, therefore, I hope to show that the unique characteristics displayed by this medium can qualify it for a place within those specialised areas of photographic practice that are concerned with fine art and archival documentation.

As to cost, it is true that a gold print is more expensive than one in silver, but it is substantially less than a print in platinum or palladium, which are once more being widely used.[63] As we saw in Chapter 1, gold has found rather little practical use in industry, until recently, compared with platinum and palladium, and the actual consumption of gold has been small. However, there have been some exciting developments and discoveries in the catalytic chemistry of gold within the last decade which portend a substantially greater use of the metal by industry in the future.[64] While a small proportion of the world's extracted gold is put to good decorative use, which most people can enjoy, the great bulk still resides in underground vaults, inactive and useless, except as a token of wealth. At present, to employ a tiny portion of it for the 'frivolous' purpose of picture-making is not going to deprive commerce, science, or the eco-system of a much-needed resource.

Science in Photographic Art

Concerning the creation of any work of art, it must be conceded that science has no right to comment. The mind-set of the artist does not yet fall within the purview of scientific analysis – and for the sake of our humanity, perhaps it never should.[65] The artist invokes poetic tropes; but metaphor and allegory find no place in formal scientific descriptions, where the exposition of ideas is more

63 The market price of palladium has of late been extremely volatile, thanks to the activities of speculators and its important commercial application as a catalyst for the compulsory reduction of the pollution from automobile exhausts.

64 David T. Thompson, 'The International Conference on Catalytic Gold, Cape Town, South Africa, 2-5 April 2001', *Gold Bulletin* 34:2 (2001) 56-66.

65 The role is confined to conservation of the art object: science may well be called upon eventually to aid its preservation.

narrowly restricted to a literal symbolism, and is only allowed, at most, to enlist simile and analogy to help clarify its meanings.

In contrast to the classical graphic arts, photography is generally acknowledged to be that rare hybrid, an 'art-science'. The application of photography, from start to finish, calls for the deployment of much more technology and quantitative reasoning, either explicit or implicit, than is required for the practice of other fine-art media, where the reliance has always lain on time-honoured craft experience and psychomotor skills of a traditional, unquantifiable kind. It is coming to be more widely acknowledged, however, that many respected painters did not disdain the use of geometrical and optical aids to assist their draughtsmanship, and the art-historical significance of these instruments has recently been re-evaluated.[66] As a necessary pre-cursor to photography, the *camera obscura* played an essential role.

Photography may now be practised quite effectively as a medium of art, without giving any thought to the science underpinning it, which can be submerged invisibly below the surface. Artist-photographers may choose to leave the technology of the image-making process entirely to others – their assistants, printers, photographic scientists, and even high-street photography shops. Modern automated equipment, employing commercial materials dependent on high-technology, and a vast support industry have all evolved to equip present-day photographic artists with this freedom to exercise their vision unfettered. To reach this state of refinement, the medium of silver-gelatin photography has, over its commercial lifetime of more than a century, received the closest attention from a host of professional scientists, deploying the most sophisticated resources, within the research laboratories of the major photographic companies, such as Agfa, Fuji, Ilford, and Kodak. As the dividend from a huge investment in countless scientist-years of research, the materials and processes of the photographic industry, based on gelatin-silver halide emulsions, have today reached a highly

66 Martin Kemp, *The Science of Art*, New Haven: Yale University Press 1990; Philip Steadman, *Vermeer's Camera*, Oxford: Oxford University Press 2001; Doug Nickel, 'The Camera and other Drawing Machines' in *British Photography in the Nineteenth Century*, Ed. Mike Weaver, Cambridge: Cambridge University Press 1989; David Hockney, *Secret Knowledge*, London: Thames & Hudson 2001.

reliable, user-friendly state. It is ironic that, just as the practice of analogue chemical photography has reached this apogee of perfection, it should be so profoundly challenged by digital electronic imaging – but that is a topic for the next chapter.

Besides the 'artist-photographers', there is also a class of practitioners, the 'artist-scientists' of photography, who choose to combine the picture-making with a personal involvement in the technical workings of the medium – and this necessarily entails some comprehension of its chemistry. Such practitioners tend to be attracted particularly to the alternative processes, but here they cannot call upon technical support from a huge professional resource-base like that of the commercial silver-gelatin medium. Sensitised materials for the alternative photographic processes are not produced industrially – or they ceased to be a century ago – so they must now be prepared by the users themselves. As a consequence of their non-commerciality, these alternative processes have undergone rather little scrutiny by professional scientists in modern times. Because they originate with nineteenth-century chemical concepts, their theoretical basis is now out-of-date. They entice would-be practitioners into an unmoderated arena of amateur experimentation that is bereft of professional standards or academic evaluation.[67] When, from time to time, a claim emerges from this arena for a 'new process' of alternative photographic printing, the lack of any peer review of the science must always leave doubt if the process is photochemically sound, or if the claim put forward for novelty is justified. Unrefereed self-publication, or broadcasting on the Internet, is unrestrained in its dissemination of fallacies concerning alternative photographic processes. As with so many of the other practices that display the label 'alternative', the maxim should be: *Caveat lector*.

Now, it cannot be denied that good art may be accomplished by means of bad science. Indeed, it is obvious that good art can be made without any science at all. But the making of art – of any quality – does not legitimise bad

67 I hold no brief against amateur chemistry: it can provide instructive (if sometimes hazardous!) recreation for enthusiasts. We all have to begin somewhere.

science as a preferred methodology for others to follow. Chemical procedures conceived by amateur artist-scientists often prove unsound and are rarely optimised; their anecdotal accounts usually serve only to muddy the pool of knowledge by obscuring the elegant simplicity of an original idea, and may cause waste and unnecessary expense. As the early chemical author Samuel Parkes (1761–1825) wisely observed: "An experimentalist without theory is the dupe of every illusion."[68]

68 Samuel Parkes, *The Chemical Catechism*, London: 1814

As we have seen, the history of photographic processes is littered with the productions of the "prowling plagiary", whose technique is to appropriate a well-established process, make some altogether trivial modification and give it a fancy name, to justify the claim that their "new" process is "not identical" to the old. Alternative processes that are not founded on properly-understood chemical principles usually betray themselves by needless over-elaboration, sometimes offering a breadth of choice akin to purchasing a lottery ticket – and with similar chances of repeatable success. Typically, the ingredients in the chemical recipe or the number of steps in the process become implausibly numerous, and potential users are enticed with the promise of a "vast range of creative options" in order to disguise the inadequate chemistry. At the other extreme, claims for the further 'simplification' of processes which are already irreducibly simple, can only result in degrading their quality. It is obvious that true creativity in photography can never derive from endless variations in its chemistry, but only from that unique source, the personal vision of the individual artist.

Thoroughbred Processes

Paul Strand, writing about the conventional silver-gelatin medium, was emphatic – and some might even say prejudiced – in his vision of the purity of process:

"The full potential power of every medium is dependent upon the purity of its use, and all attempts at mixture end in such dead things as the color-etching, the photographic painting and in photography, the gum-print, oil-print etc., in which the introduction of handwork and manipulation is merely the

69 Paul Strand, 'Photography', from *Seven Arts* 2 (August 1917) 524-5. Reprinted in *Photography: Essays & Images Illustrated Readings in the History of Photography*, Ed. Beaumont Newhall, New York: Museum of Modern Art 1980, 219-220.

expression of an impotent desire to paint. …The photographer's problem therefore, is to see clearly the limitations and at the same time the potential qualities of his medium…"[69]

The best monochrome photographic printing processes have a thoroughbred pedigree: they are heirs to a tradition that produces, by simple means, images consisting of single, well-characterised, inert substances, such as pure silver, platinum, palladium, gold, or a stable pigment. Single substances – *i.e.*, elements or well-defined compounds, rather than mixtures – have optical properties that are intrinsic to their nature: admittedly, each can usually display only a narrow range of colour, but they are completely reproducible. It is well-known that most photographic image substances can be visibly manipulated by a plethora of chemical toning procedures, in which they are converted, wholly or partially, into derivative compounds, or are coated with totally different substances, which are sometimes less stable than the original. To the purist, such practices only betray the irrational compulsion "to gild refinèd gold, to paint the lily…" which, as the Bard so deftly put it, "… is wasteful and ridiculous excess."[70]

70 William Shakespeare, *King John*, act 4, scene 2. See the epigraph prefacing chapter 5.

In the case of silver prints, however, where the original image material does not enjoy the highest chemical stability, it must be admitted that the judicious use of toning can yield an enhanced appearance and improved permanence; so we have the well-tested recommendations for toning silver prints with selenium, or gold as described in the last Chapter. But to engage in similar practices for the metals more noble than silver, is simply to repudiate the quality of our materials. So far as platinum and palladium are concerned, we might re-iterate Henry Ford's specification for his Model T: "Any colour – so long as it's black". Or brown.

When viewing a photograph, we each make our own judgment as to whether it is a good work of art – but how often do we ask if it is also a good work of science? Bad science is wasteful of time and materials, and few

self-respecting artists can welcome waste. Their task is hard enough, without having to reject work because of technical shortcomings in the materials. Yet the art-science of alternative photographic printing sometimes seems to offer a haven of self-justification for those who are prone to suffering failures with their materials – and then try to make a virtue of the sadly inadequate outcome. This is not to deny the value of the occasional, delightful stroke of serendipity, which may lead us on to fresh pictorial discoveries, but it is quite another thing to surrender oneself into the arms of chaos. If that practice is argued by some alternative print-makers to be a valid artistic position, then so be it – but this book is not for them. Photography is a tree rooted both in art and science; it is not valid to judge the fruit of that tree solely by the criteria of either.

My attempts to revive and revise alternative photographic processes are founded on a conviction that artists deserve the *best* science – even if they may sometimes exercise the right to refuse it! The working materials that science offers to art should be impeccable. Iron-based alternative processes can provide the artist with a medium that is deeply satisfying in its own right: the end-product is an accessible and enduringly stable image, constituted of a remarkable union between the rarest of metallic elements and the commonest of organic molecules to be found on this planet: a noble metal embedded in the fibres of pure cellulose paper. The hand-making of a photographic print by such means, yields an object that has a simple integrity *per se*, and is consonant with the artistic ideal of being true to one's materials.

The Eightfold Path

In every attempt to improve and develop the iron-based alternative processes, the following criteria are the paramount principles that have guided my work:
Clarity
The procedure should be fully described so that any competent practitioner is able to follow it without

unnecessary fuss, complication, or uncertainty. This requires that the methodology be given a close shave with Occam's Razor – the 'principle of parsimony'.[71]

71 Occam's Razor - the "principle of parsimony" - has been stated in many ways, but for the present argument: "It is futile to do with more what can be done with fewer."

Facility

The necessary chemicals and paper should be well-characterised and unambiguously specified; they should be globally available and as reliably consistent as possible. The use of ill-characterised chemical compounds, or proprietory preparations of unspecified or secret composition, which are changeable at the whim of the manufacturer, should be avoided.

Safety

The use of the chemicals in practice should be safe, given reasonable precautions. Hazards which are inevitable should be clearly stated, so that each reader can assess their own capability of dealing with them. The processing chemistry should take due regard of any threat to the environment.

Stability

Sensitiser solutions should have good stability and shelf-life, and not suffer any change in their properties within a reasonable time span of use, preferably of a year or more.

Economy

Usages should not be wasteful, especially of the precious metals (*e.g.* in developer baths); sensitiser formulations should not be so weak as to require double-coating to achieve an adequate maximum optical density.

Controllability

It should be possible to control the characteristics of the image – especially colour and contrast – within the natural limits permitted by the image substance. Striving to impose characteristics which are not innate to the substance is contrary to the principle of 'truth to materials', and rarely leads to the finest results.

Consistency

There should be a consistency among all the iron-based processes, so that one correctly-made negative will print well in all of them. Practitioners should reconcile

themselves to the fact that such a negative will *not* be suitable for projection printing on conventional commmercial silver-gelatin papers.

Quality

The resulting prints should be of the highest possible quality, in terms of tonal separation and resolution, *i.e.* their Modulation Transfer Function.[72] They should also be processed to a standard of permanence as high as the intrinsic chemical stability of the image substance allows.

72 The MTF is defined in H.J. Walls and G.G. Attridge, *Basic Photo Science*, London: Focal Press 1977.

Optimisation

Inevitably, some of these criteria may prove to be mutually incompatible, and then one has to decide priorities and make compromises. In the final analysis, it is the quality of the print that should be paramount, but this is no excuse for reiterating the old refrain: "the only thing that matters is the print" in order to justify slipshod or inadequate science.

Ideally, it should be possible to make up and store the sensitiser for an alternative process within a single bottle, so that practitioners need do no chemical mixing themselves, but simply coat their chosen paper. This convenient working method has been achieved for most of the iron-based processes, including platinotype, palladiotype, argyrotype, and new cyanotype, where it has been possible to devise 'one-bottle' sensitisers with a long shelf-life. However, the new chrysotype is such a subtle and chemically sensitive process that I have not yet succeeded in reducing it to this ideally simple state, and I can see no prospect of doing so. It remains a 'three-bottle process' at best, and, to achieve the widest range of options, a 'four-bottle process' is called for. All these separate components do last indefinitely as stock solutions, however. Their preparation, mixing, and use is fully described in the *The Chrysotype Manual*[73].

73 Mike Ware, *The Chrysotype Manual*, Brighton, Ffotoffilm Publishing, 2006.

7 The Future of Chrysotype

Aetas Auri Regetur
(The Golden Age is restored)

Coronation Ode of Richard the Lionheart 1189

Identification

The collector, the curator, and the conservator all need to know, with confidence but in varying degrees of detail, something of the physical nature of the objects in their keeping. What evidence is there that chrysotypes are, as claimed, composed only of gold? How can any questioned specimen be tested to determine if it is indeed a chrysotype – or some other process? The unambiguous answer to these questions is provided by the 'non-destructive' methods of analysis using X-ray fluorescence spectrometry (XRF, for short) and scanning electron microscopy with energy-dispersive X-ray analysis (SEM/EDX). These well-established techniques, long used for the analysis of other, more robust museum objects, are now finding wider application for the identification of photographic processes, as museum professionals gain confidence that their application is indeed 'non-invasive' and does no harm to the photographs.[1]

For those readers who have an interest in the mechanisms of such things at an atomic level, a brief non-technical description of the phenomena now follows. Both XRF and EDX depend on the process of knocking out one of the electrons from the electronic 'core' of the atom, close to the nucleus: XRF achieves this by using a beam of highly energetic X-rays to collide with and displace the electron; EDX uses a stream of high energy electrons to perform this 'sub-atomic billiard game'. Loss of one of its core electrons creates a 'hole' in an atom's inner electron shell, but this vacancy is rapidly filled by one of the electrons that are less tightly bound, in the outer reaches of the atom, dropping down into it, with the energy difference consequently being emitted as electromagnetic radiation. This energy is so high that the radiation takes the form of

1 James L. Enyeart, Adelaide B. Anderson, Steven J. Perron, D.K. Rollins and Quintus Fernando, 'Non-Destructive Elemental Analysis of Photographic Paper and Emulsions by X-ray Fluorescence Spectroscopy', *History of Photography*, 7:2 (April-June 1983) 99-113; Siegfried Rempel, 'Energy Dispersive X-Ray Fluorescence Applications in the Examination of Historic Photographic Artifacts', *Proceedings of the 10th Anniversary Conference of the Institute of Paper Conservation, The Paper Conservator*, 12 (1988) 80-85.

X-rays, rather than light (the original phenomenon of fluorescence).[2] Now, atomic energy levels are quantized, that is, they can only take certain well-defined values. So when atoms are strongly excited in this way, they emit X-rays having characteristic energies (or wavelengths, which are equivalent), which can be analysed spectrometrically, and because they depend on the atomic number (Z) of the element, they identify the element whose atoms are being excited.[3] More than one transition (or electron 'jump') can occur within the atoms of a given element, so a whole set of characteristic, closely-spaced X-rays is emitted, whose energies identify that element as uniquely as if it were labelled with a supermarket barcode.

2 The energy difference is proportional to the frequency of the radiation $\Delta E = h\nu$

3 The atomic number Z is proportional to the square root of the energy.

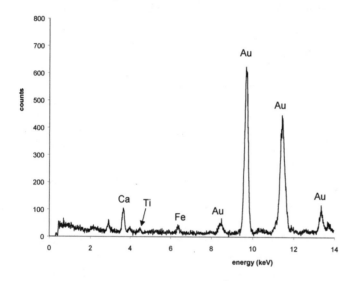

Figure 7.1 *X-ray fluorescence spectrum (XRF) of a new chrysotype ('Poppies at Woodrising', 23/07/90, by Mike Ware). Gold (Au) is the only constituent of the image; the trace elements (Ca, Ti, Fe) also occur in the blank paper. Courtesy of Dr. Karen Trentleman, Conservation Department, The Detroit Institute of Arts, Detroit, Michigan.*

There are some differences in the way the instrumentation for these two investigative techniques can be applied. It is possible to configure the XRF apparatus so that it is entirely non-invasive, and can be applied to an object of any size: the X-ray source and detector assembly is simply 'wheeled up' to the specimen and kept a few centimeters distant from it, so there is no contact. Due to the X-rays traversing a short path of air – the atoms of which (especially the 1% argon) obscure the light elements, the chief restriction of the XRF technique is that, as usually applied, it can only detect elements with atomic number, Z,

greater than 18 (argon); sulphur (16) and chlorine (17) may be hard to detect unless they are present in high concentration. This problem can be partially overcome by directing a flow of helium gas to displace the air between object and instrument.

In contrast SEM/EDX requires the object to be placed in a vacuum chamber of the instrument, which is of limited size (usually no more than 20 cm), so only small prints or detached fragments can be examined. However, the EDX method can detect the lighter elements, down to atomic number Z=10. The electron microprobe is produced in a scanning electron microscope (SEM), and so the EDX analysis is usually coupled advantageously with visual imaging of the object. The magnified image of the target area simultaneously obtained by electron microscopy makes this a powerful tool for probing heterogeneous specimens, in which individual particles, crystals, and fibres can be analysed, but the electron beam only penetrates the surface to a very shallow depth, compared with the X-ray method, so any material in the interior of a sheet of paper is masked. Until recently, technical problems confined the magnification to few hundred times, because non-conducting samples acquire an electrostatic charge in the electron beam, which distorts the image. This is usually remedied by coating the sample with an electrically-conducting substance such as graphite or gold – not a useful procedure if it is gold that one is looking for! But recently state-of-the-art SEM instruments have made it possible to magnify uncoated specimens more than 100,000 times – enough to see the individual nanoparticles of gold in a chrysotype residing in the cellulose fibrils (see Figures 2.1–2.3, page 49).

While both these methods can state what chemical elements are present in a sample, they say nothing about the state of chemical combination of those elements, *i.e.* the compounds that may be present; the information is atomic and not molecular in nature.[4] The analysis is also essentially qualitative, or semi-quantitative at best: although peak heights in the spectra are related to the concentrations of the elements, there are several factors depending on the

4 For molecular information it is necessary to turn to vibrational spectroscopy - infrared and Raman.

5 Constance McCabe and Lisha Deming Glinsman, 'Understanding Alfred Stieglitz' Platinum and Palladium Prints: Examination by X-ray Fluorescence Spectrometry', *Conservation Research*, (1995) 71-85; Katherine Eremin, J. Tate, A.D. Morrison-Low, J. Berry, and S. Stevenson, 'Non-destructive analysis of nineteenth century Scottish calotype negatives and salt prints', *Materials Issues in Art and Archaeometry VI, Materials Research Society (2002)*; Katherine Eremin, J. Tate, and J. Berry, 'Non-destructive investigation of nineteenth century Scottish photographs', *Proceedings of Conservation Science 2002*; Jacqui Rees and Megan Gent, op. cit. ref. chap. 6, n. 24; Lisa Barro, op. cit. ref. chap. 6, n. 25.

nature of the sample that complicate this relationship, and it is only possible to obtain quantitative data with reference to carefully prepared and calibrated standards.

The X-ray spectra of historic photographs have now been studied in a number of institutions, which have satisfied themselves that the methods using modern instrumentation are indeed non-destructive.[5] By recording spectra from dense regions of the image, and comparison with the spectra from highlight regions and the untreated margins of the sheet, if any, the elements that comprise the photographic image may be distinguished from those present in the paper substrate, as additives or impurities. Care must be taken, because of the penetrating nature of the X-rays, to eliminate signals from the mounting media, or other photographs in an album. These methods have been successfully applied to distinguish between platinum (Z=78), palladium (Z=46) and silver (Z=47) images, and combinations of these, in the archives of some of the most celebrated photographers, such as Paul Strand, Frederick Evans, and Alfred Stieglitz. Toning agents such as mercury and selenium are detectable, and gold, being a very heavy element (atomic number Z=79), produces a strong and readily identified X-ray signal, so is easily detected for example in gold-toned silver images, which also always show a strong signal from the residual silver, as well as the gold plating it. Chrysotypes, however, show no other heavy metal but gold in their X-ray spectra, as the predominant component, the only other peaks appearing weakly are trace amounts of iron, calcium, copper, and zinc due to impurities in the paper. Figures 7.1–7.2 illustrate the X-ray spectrum of chrysotype images.

Quest for Permanence

Since the earliest days of photography, the problem besetting conventional silver images has always been their chemical reactivity and consequent impermanence. The vulnerability is exacerbated when the silver nanoparticles[6] are not enclosed in a colloidal binder of albumen, collodion, or gelatin. In plain salted paper silver prints, the

5 Constance McCabe and Lisha Deming Glinsman, 'Understanding Alfred Stieglitz' Platinum and Palladium Prints: Examination by X-ray Fluorescence Spectrometry', *Conservation Research*, (1995) 71-85; Katherine Eremin, J. Tate, A.D. Morrison-Low, J. Berry, and S. Stevenson, 'Non-destructive analysis of nineteenth century Scottish calotype negatives and salt prints', *Materials Issues in Art and Archaeometry VI, Materials Research Society (2002)*; Katherine Eremin, J. Tate, and J. Berry, 'Non-destructive investigation of nineteenth century Scottish photographs', *Proceedings of Conservation Science 2002*; Jacqui Rees and Megan Gent, op. cit. ref. chap. 6, n. 24; Lisa Barro, op. cit. ref. chap. 6, n. 25.

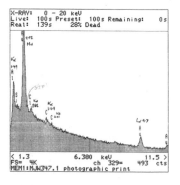

Figure 7.2 *Energy dispersive X-ray spectrum of a new chrysotype print from a scanning electron microscope (SEM/EDX). Note the three strong peaks due to gold (Au). Other significant features are due to aluminium (Al), silicon (Si), chlorine (Cl), and calcium (Ca), which are all constituents of additives to the paper. Courtesy of the Science Department, The National Gallery, London.*

6 Their diameter is about 10 nm. The surface area becomes enormous when the metal is so finely divided - see ref. chap. 5, n. 3.

nanoparticles of metal which make up the silver monochrome image are highly susceptible to attack by atmospheric pollutants and residual chemicals in the paper and mount. Especially destructive in this respect are compounds of sulphur, an element that is avid for silver and reacts with it to form silver sulphide, a substance which is much less strongly-coloured than nanoparticle silver itself, and so the image suffers fading.[7] Many readers will have seen yellowing albumen, or salted paper prints from the last century, and have regretted that so much of our important visual history is in jeopardy through this destructive affinity of sulphur for silver. Photographs were notorious for their failure to survive, even in the 19th century, and the medium was lampooned, as exemplified by the verse and cartoon from Punch magazine (figure 7.3).

7 Mike Ware, *Mechanisms of Image Deterioration in Early Photographs*, London: Science Museum and National Museum of Photography, Film & Television, 1994.

Behold thy portrait – day by day,
 I've seen its features die;
First the moustachios go away,
 Then off the whiskers fly...

Figure 7.3 *A cartoon and verse satirising photographic fading, from Punch, 1847.*

The problem of impermanence was recognised from the first years of photography, and soon induced the Photographic Society to set up the aptly-named 'Fading Committee' of 1855, to investigate its causes. When it finally reported, the committee's recommendations included the toning of prints with gold salts, in order to coat the silver particles with a protective layer of gold, which is far less susceptible to attack than silver. Albumen prints that have been treated in this way usually display a rich purplish-brown colour, with little evidence of fading. Likewise, the 'gilding' of daguerreotypes had been an accepted procedure as early as 1840, as was described in Chapter 5.

Later achievements in the quest for photographic permanence found an answer by avoiding the use of silver altogether, including the carbon process, due to Poitevin 1855 and Swan in 1864, and the previously mentioned platinotype process of William Willis, which enjoys the justifiable reputation of providing the most beautiful of all photographic images, in the most permanent of metals. By the end of the 19th century this process had won the pre-eminent place for making the exhibition prints to be seen on the walls of all the major salons.[8]

8 Mike Ware, 'The Eighth Metal: the rise of the platinotype process', in *Photography 1900: The Edinburgh Symposium*, edited by Julie Lawson, Ray McKenzie, and A.D. Morrison-Low, Edinburgh: National Museums of Scotland and National Galleries of Scotland 1993.

Catalysis and Catastrophe

But even that redoubtable metal, platinum, has its Achilles heel: in its finely-divided state, called 'platinum black', which constitutes the images of platinotype, it is a substance of high catalytic power; that is, it can promote and accelerate chemical reactions without itself suffering any change. (This is readily demonstrated by placing a tiny drop of hydrogen peroxide[9] in a dark corner of a platinotype: the drop will be seen to effervesce, evolving oxygen gas, and decomposing to pure water, which does no harm to the image). Since it is not masked by an impervious layer of colloidal binding agent, the platinum black is accessible to the air. In polluted atmospheres, this powerful catalyst can promote the formation of strong acids, particularly sulphuric acid, within the paper, which severs the cellulose chains constituting the fibres, and seriously embrittles the paper sheet.

> 9 Strength about 6% - otherwise known as "20-volume".

Another tell-tale catalytic effect can arise where a platinotype is mounted in an album, book, or folder, in contact with a facing page: if this paper contains some woodpulp, the platinum black may catalyse the decomposition of the lignins to form coloured quinones, so a yellowish-brown positive imprint of the platinum image is exactly offset into the facing sheet. This catalytic power of platinum black has even been employed practically in a printing process called Catatype. By comparison, the catalytic activity of nanoparticle gold is slight and rather specific,[10] and does not give rise to the formation of acids within the paper. There are good reasons, therefore, to expect that prints in gold will have an archival permanence greater even than prints in platinum.

> 10 David Thompson, 'The International Conference on Catalytic Gold, Cape Town, South Africa, 2-5 April 2001', *Gold Bulletin* 34:2 (2001) 56-66.

Considering the stability of modern materials, the most enduring conventional photographs are monochrome prints using the best modern silver-gelatin papers that have been archivally processed and toned by selenium or gold. Most present-day colour photographs will prove even more ephemeral than their silver counterparts (indeed, many of the early colour prints from the 1950s are already lost);

great care must be taken with their conservation, because they use organic dyes that have a limited lifespan from the archival point of view. The only certain method is to store the colour information as black and white (silver) separation negatives of the three primary colours, from which the colour image can be reconstructed at any time. The 'colloid hardening' processes also offer a method of making three-colour pigment prints, which have good prospects for longevity. The conditions of storage in archives are continually being improved, and recent research has shown the benefits to longevity by storage at low temperatures.

Impact of Electronic Imaging

The closing decade of the twentieth century saw the onset of a revolution in imaging technology – a revolution which was brought about by the wholesale displacement of the core science that underpins lens-based media, from chemistry to physics: from analogue recording by spatially-fixed photochemical reactions, to digital recording of a stream of electronic signals emitted from a photo-receptor as the image is scanned. The chemical processes of the traditional photographic darkroom, wet and sometimes smelly, which are carried out on sheets of gelatin-silver halide emulsion, have now been substantially displaced by the dry and odourless electronics of the desktop computer, which can be employed to process, display, and print the digitally-encoded image files recorded from the output of various opto-electronic devices. In short, the traditional photographic silver-gelatin negative is being replaced by the string of binary code.

It is undeniable that these new methods of imaging technology already offer unparalleled speed, immediacy of production, and economy; not least in regard to the quantity of precious silver that is saved thereby. The power to transmit and universally disseminate images by electronic means, represents a new level of achievement in the flow of day-to-day pictorial information within society. The 'hard copy' end-product of electronic imaging – usually an

ink-jet print[11] – may be superficially indistinguishable from a photographic print, although a 'good eye' or examination with a magnifier will usually reveal its true nature. But the original graphic record – the captured image as a digital file, encoded and stored optically, magnetically, or electronically – is profoundly and obviously different in physical structure from a camera negative.

The choice among manufactured photographic printing papers has been narrowing steadily since the beginning of the 20th century. With the growing takeover by digital ink-jet printers in the 21st century, their production may soon cease altogether. The making of analogue silver-gelatin camera negatives is at present still competitive with digital electronic camera imaging, and may outlive the commercial silver-gelatin print by some years, within hybrid analogue/digital systems, but there is growing evidence from the shifted emphasis in the major industrial companies that its continuing widespread practice is doomed.

Electronic imaging brings with it the problems of sustaining an on-going access to digital files stored in a variety of media; an access which is totally dependent on the availability of specific hardware devices to 'read' and display them, appropriate software to decode the message, and the maintenance of the necessary computers and compatible operating systems, which will inevitably become obsolescent. Within the last ten years alone, even the non-professional user of domestic computer equipment has seen a whole whelter of data storage systems come and go: at least three different formats of floppy disc, and three species of removable hard drive, all now replaced by about six varieties of compact disc (CD). These are composed of plastics with reflective metallic coatings – usually aluminium, a highly reactive metal which is not noted for its longevity.[12] The types of CD that may be written to, or 'burned' in domestic computer equipment usually employ photosensitive dyes to record the data, and are therefore likely to prove quite ephemeral. Some manufacturers have, in an endeavour to provide a truly archival CD, employed gold as the reflective surface! It is significant that they

11 Now dignified by the neologisms "piezotype" or "giclée print".

12 Aluminium is only prevented from rapid oxidation in the air by the fact that a very thin, but rather impervious, surface layer of oxide protects it.

should have resorted to the same metal that is used in the present work to make permanent images. There is another obvious difference between an analogue image and its digital file: the deterioration of the former is gradual, and perceptible, and measures may often be taken to rectify the problem; but when a digital file becomes unreadable, it does so suddenly, catastrophically, and usually irreversibly. It is therefore essential to keep duplicate copies.

Little wonder, then, that deep misgivings remain among archivists, curators, and conservators as to the viability, cost, and permanence of the long-term storage of digital image files, in equipment-dependent formats that will remain both accessible and uncorrupted for centuries. There is much professional debate as to how we should best proceed for the future. Frequent copying or re-formatting, called 'data migration' in the business *i.e.* the copying of entire archives when this is dictated by some enforced commercial change, may prove to be an unaffordable expense in equipment and manpower. The physical endurance of digital files on magnetic or optical media is also very much in question.[13] The technology of the 'hard copy' image – the inkjet print, now dignified with the generic name of 'piezotype' or, for the Francophones, 'giclée print' – has some way to go before it can be claimed that the inks employed are archivally permanent, although there have been considerable recent improvements in the use of pigment, rather than dye-based inks. It is significant that the best practice of digital archiving of images still recommends the making of analogue copies first by conventional photography: large format colour transparencies or monochrome colour separations, as the primary backup, which may then be safely scanned without risk to the original. The resolution achievable by everyday scanning and printing has some way to go before the dot size (*ca.* $\frac{1}{25}$ mm) matches that of a so-called 'continuous tone' fine-grain silver-gelatin negative, which is at least an order of magnitude smaller.

13 The care of CDs is dealt with at: http://www.clir.org/pubs/abstract/pub121abst.html

What in the future will constitute the primary means by which our civilisation stores its photographic images? The traditional silver-gelatin negative is doomed, in the sense that its eventual disappearance as a commercially-available material seems an economic inevitability. Far fewer negatives are now being made; but many of those that we already have in our archives can probably be conserved for centuries yet. In contrast, the strings of binary code that are replacing camera negatives have no independent existence: they require some form of physical embodiment, but none of those incarnations realised so far can compare with the utility and durability of the silver-gelatin negative.

It is not inconceivable that the primary repository for a valued photographic image in the future could be the simple noble metal print on paper, which would have been printed from an ephemeral digital negative. Thus, the original image would be directly accessible, with no need for machines of any kind, and could be copied without limit if need be, and at any time, using whatever scanning technology is current. The major complication would be the need to store colour information as digital separations into the three primaries. The objects themselves – preferably gold images on pure cellulose paper – are the most chemically stable and physically robust that can reasonably be achieved with any materials, and could be conserved for a millennium, to judge by illuminated manuscripts from the distant past that still adorn our archives today.

The Issue of Verity

The computer manipulation of images as digital files has already become so facile and commonplace, that the veracity of any photograph produced by this means is now automatically called into question: no-one any longer expects a photograph to be a genuine 'quotation from reality'. Of course, the camera has always had the ability to lie in some degree: the practice of combination printing from more than one negative was cultivated as a legitimate

art in the 19th century, before panchromatic emulsions became available, in order to accommodate all the photographic information on a single print; leading exponents such as Gustave Le Gray are honoured, rather than execrated, for their skillful technique, which could impart detail to an otherwise empty sky. Even the totally staged, multiply-composite *tableaux vivants* of Henry Peach Robinson and Oscar Reijlander were recognised as works of art, albeit in frank imitation of painting. Cases of outright photographic fraud or misprepresentation tended to be rare, owing to the difficulty of darkroom manipulations and the great skill needed to fake a totally convincing image undetectably. Photographs of spirits, ghosts, and fairies have only ever succeeded in convincing the gullible, who passionately wanted to believe in the reality of such things anyway.[14]

14 The "Cottingley Fairies" is a case in point.

Today, on the other hand, it is unwise to assume that any digital photographic image, however seamlessly persuasive, has *not* been manipulated. Indeed, some of the photographic productions from the desktop are wild imaginings that bear no coherent relationship whatsoever to any pre-existing objects in the real world. This is not to condemn the practice – on the contrary, as a creative medium it offers limitless expressive scope – but there may be a case for distinguishing such pictures by a new and different name. Perhaps the word *photograph* should be reserved for its traditional meaning of a photochemical analogue (either negative or positive) of a real optical image, which can be generally relied upon to bear a fairly accurate one-to-one correspondence with some aspect of external reality. For digital photographs, a new name has yet to be proposed, let alone accepted. Is a name such as 'digigraph', 'electrograph' or 'pixelograph' too infelicitous to designate the electronically-recorded (and probably manipulated) image? For the computer-generated ink-jet print, the words 'piezotype' and 'giclée print' have already been put forward, and widely adopted.

When it is thought desirable that a photograph should guarantee some measure of truth to reality, then alternative printing may be able to furnish protocols which confer a

higher confidence in the authenticity of the image. In a noble metal print, the substance of the continuous-tone image – platinum, palladium, or gold – can be quite readily identified by non-destructive instrumental means, as described earlier. One can then be fairly confident that an image made of these substances was not applied by any digital ink-printing device. Although it is not impossible that a platinotype sensitiser solution could be applied through an ink-jet printer and then processed to make a digital image in platinum,[15] it is far more likely that any platinum photograph was contact-printed from a negative, as a faithful analogue facsimile. If the border of the print is not closely masked, so that it also shows the rebate of the negative and the hand-coated, overexposed margin, then the task of any faker is made even more difficult. However this only takes us back one step in the chain, and does not guarantee the authenticity of the image in the original negative, although examination of the microscopic structure of this could go a long way towards establishing its genuineness as a real optical image captured directly at the focal plane of a camera, especially if the original camera negative were available – the most secure piece of evidence for its optical veracity. However, this might require microscopy to distinguish it from a negative that has been made by digital means, and therefore could easily have been manipulated. Alternative printing processes in noble metals, appropriately documented, are therefore able to offer a better guarantee of the veracity of a photograph, compared with images that have been digitally manipulated. By this means, we might restore confidence in the idea that Martin Kemp and Kelley Wilder refer to when they state:

> "Herschel's idea of the primary role of photography as a vehicle of certified truth remains embedded in the public trust accorded to the still photograph…"[16]

15 It would be much more difficult to apply a gold image by this means.

16 Kelley Wilder and Martin Kemp, 'Proof Positive in Sir John Herschel's Concept of Photography', *History of Photography*, 26:4 (Winter 2002) 358-366.

The Alternative Future

The elegantly simple processes of alternative printing deserve more scientific attention than they have received in the last hundred years. Their investigation needs to be informed by a degree of chemical professionalism in no way inferior to that which has been devoted to the conventional photographic medium for over a century. Had the resources and motivation been available, who knows what innovations and developments might result in gold photography? For instance, it should be possible to re-formulate the sensitiser so that it is compatible with polymeric binders; the making of images comprising nanoparticle gold suspended in gelatin or other transparent binder, on glass plates, could offer a photographic material of extremely high resolution which might be of value to holography or Lippmann photography. On the other hand, the colours obtainable with nanoparticle gold might be susceptible to 'fine-tuning' to the point where they could serve as primaries for a three-colour printing process, whose image would consist of nothing but gold – the ideal solution to the problem of colour impermanence. There is also the possibility of increasing the effective speed of gold printing by a development process of electroless deposition of the metal from a plating solution onto a latent image of gold nanoparticles; Herschel himself noted the ongoing development of chrysotype images in this way. Unfortunately, the alternative processes are never likely to receive the lavish scientific attention needed to accomplish such advances, for there is little or no financial gain to be had from this kind of research. Today even the silver-gelatin medium is in steep decline, as the traditional negative-positive process is inevitably forced to surrender to the commercial challenge of electronic imaging, and to relinquish the hegemony that it has enjoyed for 150 years.

This is a time of profound change in the prevailing technology of photography, when usages deemed obsolete or uncommercial are discarded *volens nolens*. It is vital, therefore, that the methods of alternative photographic

printing should be carefully researched, and the skills entailed in their practice should be wisely nurtured, if we are to retain the ability to make permanent photographic images that will endure and remain accessible for the next millennium. It may be hoped that digital imaging will, in its turn, do for analogue photography what the first photography itself did for painting in the nineteenth century; namely, to take over all the humdrum tasks of ephemeral pictorial representation, and liberate the artists themselves to seek new expressive horizons within both the traditional, and the contemporary media.

I've touched a thousand things, but which one of them have I turned into gold? The artist has to do only with that – he knows nothing of any baser metal.

Henry James (1843–1916)
The Lesson of the Master

Index